ROYAL COMMEMORATIVE
MUGS AND BEAKERS

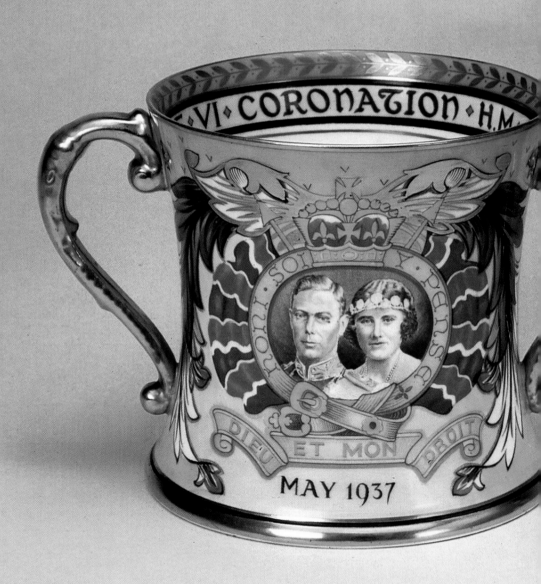

Royal Commemorative Mugs and Beakers

PETER LOCKTON

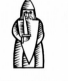

TUCKWELL PRESS

TUCKWELL PRESS
The Mill House
Phantassie
East Linton
East Lothian
EH40 3DG
Scotland

ISBN 1 86232 270 8

A catalogue record for this book is available from the
British Library

Book and Cover design by
James Hutcheson, Edinburgh.
(Set in 10.5/15pt Sabon)

Images, of the featured mugs and beakers, by Gerald Wells
and Gareth Walker of Northern Counties Photographers,
Burslem, Stoke on Trent.

*With the exception of the King George III, the Queen
Charlotte and King George IV coronation mugs illustrated
on pages 24 & 25, all the mugs and beakers featured in this
book are from the Author's collection.*

Printed in Spain by BookPrint S L

DEDICATION

This book is dedicated to all those who have a Royal commemorative and to my wife, Lucy, who never tired of my 'sermons' on Royal commemoratives to unsuspecting visitors to our abodes, be it a vacuum cleaner salesman or an Air Marshal.

Contents

Acknowledgements

Owning Royal commemoratives is an exciting pastime in itself and when displayed they invariably attract attention and arouse interest in many of us. When researched Royal commemoratives reveal considerable historical and local information which generates even greater interest. Such information contained in this book has been provided by the many people and organisations listed below. Without exception all responded promptly and with tremendous enthusiasm.

Fig. 1.01 is from *The Tale of the Pie and the Patty Pan* by Beatrix Potter. Copyright© Frederick Warne & Co., 1905,1987. Reproduced by kind permission of Frederick Warne & Co.

Information on M.B.Foster & Sons in Chapter Two and Six by courtesy of the Bass Museum, Burton Upon Trent.

The National Trust very kindly made the arrangements for the photograph of Beatrix Potter's King Edward VII coronation teapot, Fig. 1.02 in Chapter One.

Royal Doulton plc provided the original images from which Figs. 1.06; 2.01; 4.01; 5.02; 5.12; 9.02 and 10.32 have been reproduced.

The British Library for permission to reproduce Figs. 6.02 and 6.03 (British Library, Oriental and India Office Collection, shelfmark numbers 1/14(1) and 380/3(5) respectively).

The Royal Crown Derby Porcelain Company, Derby provided the original image from which Fig. 10.47 has been reproduced.

The Newcastle Chronicle and Journal Ltd. for permission to reproduce Fig. 7.03.

The Wedgwood Museum Trust Limited, Barlaston, Stoke on Trent.

Royal Worcester.

The British Broadcasting Corporation.

The National Archives, Public Record Office for permission to reproduce the entry, Fig. 3.06A, registering the design on the cup and saucer shown in Fig. 3.06.

The British Museum for providing the images of the King George III and Queen Charlotte coronation mugs in Fig. 1.08.

The Harris Museum and Art Gallery, Preston for providing the image of the King George IV coronation mug in Fig. 1.08. Photography by Norwyn Photographics.

In addition to the Companies / Organisations named above I wish also to acknowledge the tremendous help received from the following:

Rajeev Varma, Manager, Public Affairs & Cultural Relations, Australian High Commission, New Delhi.

Ishwara Bhat, Regional Librarian North India, British Council Division, British High Commission, New Delhi.

Phillip Atkins, Librarian, National Railway Museum, York.

Nicola Saunders, Rights Executive, Frederick Warne & Co.

John McLellan, Humanities Librarian, Cardiff County Council.

Steven N. Jackson, Secretary, Commemorative Collectors Society.

Elizabeth Press, Keeper of Documentation, Bass Museum.

Dr Michael Siddons, Wales Herald Extraordinary.

Robert Noel, Lancaster Herald and Timothy Duke, Officer in Waiting, College of Arms, London.

Sir Malcolm Innes of Edingight, The Lord Lyon King of Arms, Edinburgh.

Shona Owen, Assistant Marketing & Communications Manager, NW Region, The National Trust.

Marcus Payne, Senior Librarian, Penarth Library, Penarth, Vale of Glamorgan.

Jasbir Singh, Sr Press & Public Affairs Advisor, British High Commission, New Delhi.

John Falconer, Oriental and India Office Collections, The British Library, London.

Gill Gould, Newcastle-under-Lyme Library, Cultural and Corporate Services Department, Staffordshire County Council.

Nick Dolan, Curator, Shipley Art Gallery, Gateshead, Tyne & Wear.

Julie McKeowen, Curator, Sir Henry Doulton Gallery, Royal Doulton plc, Burslem, Stoke-on-Trent.

Katharine Spackman and Jan Marsh, Reference Library, Bournemouth Borough Council.

The Hon. H.M.T.Gibson, Managing Director, Royal Crown Derby, Derby.

Sally Woodward, Secretary to The Hon. H.M.T.Gibson.

Aileen Dawson, Curator, Department of Medieval and Modern Europe, The British Museum, London.

Daniela Rizzi, Picture Library, Museum of London.

Alistair McLean, Curator, Royal Air Force Museum, Cosford, Shifnal.

Lynn Miller, Museum Information Officer, The Wedgwood Museum, Barlaston, Stoke-on-Trent.

J.Clayson, Researcher, Putney, London.

Wendy Cook, Curator, The Museum of Worcester Porcelain, The Dyson Perrins Museum Trust, Worcester.

Karen Wood, Assistant to Mr Rumi Verjee, Chairman, Thomas Goode & Co Limited, London.

Katey Banks, Museum Officer (Ceramics), The Potteries Museum & Art Gallery, Stoke on Trent.

Alexandra Waker, Head of Arts and Heritage Services, The Harris Museum and Art Gallery, Preston.

In a project such as this the overall design of the book and the definition and quality of the images are paramount. The work of James Hutcheson, Gerald Wells and Gareth Walker is outstanding. A sincere appreciation for all the hard work that they have devoted to this project. They very quickly became as enthusiastic as Lucy and I.

The help, support and encouragement provided by my wife has been outstanding. Without this I am doubtful that we would have achieved publication. I am most sincerely grateful to Lucy and everyone listed above. This has been a true team effort.

Peter Lockton
June 2001

Foreword

by STEVEN N. JACKSON,
Secretary, Commemorative Collectors Society.

To those who collect in this field, books on commemorative ceramics are rare enough in themselves to become collectors items. So little is known about the subject that all information is both welcome and valuable.

Ceramic commemorative plates, mugs and beakers have been around for well over 300 years and make a fascinating panorama of history, 'windows into the past, reflections of men's souls' is how Macaulay described them, and a definition still very apt today.

Whilst the range of events and variety of commemoratives is very large the definition and discipline of collecting them is very clear and simple – 'an item produced for sale to the public at large which marks or 'commemorates' a specific event, achievement or person, contemporary with the times when it was produced!

Royal commemorative pieces are popular and sought after by Collectors everywhere and the information published here will add to the knowledge and enjoyment of everyone who is interested in this subject.

Peter Lockton's excellent book will be of interest and help to new and old Collectors alike.

STEVEN N. JACKSON

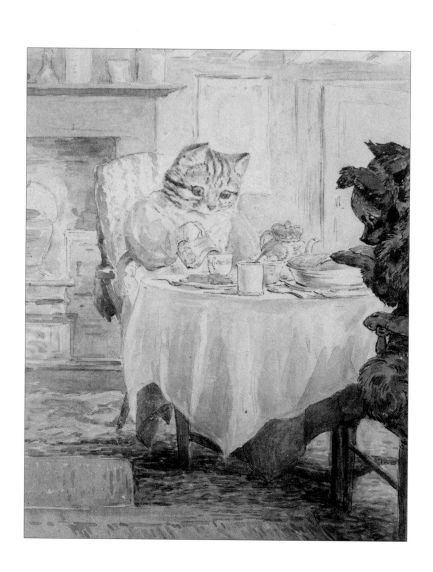

CHAPTER ONE

Introduction

In conversations over the years it seems to me that everybody has one. Mrs Ribston certainly has. Has what? A Royal commemorative. Mrs Ribston, known as Ribby 'was a Pussy-cat'. She invited 'a little dog called Duchess to tea'. This is from one of Beatrix Potter's delightful stories – *The Tale of the Pie and the Patty Pan*. The original illustration, reproduced on the opposite page, Fig. 1.01, clearly shows the Royal commemorative teapot on the tea table. Beatrix Potter used her own fine porcelain teapot, with crown shaped lid, as the model for the illustration she painted in 1905. This teapot, commemorating the coronation of King Edward VII, (see Fig. 1.02), can be seen to-day in her display cabinet at Hill Top, her little farm Near Sawrey, Ambleside where she wrote and illustrated *The Tale of the Pie and the Patty Pan*.

The displaying of ornaments and *objets d'art* came into its own towards the end of Queen Victoria's reign, flowered whilst King Edward VII was on the throne and continued to bloom during the reign of King George V. The desire to display more and more prompted the ceramic industry, not only in Britain, but also in a number of European Countries – notably Germany – to produce low priced souvenirs and commemoratives. It is interesting to note that the Queen Victoria Diamond Jubilee Aynsley mug made for Harrods carries a 'Made in England' banner beneath the design registered number, (see Fig. 1.03). Presumably this was an appeal to the patriotic. On a King George V coronation mug (1911) again for Harrods, there is a banner which reads 'Guaranteed All British', (see Fig. 1.04).

Mugs quickly established themselves as the most popular form of Royal commemorative. This was due to both their usefulness as drinking utensils and the ease by which they could be displayed – even (God forbid) hung on a hook! Fig 1.08 depicts the Royal descent through the medium of coronation mugs from King George III to Queen Elizabeth II.

The first Royal event where a range of commemoratives were

Fig 1.01

One of Beatrix Potter's illustrations, featuring the Royal commemorative teapot, from the book *The Tale of the Pie and the Patty Pan*.

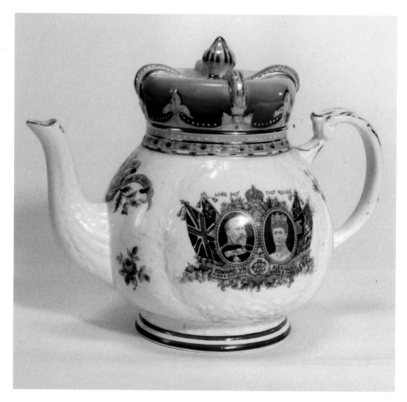

Fig. 1.02

Beatrix Potter's King Edward VII coronation teapot, with crown shaped lid, which she used as the model for the teapot in the illustration reproduced in Fig. 1.01. The National Trust exhibited the teapot at the Hankyu exhibition in Tokyo in 1994. Although there is no manufacturer's mark it is likely to have been made by Samuel Radford (Ltd), Fenton, Staffordshire.

Fig. 1.03

On the base of the Aynsley mug, commissioned by Harrods, commemorating Queen Victoria's Diamond Jubilee in 1897 is the banner MADE IN ENGLAND. The Aynsley mark also includes ENGLAND above the manufacturer's registered number. Harrods also registered this item.

Fig. 1.04

The backstamp of the mug, commissioned by Harrods Ltd, to commemorate the coronation of King George V (1911) has the banner GUARANTEED ALL BRITISH around the Harrods mark.

produced (relative to the few for Queen Victoria's coronation) was the Golden Jubilee of Queen Victoria (1887). The range increased further for the Diamond Jubilee (1897) when a growing number of potteries turned their hands (and wheels) to the production of Royal commemoratives. For each Royal occasion commemorated, competition increased, and designs became more imaginative. Even those sporting moustaches were catered for, (see Fig. 1.05). There was a move to higher quality items. Limited editions were introduced as early as 1902, although the high volume low priced

Fig. 1.05

A Queen Victoria Diamond Jubilee moustache cup and saucer produced by Wileman and Company, Longton, Staffordshire. The transfer design is the same as that on the china mug published by the Wileman company illustrated in Fig. 3.24.

market was still the anchor of the souvenir industry. The production of ceramics was becoming an important part of Britain's industrial heritage, additionally the production of ceramic Royal commemoratives, prior to television and the tabloid press, was an excellent way of promoting the monarch of the day as well as chronicling our heritage. The higher the monarch's popularity the greater the demand for Royal commemoratives resulting in a larger involvement for the ceramic industry. Royal visits to the potteries were both in recognition of the important part they were playing in the building of Britain's industrial base and a sign of appreciation for keeping the monarch to the fore of the people. Fig. 1.06 shows Albert, Prince of Wales'(later King Edward VII) visit to Doulton's Lambeth Art Pottery in 1885. A number of such visits are featured in the chapters that follow and the United Kingdom's ceramics industry continues to feature in the Royal visit programme.

When one visits the houses of friends and relations a Royal commemorative can frequently be seen proudly displayed on the mantelpiece beside the clock. Often these were personally presented to the owner during his or her schooldays at the time of a Royal event. Some have been passed down in the family and are not on display, perhaps tucked away with 'Aunty Esme's' belongings in the trunk in the attic or even relegated to 'toothbrush duty' in the bathroom.

Whether you are a collector of Royal commemoratives; a student of design interested in the way designs have changed over the years capitalising on new production techniques, developments in transfers and changes in public taste; an owner of that Coronation mug or beaker on the mantelpiece; the employer of the Royal commemorative on toothbrush duty or the person in charge of Aunt Esme's remnants; this book, hopefully, will be of considerable interest. Fig. 1.07 illustrates one pottery's range of Royal commemorative mugs and beakers, each one for a different Royal event, commencing with Queen Victoria's Golden Jubilee. These fourteen items have all been made by Royal Doulton. The simplicity and quality of their designs has been retained throughout the years. Whilst they utilised polychrome transfers from King George V's coronation, monochrome designs in sepia were selected for King George V's Silver Jubilee and for two of the last three items illustrated.

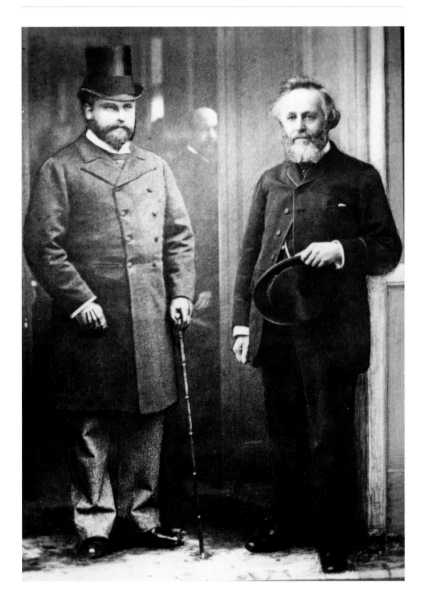

Fig. 1.06

Albert, Prince of Wales, later King Edward VII, with Sir Henry Doulton during the Prince of Wales' visit to Doulton's Lambeth Art Pottery in 1885 when he presented Sir Henry with the Albert Medal of the Society of Arts.

There are many excellent books, catalogues and articles published on Royal Memorabilia (see the Bibliography on page 192) but none concentrate on Royal commemorative mugs and beakers from 1837. In this book many examples are described in detail and all are illustrated in colour. You may find the Royal commemorative which adorns your home on one of the following pages – we hope so. If this encourages you to collect further Royal commemoratives then we will be delighted. But looking at the illustrated pages of this book could mislead you into thinking it will be easy to

19

Fig. 1.07

A selection of Royal commemorative mugs and beakers produced by Royal Doulton at their Nile Street potteries, Burslem, for fourteen different Royal occasions commencing with Queen Victoria's Golden Jubilee in 1887.
The Royal occasions commemorated, from LEFT TO RIGHT, are:
BOTTOM ROW: Queen Victoria's Golden Jubilee (1887); Queen Victoria's Diamond Jubilee (1897); Queen Victoria's Death (1901);
King Edward VII's Coronation (1902);
King George V's Coronation (1911);

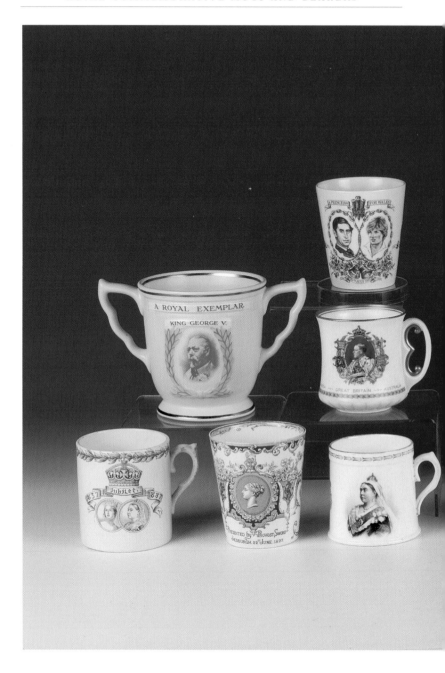

accumulate a worthwhile display quickly. The mugs and beakers detailed in this book are from a collection which has taken over forty years to assemble. A conscious decision was made from the start to specialise in mugs and beakers. A strong discipline is necessary to ensure one does not deviate. An occasional teapot or jug, or even a biscuit tin may spark interest but stick to your selected

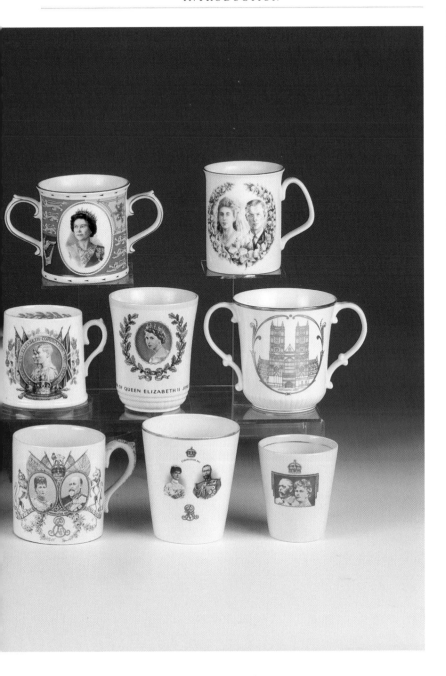

CONT.

King George V's Silver Jubilee (1935); MIDDLE ROW: King George V's Death (1936); King Edward VIII's Coronation (1937); King George VI's Coronation (1937); Queen Elizabeth II's Coronation (1953); The Silver Jubilee of Queen Elizabeth II's Coronation (1978); TOP ROW: The Marriage of The Prince of Wales and Lady Diana Spencer (1981); Fortieth Anniversary of Queen Elizabeth II's Acession (1992) and The Golden Wedding Anniversary of HM The Queen Elizabeth II and HRH The Duke of Edinburgh (1997).

specialisation. Even if mugs and beakers are the chosen discipline further specialisation is preferable. Perhaps only mugs or only beakers, not both. Or a particular reign, or even a specific pottery and so on. The more one specialises the quicker one gets into the subject. The more knowledgeable you are the more interesting becomes the hunt to find the pieces you are looking for. Always try

to obtain articles in at least good condition, preferably excellent condition. Be patient. Always keep your eyes open. You never know where you may find an interesting piece. Keep learning about your speciality, not only by reading but by talking to fellow collectors and those in the trade. Although my specialisation is mugs and beakers I have to admit to having a few cups and saucers and three glasses, one of which is particularly interesting and is discussed in Chapter Six. A case of doing as I say not as I do! Over the years one becomes more selective, and whilst continuing to keep the collection up to date, (see Fig. 1.07A) I now concentrate on 'local' Royal commemoratives which are discussed in Chapter Two. The information detailed research reveals is often very interesting, even to non historians, and the results of such research undertaken on some of the mugs and beakers featured in this book is recorded and this may act as a catalyst for you to conduct similar exercises. One has to be both patient and persistent but the results can be very rewarding.

Many people who acquire a piece of china immediately turn the article upside down to determine where it was produced and by whom. Often the manufacturer is not obvious from the information given. There will often be one of the following, or a combination:- letters; initials; a monogram; devices etc.. From this information it is possible to establish the manufacturer and the pottery where the article was made. In this book we have attempted to identify the manufacturer of all the items illustrated. Where there are no marks, other than a supplier's name, it has been possible to identify the likely manufacturer in some cases. Where this has been done the factors which have assisted in the identification of the manufacturer are discussed.

Let us hope that the mug or beaker on 'toothbrush' duty is rescued from the bathroom as the result of the owner reading this book.

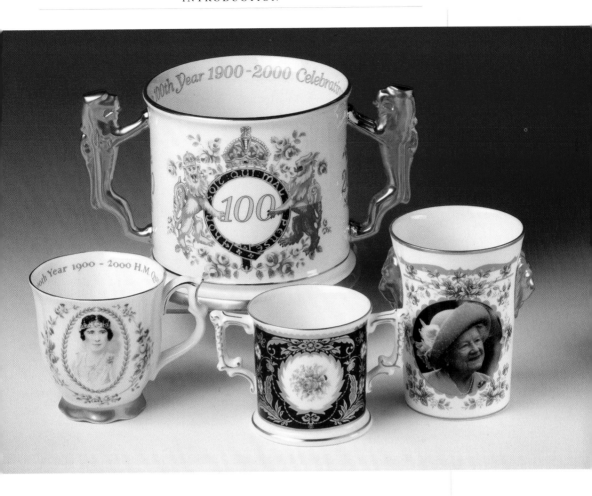

Fig. 1.07A

Recent Royal commemoratives are those celebrating Queen Elizabeth,
The Queen Mother's Centenary. The common theme in this group is the pink roses –
the Queen Mother's favourite flower.

Fig. 1.08

Coronation mugs for
each reign in
descending order from
King George III

*These first period
Worcester mugs, with
hand enamelled Robert
Hancock transfers,
commemorate both the
wedding and
coronation.
© Copyright
The British Museum*

**One of the few mugs
commemorating the
coronation of King
George IV. The 1819
date of accession on
this mug is incorrect.
The actual date was
1820.

*** A Staffordshire
mug with a half length
portrait of Queen
Adelaide on the
reverse. Inside the rim
is a caption for each
portrait. Opposite the
handle is a large crown
surrounded by three
national plant
emblems.

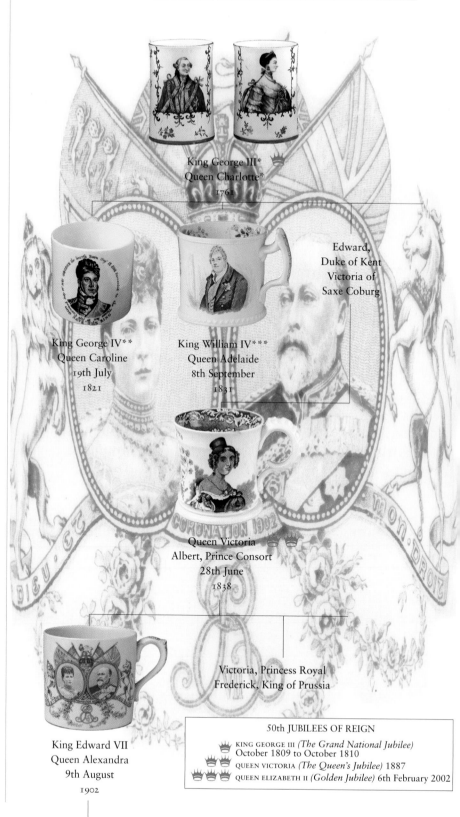

King George III*
Queen Charlotte*
1761

Edward,
Duke of Kent
Victoria of
Saxe Coburg

King George IV**
Queen Caroline
19th July
1821

King William IV***
Queen Adelaide
8th September
1831

Queen Victoria
Albert, Prince Consort
28th June
1838

Victoria, Princess Royal
Frederick, King of Prussia

King Edward VII
Queen Alexandra
9th August
1902

50th JUBILEES OF REIGN

KING GEORGE III *(The Grand National Jubilee)*
October 1809 to October 1810
QUEEN VICTORIA *(The Queen's Jubilee)* 1887
QUEEN ELIZABETH II *(Golden Jubilee)* 6th February 2002

Fig. 1.08

(cont.)

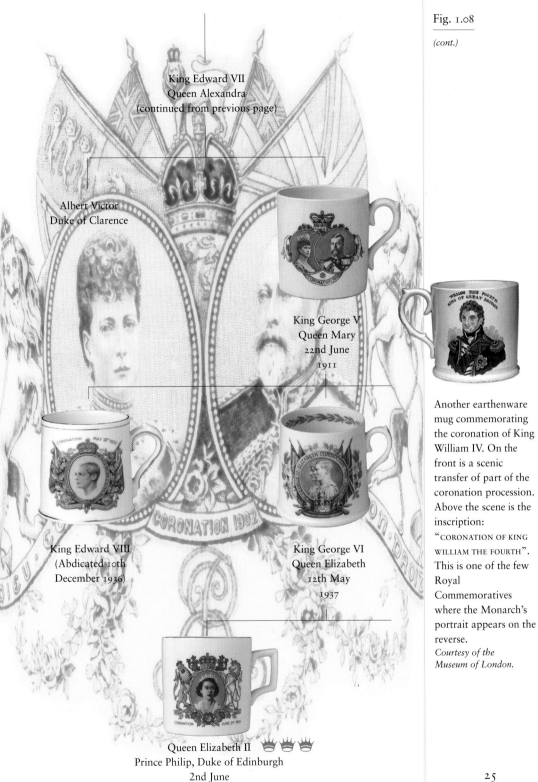

King Edward VII
Queen Alexandra
(continued from previous page)

Albert Victor
Duke of Clarence

King George V
Queen Mary
22nd June
1911

King Edward VIII
(Abdicated 10th
December 1936)

King George VI
Queen Elizabeth
12th May
1937

Queen Elizabeth II
Prince Philip, Duke of Edinburgh
2nd June
1953

Another earthenware mug commemorating the coronation of King William IV. On the front is a scenic transfer of part of the coronation procession. Above the scene is the inscription: "CORONATION OF KING WILLIAM THE FOURTH". This is one of the few Royal Commemoratives where the Monarch's portrait appears on the reverse.
Courtesy of the Museum of London.

25

COUNTY BOROUGH OF BOURNEMOUTH.

PULCHRITUDO ET SALUBRITAS

CORONATION CELEBRATION.

·1911·

ALDERMAN C. HUNT
MAYOR.

CHAPTER TWO

Local Commemoratives

Commemoratives which have been commissioned by a local authority, such as a town council, a borough corporation etc. are referred to as local commemoratives. One of the first local commemoratives was a mug, produced by Davenport, for Queen Victoria's coronation on 28th June 1838. Around the mug is inscribed 'Success to the Town and Trade of Preston'. The number of local commemorative mugs and beakers increased for the Queen's Golden Jubilee and really became established for the Diamond Jubilee, and peaked for Edward VII's coronation and George V's coronation. Thereafter the number of local commemoratives has fallen away quite dramatically, although the number of limited editions produced has increased. Millions of these local Royal commemoratives were handed out to schoolchildren and the under-privileged on the occasion of a Royal event: good corporate relations for the concerned council and good business for the pottery which secured the contract.

Local commemoratives are commissioned pieces and manufactured to an order in which the quantity is specified. As such they can be taken as a limited edition, even though some of the quantities have been very large. The large orders were usually for functions organised by a member of the Royal family. An excellent example of this was the huge children's party held in Hyde Park in June 1887 on the occasion of Queen Victoria's Golden Jubilee for which Doulton's (Royal Doulton) at their Burslem pottery, produced 30,000 fine porcelain tapered beakers decorated with a gold transfer, (see Fig. 2.01). The driving forces behind this event were Their Royal Highnesses The Prince and Princess of Wales (later King Edward VII and Queen Alexandra). Another gargantuan event at which Royal commemorative beakers were distributed was King Edward VII's coronation dinners for London's under-privileged citizens. These were held on 5th July 1902. Over 500,000 tapered beakers were produced by Royal Doulton at their Burslem pottery, (see Fig. 4.06 and 4.07). King George V ordered 100,000

27

beakers from Royal Doulton's Burslem pottery for the children's fete held at the Crystal Palace on 30th June 1911, (see Figs. 5.08 to 5.11 inclusive).

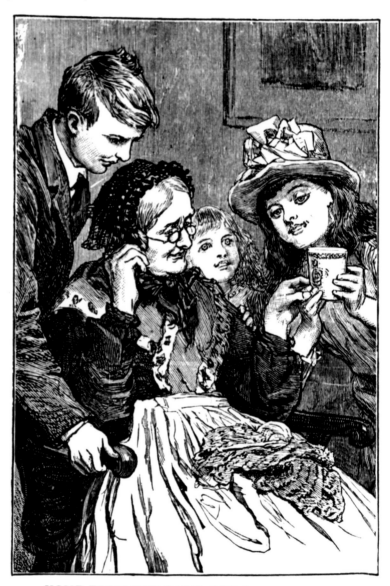

HOME FROM THE PARK—THE JUBILEE MUG.

Fig. 2.01

A contemporary illustration of children returning from the Hyde Park party in June 1887 with one of the thirty thousand Doulton (Royal Doulton) produced beakers commemorating Queen Victoria's Golden Jubilee. The illustration's original caption is incorrect in that it was a beaker that was presented – not a mug.

Local commemoratives bear an inscription; these inscriptions usually include the coat of arms of the commissioning body, sometimes only the coat of arms is displayed. Fig. 2.02 shows examples of inscriptions not featured elsewhere in this book. The

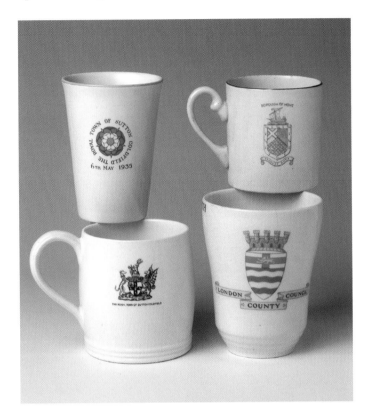

Fig. 2.02

Four Royal commemorative mugs and beakers displaying 'local' inscriptions.
From top left:
(1) A tapered beaker commemorating the Silver Jubilee of King George V commissioned by The Royal Town of Sutton Coldfield (near Birmingham) for distribution to local schoolchildren. The manufacturer was Wood and Sons, Burslem, Staffordshire who also produced the other beaker in this group.
(2) This handsome King George VI Coronation mug with colour printed transfer of their Majesties on the front, copyright Van Dyk, was another commission by The Royal Town of Sutton Coldfield. The Town crest replaces the emblem displayed on the earlier beaker. This mug was produced by Barker Bros. Ltd., in their Tudor Ware range at their Barker Street pottery in Longton. Impressed on the base is 'Patent Applied For'.
(3) A King George VI Coronation tapered waisted beaker produced for the London County Council. The design on the front is the Royal Coat of Arms.
(4) A King George V Silver Jubilee mug commissioned by the Borough of Hove. The base mark is of the supplier only:
Direct Pottery Supply, 32 George Street, Hove.

King George V coronation mug shown in Fig. 2.03 is unusual in that the local inscription contains no coat of arms but is explicit in its purpose.

Fig. 2.03

The inscription on the reverse of a King George V coronation (June 1911) earthenware mug. This inscription is particularly explicit with the inclusion of the words 'PRESENTED BY...'.

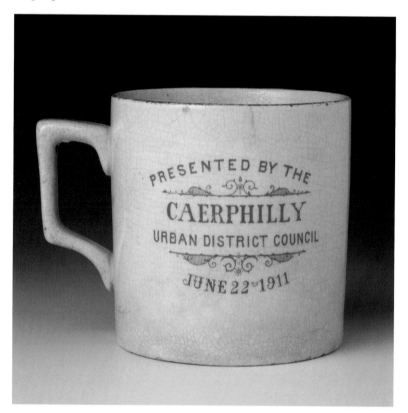

The inscriptions are sometimes incorporated into the design of the main transfer, (see Fig. 3.10), although in some cases it is an overstamp on an existing design. An example of this is the Edward VII coronation beaker presented in Woking, (see Fig. 4.12). In some cases the design on the selected mug or beaker leaves insufficient room for even an inscription, let alone a shield. The potteries overcame such a situation by printing the inscription on the base, (see Fig. 2.04). This high class earthenware mug commemorating the coronation of King George VI, was presented by Brittains Limited, to the employees, and local schoolchildren, at their Cheddleton Paper Mills, near Leek, Staffordshire. Wetley Rocks is an adjacent village where a number of the employees lived. An outline of the activities of Brittains Limited is included in the description in Chapter Nine, Fig. 9.05. A paper mill was established, on this site, at the end of the eighteenth century for the manufacture

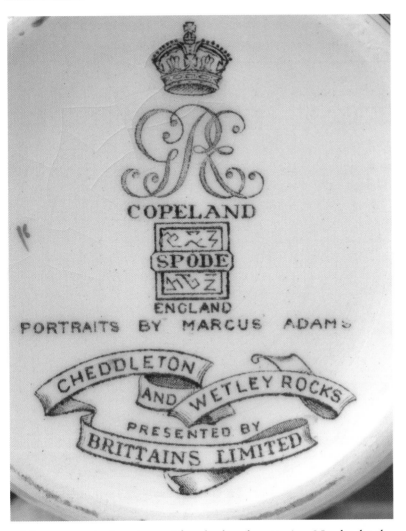

Fig. 2.04

In some instances the commissioning body selected an existing design which was printed on both the front and the reverse of the mug / beaker leaving no space for their 'local' inscription. In this case the pottery, W.T.Copeland (& Sons Ltd), Spode Works, Stoke, Staffordshire, incorporated the inscription in the base stamp of this King George VI coronation mug, see FIG. 9.05. The inscription reads: 'CHEDDLETON AND WETLEY ROCKS Presented by BRITTAINS LIMITED'. The description accompanying FIG. 9.05 includes information on Brittains Limited – a specialist paper manufacturer.

of 'pottery printing tissues' for the local potteries. No doubt the manufacturer of this mug, W.T.Copeland (& Sons Ltd) at their Spode Works, utilised transfers printed on papers supplied by Brittains, who commissioned this mug. A supplier turned customer! Another example of printing the 'local' inscription on the base is the King George V Silver Jubilee mug, produced by British Anchor Pottery Co Ltd, Longton, Staffordshire. The inscription on the base reads 'BISHOP'S STORTFORD PRESENTED BY THE CITIZENS, (see Fig. 5.03).

Sometimes the commissioning body contracted a local supplier to undertake discussions with the potteries, place the order and oversee the supply of the finished product. In such cases the supplier's name was printed on the base of the mug or beaker.

Fig. 2.05

A King Edward VII coronation mug commissioned by Brixham Coronation Celebration Committee. Printed in green, this mug was produced by Wileman & Co. at their Foley China Works, Fenton, Longton. The base stamp, in addition to the manufacturer's details, includes the details of the supplier – 'Manufactured for P.Williams, Fore Street, Brixham.' Opposite the handle is the 'badge' of the commissioning council. At the bottom of the shield is I WILL MAINTAIN and underneath the scrolled ribbon inscribed BRIXHAM is: LANDING OF THE PRINCE OF ORANGE 1688.

Figs. 2.05 and 2.06 are examples of supplier involvement. It appears that on the larger commissions the commissioning body worked directly with the selected pottery.

The inscription frequently includes the name of the Provost

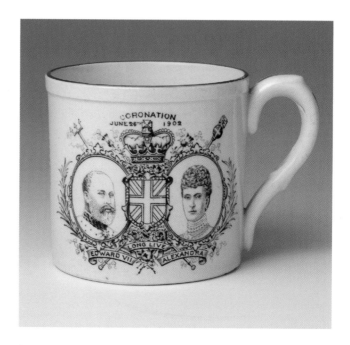

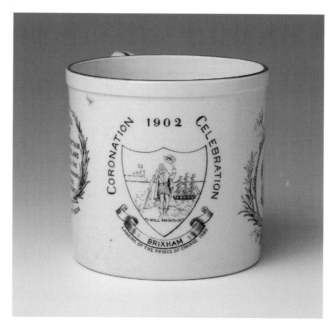

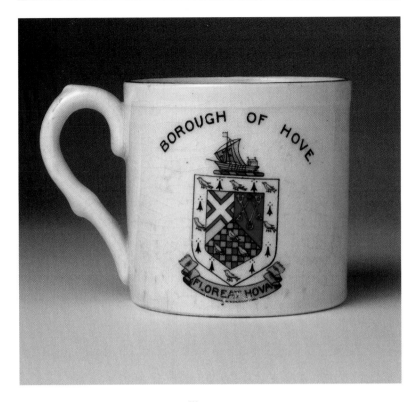

Fig. 2.06.

A typical Coat of Arms presentation as found on the reverse of many local commemoratives. The base of this King George V coronation mug, with a copyright decoration on the front, has two marks – the manufacturer's and the supplier's. The manufacturer was Shelley. However above Shelley is printed Late Foley. Wileman & Company of the Foley China Works became Shelley Potteries Ltd. in 1925. The Shelley trade name was used from 1911. Therefore the same pottery produced the mugs shown in Figs. 2.05 and 2.06. The second mark is that of the supplier – 'Made for Diplock's, 27 & 29 Western Road, Hove.'

or Mayor. Occasionally a portrait of such a dignatory accompanies the town's or borough's coat of arms as shown in Fig. 5.26. The detailed description of that particular beaker records how these were distributed to the schoolchildren who participated in the celebration festivities. As stated earlier in this chapter millions of beakers were presented to schoolchildren, at similar functions held throughout the country, to commemorate a Royal event. At Queen Elizabeth's Silver Jubilee in 1977, fewer mugs and beakers were commissioned for presentation to schoolchildren hence the selection

Figs. 2.07 and 2.08

The C.T.Maling and Sons King George V coronation beaker commissioned by the City and County of Newcastle Upon Tyne. A fine polychrome printed transfer decorates the front of the beaker. The inscription on the reverse includes the name of the Lord Mayor and the Sheriff. This beaker was presented to the local schoolchildren – one recipient attended Bath Lane School in Newcastle-upon-Tyne.

of 'were' in the last sentence. Hopefully many local authorities and education committees will continue the very long-standing tradition for Queen Elizabeth II's Golden Jubilee on 6th February 2002.

Often the pottery which won the contract was situated within a few miles of the commissioning town: an early example of assistance to local industry. The beaker commissioned by the City and County of Newcastle for the coronation of King George V was produced by C.T.Maling and Sons at their A & B Ford Potteries, Newcastle-upon-Tyne. Fig. 2.07 and 2.08 show both sides of this smart tapered beaker. A most interesting detail of the main transfer is the tiny inscription, in yellow, running beneath the flags on each side of the central decoration. It reads 'Harrods Ltd. Exclusive Design.' This information helped to confirm the manufacturer of the Harrods King George V coronation mug, Fig. 5.23, as C.T.Maling and Sons.

The Northumberland County Education Committee commissioned a tapered beaker for the Silver Jubilee of King George V, (see Figs. 2.09 and 2.10). There is no printed mark on the base of this beaker – only an impressed '2085' – and a hand-painted silver

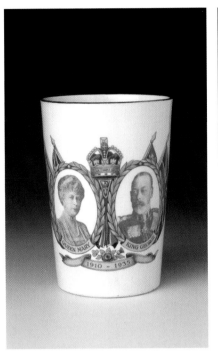
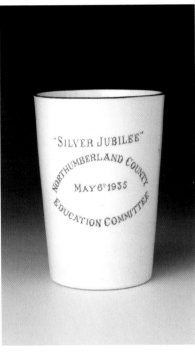

Fig. 2.09 and 2.10.

A polychrome decoration surrounding monochrome portraits of King George V and Queen Mary on this beaker commemorating their Silver Jubilee. The reverse identifies the commissioning body as the Northumberland County Education Committee. The base has no mark other than an impressed 2085. The manufacturer's mould or shape number.

'T' of the paintress who painted the silver rim. However a King George VI tapered beaker, of identical dimensions, (see Fig. 2.11 and 2.12) has the same impressed number in its base (2085) together with a Maling stamp. This piece was commissioned by Newcastle-upon-Tyne City Corporation. The number 2085 is a Maling beaker shape or mould number, therefore Maling were the manufacturers of the King George V Jubilee beaker discussed above, and the Maling paintress was Janet Taylor, whose sign was a hand painted 'T'. Another example of assistance to local industry is the Maling Queen Victoria Diamond Jubilee mug ordered by the supplier, Cullen & Son, Newcastle-upon-Tyne, on behalf of the Borough of Morpeth, a market town some twelve miles north of Newcastle-upon-Tyne, (see Figs. 3.14, 3.15 and 3.16).

Occasionally private individuals commissioned pieces to commemorate Royal events. An example of this is the Queen Victoria Golden Jubilee (1887) mug (see Fig. 3.05). An old scholar of St. Augustines School, Penarth commissioned this fine mug for presentation to those attending the school at the time of the Jubilee celebrations. The detailed description of this mug (see page 43) includes the results of research undertaken to learn more about St

Figs. 2.11 and 2.12.

An identically sized beaker, with an impressed 2085 in its base, to that illustrated in Figs. 2.09 and 2.10. Commemorating the coronation of King George VI, the reverse is printed with the Coat of Arms of Newcastle-upon-Tyne. Maling (C.T.Maling & Sons, A& B Ford Potteries, Newcastle Upon Tyne) is the manufacturer's printed mark on the base.

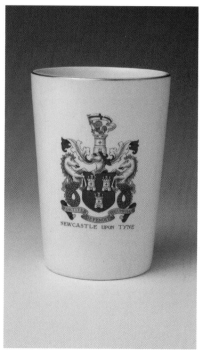

Augustines School and the identity of the Old Scholar. Business organisations also commissioned Royal Commemoratives to promote their products at the same time as celebrating a Royal occasion. An interesting example of this is a beaker commemorating the coronation of King George V, (see Figs. 5.21 and 5.22). The panel on the reverse is an advertisement for soft drinks 'Coronation Drinks' produced by a W.A.Wilkinson of North Shields. The drinks are listed as:- SMILA, TYNO, PINEOLA and LI'KSALL. Spoken with a Geordie accent you cannot get more local than that! Another example of a 'sponsored' Royal Commemorative is the deep blue King George V coronation mug distributed in India by M.B.Foster & Sons Ltd. of London, bottlers of Bass's Ales and Guiness's Stout, (see Figs. 6.05 and 6.10). All the examples of local commemoratives discussed in this chapter were free to the recipient. A mug commemorating the marriage of Prince Andrew and Miss Sarah Ferguson on 23rd July 1986 (see Fig. 2.13), commissioned by the London store Fortnum & Mason, and featuring their famous clock, was on sale at their store at the time of this Royal wedding: an example of business adapting to the opportunities of the tourist trade, and that was the bread and butter of the souvenir industry

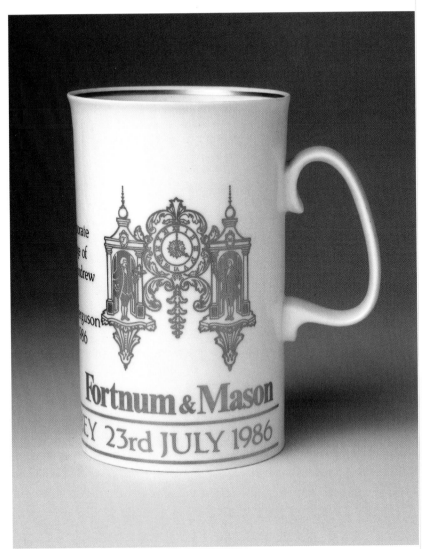

Fig. 2.13.

A tall mug commissioned by Fortnum & Mason, and purchased from their famous London store in Piccadilly showing its equally famous clock, bearing the inscription – *'To Commemorate the Marriage of The Prince Andrew and Miss Sarah Ferguson 23rd July 1986'*. Around the base is inscribed 'Westminster Abbey 23rd July 1986'. Marked on the base is Prince Andrew's Royal cypher, beneath which is – 'Fine Bone China Dunoon Ceramics Made In England'.

in the late nineteenth century and early twentieth century – a far cry from the days of Mr. W.A. Wilkinson's freebies!

Note: For easy reference the 'local' mugs and beakers discussed in the later Chapters of this book are highlighted with an (L).

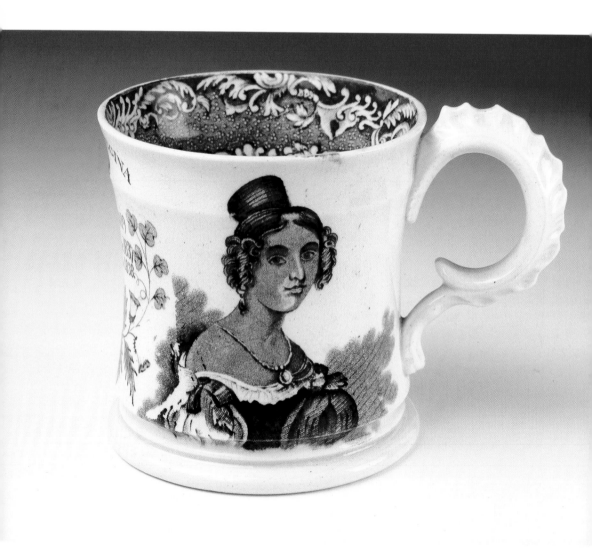

Queen Victoria
1837 - 1901

Born Alexandrina Victoria (she chose her second name for her title) on 24th May 1819, daughter of Edward, Duke of Kent, Queen Victoria 'Ascended the throne June 20th 1837', as inscribed on the Maling Diamond Jubilee mugs, on the death of her uncle, King William IV. Queen Victoria moved from Kensington Palace to Buckingham Palace on 14th July 1837 and became the first sovereign to reside in the converted building since the original building was completed in 1677. Queen Victoria was crowned on 28th June 1838 and married Prince Albert of Saxe-Coburg and Gotha on 10th February 1840 in the Chapel Royal, St James's Palace. The Queen completed the longest reign on 23rd September 1896 exceeding that of her grandfather, King George III of 59 years, 3 months and 4 days. Figs. 3.08, 3.09 and 3.09A illustrate two Longest Reign mugs, bearing the actual date, together with a full description of each of these mugs. Although the inscriptions on many of the Diamond Jubilee mugs include a reference to the Longest Reign, it is only those that have an inscription containing the September 1896 date that can be classified as Longest Reign commemoratives.

The reign of Queen Victoria has been reported as 'an era unmatched in its dynamism'. Dynamic it certainly was. From the tender age of 18 years, (see Fig. 3.01), Queen Victoria commenced her reign at a time when the stagecoach was the main means of travel but by her Diamond Jubilee the motor car had replaced the stagecoach. Britain's population almost doubled to 37 million and Britain became the world's greatest industrial power. Industry and invention flourished – 'from the railway engine to the safety match'. Progress was the order of the day. Indeed the design on a Diamond Jubilee mug, (see Figs. 3.27 and 3.28), commissioned by William Whitely Universal Provider of Westbourne Grove, London includes a picture of a sundial next to a clock beneath which is the inscription PROGRESS. There is also a picture of a steam locomotive and a naval ship. Wages steadily improved, prices were stable, hours were cut and an annual paid holiday introduced when millions of people

OPPOSITE

The much sought after Queen Victoria coronation mug with the transfer attributed to Swansea.
(see Figs. 3.02A and 3.02B)

Fig. 3.01

A portrait of Queen
Victoria at the age of
18 as featured on a
commissioned Royal
Doulton Diamond
Jubilee beaker.

took advantage of the expanding British railway network to visit
the developing seaside resorts. This new pattern of social behaviour
created an opportunity for the potteries – the production of
souvenirs, resulting in the birth of the souvenir industry. The
Harrods commissioned Diamond Jubilee mug, (see Figs. 3.22 and
3.23) is decorated with seven captioned leisure activities. The interest
in such activities was stimulated by increased wages and reduction
in the hours worked. Many of the potteries which concentrated on
the production of souvenirs, for example W.H.Goss of Stoke, also
took the opportunity to produce commemoratives for the various
Royal events for which the larger potteries had already established
a reputation. Competition increased, resulting in millions of
commemoratives being produced for Queen Victoria's two jubilees
and the coronations of King Edward VII and King George V. Many
of these were commissioned by local authorities for presentation
to the schoolchildren.

Towards the end of the nineteenth century Britain lost its

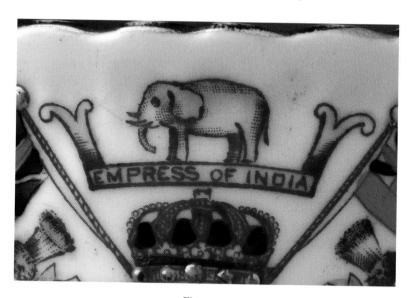

Fig. 3.02

'The indefatigable Indian elephant' from a Queen Victoria Diamond Jubilee
commemorative produced by W. Lowe, Longton, Staffordshire. The inscription
beneath the elephant reads 'Empress of India'.

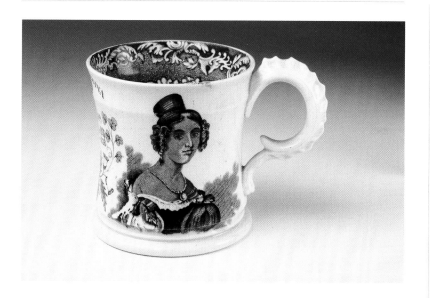

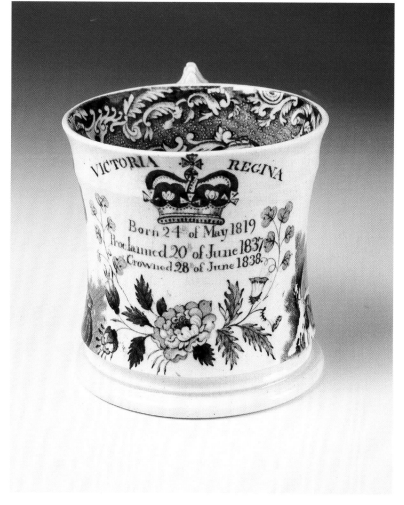

Figs. 3.02A and 3.02B

Queen Victoria coronation mug.
A waisted pottery mug, with ornate handle, printed with the Swansea purple transfer, featuring identical half-length portraits of Queen Victoria on the front and the reverse. The portraits, on this much sought after mug, show Queen Victoria with her hair in a bun and with ringlets, wearing a necklace with a plain round pendant. Opposite the handle is a crown above which is:
VICTORIA REGINA.
Below the crown is the inscription:
Born
24th of May 1819
Proclaimed
20th June 1837
Crowned
28th June 1838.
Below and flanking the inscription is a design of three national plant emblems (rose, thistle and shamrock). The inside rim is decorated with a wide band of scroll work.
MARK: There are no marks.
MANUFACTURER: Swansea Pottery, Cambrian Pottery, Swansea, Wales.

 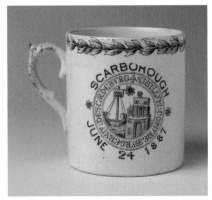

Figs. 3.03 and 3.04 (L)

A white earthenware mug with a strikingly simple sepia transfer print decoration. A band of laurel leaves decorates the rim. Two medallion type portraits of the young and old Queen Victoria form the centrepiece of the design. Above this is a scrolled ribbon inscribed: 1837 JUBILEE 1887. A crown tops the scroll. On the reverse is the Scarborough Town Crest around which is the inscription: SCARBOROUGH JUNE 24 1887.

NOTE 1: The design is similar to Doulton's (Royal Doulton Ltd.) John Slater designed beakers that were presented to 30,000 schoolchildren at the Hyde Park parties in June 1887 to celebrate Queen Victoria's Golden Jubilee. The design on the mug differs from that used on the beakers in that JUBILEE on the scroll replaces VR. The scroll has therefore been redesigned to accommodate the additional five letters and the crown's position has been lifted.

NOTE 2: This mug was the first Royal commemorative made at Royal Doulton's Burslem factory in Nile Street.

NOTE 3: Queen Victoria's Golden Jubilee was celebrated on 21st June 1887. The date of June 24th probably refers to the date of Scarborough's local celebrations.

MARK: The traditional Doulton device surrounded by the words Doulton and Burslem.

MANUFACTURER: Doulton & Co (Royal Doulton Ltd), Burslem, Staffordshire.

position as the world's greatest industrial power. This occurred around the time Britain was creating the Empire. In January 1877 Queen Victoria was proclaimed Empress of India following the passing of the Royal Titles Bill by the Government in 1876. Although India was placed under Crown rule in 1858, Queen Victoria never visited India. Many designs for her Diamond Jubilee displayed an Indian influence – notably the indefatigable Indian elephant, (see Fig. 3.02). She reigned until her death on 22nd January 1901 – 63 years 7 months and 2 days.

The mugs, beakers, cups and saucers described in this chapter

Fig. 3.05(L)

A white tapered porcelain mug with gilded scrolled handle, gilded rim and heavy gold band at the base, features a printed black transfer portrait of Queen Victoria exquisitely hand painted with colour enamels. The Queen is wearing her small crown and the Order of the Garter. This mug is a privately commissioned local commemorative and is likely to have been produced in a limited edition for presentation to all students of St. Augustines School, Penarth by an old scholar. The inscription, in gold reads:

A GIFT FROM AN	ST AUGUSTINES SCHOOL
OLD SCHOLAR (F.L)	PENARTH.
THE QUEENS	JUBILEE JUNE 20TH 1887

Note: Inquisitive collectors seeing this mug will ask themselves: does St Augustines School still exist? Whereabouts in Penarth was the school situated? what type of school was it? How many staff and boys were at the school in 1887?, and who was FL? With the considerable help of the enthusiastic Senior Librarian at Penarth Library some of these questions can be answered.

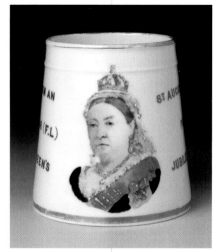

St. Augustines School was situated in Maughan Street, Penarth, but alas is no more. The street has been renamed Queen Street and the block where the school existed has been redeveloped with housing. The donor of these mugs may have been Frederick Lovett who in 1861 at the age of eight lived in Maughan Street, where his father was an innkeeper, and most probably attended St. Augustines School. At the age of eighteen he moved to Windsor Road and became a brewer. This research is a good example of the interest and excitement local Royal commemoratives can generate.

MARK: Printed in sepia:

F.W.G.

COPYRIGHT

BY PERMISSION OF A. BASSANO

OLD BOND ST LONDON. W.

F. W. G. could be the initials of the pottery and A. Bassano the supplier and holder of the copyright.

MANUFACTURER: Unknown.

commemorate Queen Victoria's Coronation (28th June 1838), Golden Jubilee (20th June 1887), The Longest Reign (23rd September 1896), Diamond Jubilee (20th June 1897) and her death (22nd January 1901). Her Silver Jubilee in 1862 was not commemorated as the Queen was still mourning the death of her husband, on 14th December 1861 aged 42, from typhoid fever. Queen Victoria's mourning lasted for over two years.

The commemoratives illustrated in this Chapter have mostly single

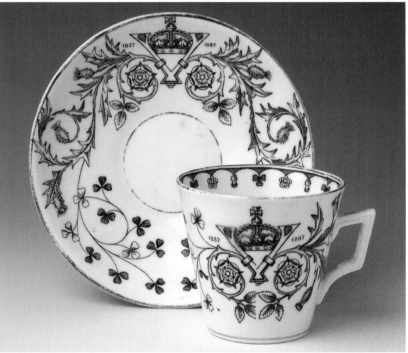

Fig. 3.06A

The delightful cup and saucer shown in Fig. 3.06 has no manufacturer's mark only a registration number – 63310, on both the cup and saucer. The Public Record Office at Kew, London, holds all the original registration books so tracing the actual party who made the initial application is possible. Featured here is a copy of the original entry registered on 11th December 1886 by Adderley and Lawson of Longton, Staffordshire.

Fig. 3.06

White bone china cup and saucer with brown printed transfer. The rim and base of the cup are gilded with a gold stroke on the handle. The saucer rim is gilded. The geometric design consists of an ornate V encompassing a crown. Two Tudor roses curl from the point of the V with thistles flanking one side and shamrock the other.

On the lefthand side of the V is the date 1837 with 1887 on the other side. The reverse is a mirror image of the design on the front. Inside the cup rim is a repeating design of a rose, a shamrock and a thistle. The saucer has a slightly different design in that there is only one V and thistles curl out of each side covering half the saucer, whilst the other half is decorated with shamrock.

MARK: Printed, on both the cup and the saucer, in brown: JUBILEE beneath which is a rectangular outline containing Rd No 63310.

MANUFACTURER: Registered by Adderley & Lawson, Salisbury China Works, Longton. Fig. 3.06A is a copy of the entry from the original Registration Book in the Public Record Office, Kew, London. The design (pattern) was registered by Adderley and Lawson on 11th December 1886. The Salisbury Works are in Edensor Road, Longton and were built in 1876. The partnership of Charles Adderley and Richard Lawson operated from the Salisbury Works from circa 1881 to 1892.

Fig. 3.07

A fine bone china tapered beaker with gilded rim. A black transfer print, hand painted in coloured enamels, decorates the front of this beaker. A large stylistic V in turquoise is topped by a arge coloured crown with 1887 below. In the V, one above the other, are the four national plant emblems. (Wales is represented by a leek.) A scrolled yellow ribbon flows from one side of the V to the other.

Inscribed on the ribbon is –

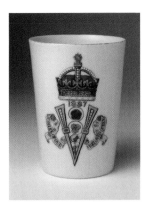

JUBILEE OF OUR BELOVED QUEEN.
MARK: Printed in black is a large eagle standing on a striped pole with W.H.Goss below. Registered number 61464 is printed above the eagle.
MANUFACTURER: William Henry Goss (Ltd), Stoke, Staffordshire.

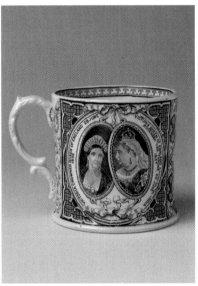

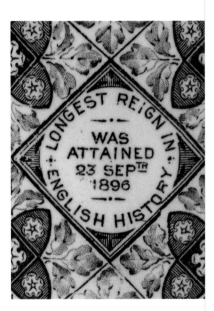

Figs. 3.08 and 3.09

Earthenware mug, flared at the foot, with an ornate handle decorated with an elaborate transfer print in grey and black, also with decoration inside the rim. The decoration on the front and the reverse are identical and consist of two portraits of the Queen, in oval frames. The first is a portrait painted at the start of her reign and the second painted in preparation for her Diamond Jubilee celebrations. The caption around the portraits reads: VICTORIA CROWNED QUEEN OF ENGLAND 28 JUNE 1938 and VICTORIA QUEEN OF ENGLAND EMPRESS OF INDIA ASCENDED THE THRONE 20 JUNE 1837. In the centre, opposite the handle is the inscription: LONGEST REIGN IN ENGLISH HISTORY WAS ATTAINED 23 SEPTR 1896.
MARK: Rd 287008. No other marks.
MANUFACTURER: The registration was made by William Alsagar Adderley (& Co), Daisy Bank Pottery, Longton, Staffordshire.
NOTE: The same registration number appears on a similar mug, but with a mainly brown transfer print, which has the inscription on the base:- MANUFACTURED FOR WILLIAM WHITELEY LONDON.

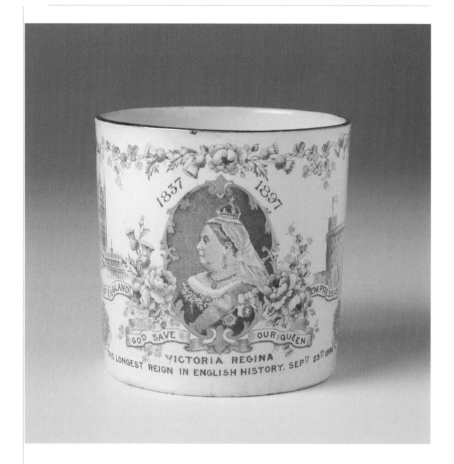

Fig. 3.09A

A white earthenware mug with gilded rim and gold stripe on the handle, featuring an
oval portrait of Queen Victoria, printed in sepia, wearing the small crown and Garter
ribbon. The portrait, opposite the handle, is framed in a handpainted gold
decoration – beautifully executed. The framed portrait is flanked by national plant
emblems of roses, thistles and shamrock. A border of these national plant emblems
runs around the mug beneath the rim. The front and reverse are decorated with
pictures of Balmoral Castle, the Palace of Westminster, Windsor Castle, HMS
Defence, HMS *Victoria* and crests of Canada, Cambria (Wales), Australasia, India
and Cape Colony together with a Union flag and the Royal Standard. Inscribed in
ribbon scrolls is EMPIRE ON WHICH THE SUN NEVER SETS; QUEEN OF ENGLAND EMPRESS OF
INDIA and GOD SAVE OUR QUEEN. Beneath the portrait is: VICTORIA REGINA and below
this is: THE LONGEST REIGN IN ENGLISH HISTORY. SEPTR 23RD 1896.
MARK: Printed in sepia on a ribbon is; REG. NO. 287962. Below this is inscribed:
MANUFACTURED FOR WILLIAM WHITELY. LONDON BY J. AYNSLEY and SONS.
MANUFACTURER: John Aynsley & Sons (Ltd), Longton, Staffordshire.
NOTE: This mug was also produced with a blue transfer and a hand coloured enamel
finished sepia print without the gilded frame.

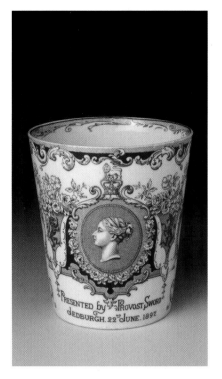 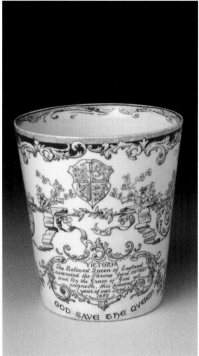

Figs. 3.10 and 3.11 (L)

White china tapered beaker with ornate olive green transfer encircling the whole beaker commemorating Queen Victoria's Diamond Jubilee. In the centre front, in an elaborately decorated cartouche, is a portrait of the young Queen without her crown. Surmounting this design is a crown topped by a lion. Supporting this design at the sides are the national flowers with lion and unicorn rampant – one at each side. Below the cartouche is the inscription – Presented by Provost Sword Jedburgh, 22nd June 1897. On the reverse is the Royal Coat of Arms above ribbons entwining the national flowers. At the bottom, within a decorative scrolled panel are the words:

VICTORIA
The beloved Queen of England
ascended the Throne June 20th 1837
and By the Grace of God yet
reigneth this present year of our Lord
1897

Underneath the panel in a curve, are the words 'God Save The Queen'.
The rim of the beaker has a bold scroll on the outside and a daintier version on the inside.

MARK: Green printed decorative diamond shape inscribed 'Victoria RI, Diamond Jubilee, Doulton Burslem Rd No 293418'.

MANUFACTURER: Doulton & Co (Royal Doulton Ltd) Burslem, Staffordshire.

colour transfer prints although polychrome prints were becoming available at the time of the Diamond Jubilee: an example of the advances of the industrial revolution referred to earlier. The majority of the coloured commemoratives that are featured in this Chapter were produced by hand painting the monochrome transfer using coloured enamels. The result is most striking; apart from each one being unique, the addition of the enamels gave the painting relief. The privately commissioned Golden Jubilee mug shown in Fig.

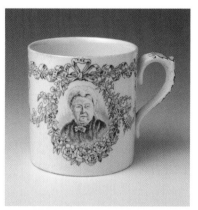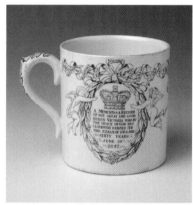

Figs. 3.12 and 3.13

White pottery mug with a most attractive ruby red transfer picturing Queen Victoria (circa 1897) without crown. The Queen's portrait is surrounded by a garland of thistles, roses and shamrock.

On the reverse is a garland supported by two cherubs. The garland surrounds an inscription topped by a crown. The inscription reads:-

A MEMENTO & A RECORD

OF OUR GREAT AND GOOD

QUEEN VICTORIA WHO BY

THE GRACE OF GOD HAS

GLORIOUSLY REIGNED OER

THIS REALM OF ENGLAND

SIXTY YEARS

JUNE 20TH

1897

Encircling the top of the mug is a continuous ribbon design with a bow over each of the garlands. The ribbon bears the words ENDUE HER PLENTEOUSLY WITH

HEAVENLY GIFTS GRANT HER IN HEALTH AND WEALTH LONG TO LIVE

GOD SAVE THE QUEEN LONG MAY SHE REIGN.

The handle is decorated in a leaf pattern.

NOTE: Doulton also produced the same mug but with a black transfer and also with a green transfer identical to the one described above.

MARK: Green printed decorative diamond shape inscribed – 'Victoria RI, Diamond Jubilee, Doulton Burslem Rd No 293421'.

MANUFACTURER: Doulton & Co (Royal Doulton Ltd) Burslem, Staffordshire.

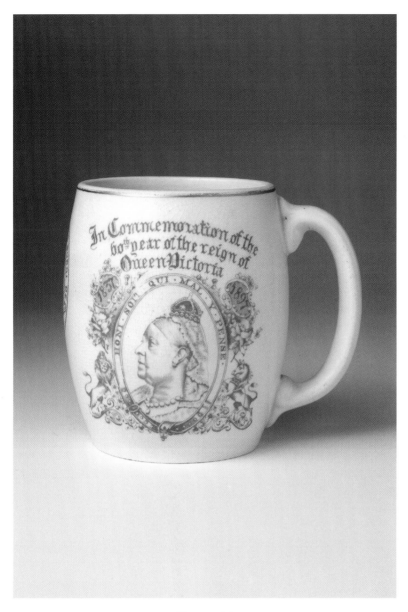

Fig. 3.14 (L)

A delightful white pottery barrel-shaped mug with blue transfer under a high glaze
finish commemorating the Diamond Jubilee of Queen Victoria. The mug with gilded
rim and a gilded stroke on the handle has on the front a portrait of the Queen
looking to the left and wearing her tiny crown, surrounded by lion and unicorn at
base, with 1837 and 1897 either side in a rose motif. Around the portrait is the
inscription – *Honi Soit qui mal y pense.* Above the portrait are the words –
'In commemoration of the 60th year of the Reign of Queen Victoria'. On the reverse,
in an oval leaf border with roses at the mid-point are the words: 'Born . May 24th
1819 . Ascended . The throne June 20th 1837'.

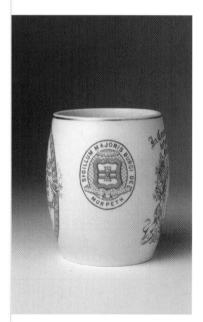
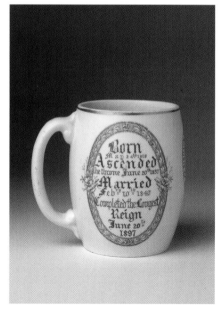

Figs. 3.15 and 3.16
Married · Febry 10th 1840 · Completed the Longest Reign · June 20th · 1897
Opposite the handle, (see Fig. 3.15), is the coat of arms of the Borough of Morpeth,
a small market town, north of Newcastle-upon-Tyne in the County of Northumbria.
In all probability, like most local commemoratives, this mug would have been
presented to the schoolchildren of the Borough.

MARK: CULLEN & SON · NEWCASTLE-ON-TYNE

printed in the same blue as used for the transfer. It is likely that Cullen & Son were
the supplier.

MANUFACTURER: No manufacturers mark, although most likely to have been
manufactured by C.T.Maling, Newcastle-upon-Tyne at their Ford Potteries. (See
details of the next three mugs which help to confirm this deduction.)

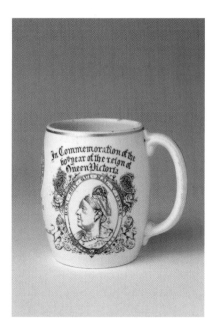 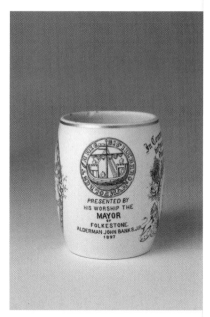

Figs. 3.17 and 3.18 (L)

This white pottery barrel-shaped mug has identical transfer to the previous mug (with the same portrait) except that the colour is black. This mug is of the same very high quality with gilded rim and gilded stroke on the handle.

Opposite the handle, (see Fig. 3.18), is the coat of arms for Folkestone, beneath which is written:

Presented by

His Worship The

Mayor

of

FOLKSTONE.

ALDERMAN JOHN BANKS, JP

1897

NOTE: Maling also produced mugs identical to this one but without the local inscription.

MARK: Printed in the same colour as the transfer is a triangle containing the initials CTM vertically one above the other with TRADE on the outside of one side of the triangle and MARK on the other. Under the base of the triangle is ESTABD 1762.

MANUFACTURER: C.T.Maling, Newcastle-upon-Tyne. Christopher T Maling originally worked for his father, William Maling at the North Hylton Pottery in Sunderland. He took over the business from his brother Robert in 1859, and built the Ford Pottery in Newcastle-upon-Tyne. This pottery, at one time in its history, overshadowed the traditional British ceramic industry's centre of Staffordshire by becoming the biggest pottery in the world.

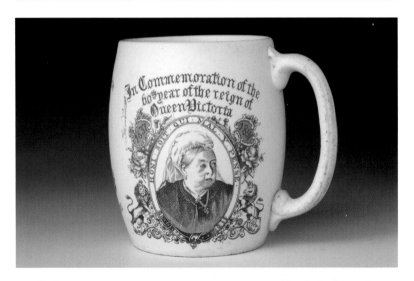

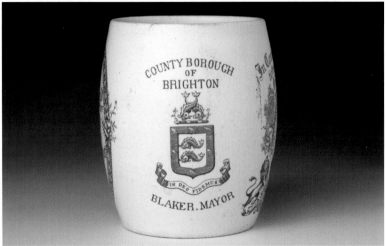

Figs. 3.19 and 3.20 (L)

A quality white pottery barrel-shaped mug without gilding, but with similar black transfer to the previous mug. Similar, not identical - the portrait of Queen Victoria (circa 1897) is without crown and looking to the right.
Opposite the handle, (see Fig. 3.20), is the Brighton coat of arms with 'County Borough of Brighton' above and 'Blaker, Mayor' below.

MARK: Printed in same colour as the transfer is the same manufacturers mark as detailed for the Folkestone mug. In addition:

W.H. SCHOFIELD

60, EAST STREET,

BRIGHTON

printed below the manufacturers mark.
W.H.Schofield was probably the supplier to the County Borough of Brighton.
MANUFACTURER: C.T.Maling, Newcastle-upon-Tyne.

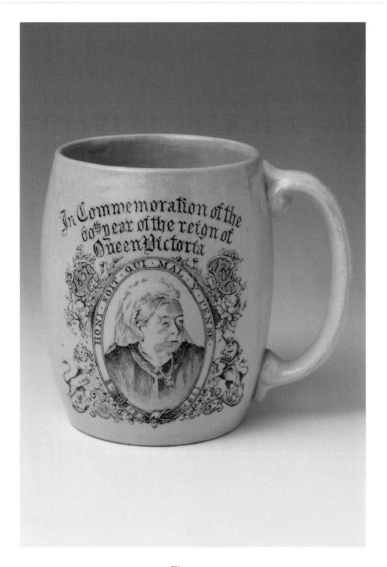

Fig. 3.21

A greyish barrel-shaped pottery mug with black transfer identical to the previous one, except that the overall quality is inferior. The portrait is of the aged Queen Victoria without crown looking to the right; again no gilding. With no local attachment this mug, presumably, was produced for sale to the general public. On this mug, as with the three similar mugs described previously, are the words 'Completed Longest Reign June 20th 1897'. Commemoratives with such a description should not be classed as Longest Reign mugs as they give the 1897 date and not 23rd September 1896 which is the date when Queen Victoria achieved the longest reign, exceeding that of her grandfather, King George III.

MARK: Printed in same colour as the transfer is the same manufacturers mark as detailed for both the Folkestone and Brighton mugs.
MANUFACTURER: C.T.Maling, Newcastle-upon-Tyne.

3.05, has a beautiful coloured portrait of Queen Victoria. This is the result of talented paintresses (the name given to women in the British pottery trade who hand decorated the products) colouring the black transfer with enamels. The garter ribbon and lace veil are raised by the use of a number of layers of paint. Often the paintress's number or even her name were hand painted on the base of each article decorated. In this instance there is no such mark.

It is interesting to see how designs changed once enamel colouring, followed by polychrome transfers, became established. The wordy inscriptions incorporated in the monochrome designs for Queen Victoria's Diamond Jubilee and to a lesser extent King Edward VII's coronation disappeared - flags, scrolls and national plant emblems came into their own. In the transition period hand colouring held the fort and was still in use, though less frequently, up to King George V's Silver Jubilee.

Careful scrutiny of the national plant emblems depicted on the mugs and beakers featured in this Chapter shows that the rose, thistle and shamrock are included in all the designs whilst the national plant emblem for Wales is only included on the W.H.Goss beaker commemorating Queen Victoria's Golden Jubilee, (see Fig. 3.07). W.H.Goss's beaker, commemorating the coronation of King Edward VII, of similar design to their 1887 beaker, (see Fig. 4.05), also includes a leek. However, the national plant emblem for Wales was infrequently seen on Royal commemoratives until the Silver Jubilee of King George V. Then, as it is to-day, sometimes the leek was used and sometimes the daffodil. This interesting issue of the national plant emblem for Wales is discussed in detail in Chapter Seven.

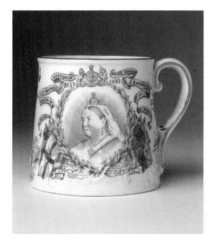
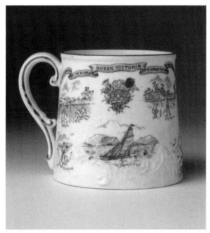

Figs. 3.22 and 3.23

A white china tapered mug, with moulded design around the base, gilt rim and scrolled gilded handle.The mug is printed with a sepia transfer which has been hand decorated with coloured enamels. On the front of the mug is a portrait of Queen Victoria, with her tiny crown, surrounded by an oval laurel frame. On top of the frame is the Royal Coat of Arms and the dates 1837-1897. Each side of the top of the frame are flowing blue ribbons inscribed-VICTORIA THE GOOD — DEI GRATIA — QUEEN OF GREAT BRITAIN, IRELAND – EMPRESS OF INDIA. National flags decorate each side of the lower half of the frame. At the base is a ribbon cartouche inscribed GOD SAVE THE QUEEN. The reverse, and the side by the handle, is decorated with seven captioned leisure activities of the period. These are: DRIVING (MOTOR CAR); FISHING; CYCLING; YACHTING, CRICKET and SHOOTING. Each a delightful cameo. A red and blue coloured ribbon cartouche tops these scenes with a crown entwined with the national flowers in the centre. The inscription on this ribbon reads: IN COMMEMORATION OF THE REIGN OF QUEEN VICTORIA THE LONGEST REIGN OF ANY PREVIOUS MONARCH

MARK: Printed in sepia – Manufactured For
HARRODS STORES Ltd LONDON
Rd No 294252 in a lined rectangle with
MADE IN ENGLAND printed underneath.
Printed in light green a crown over the name AYNSLEY in a rectangular outline over ENGLAND. Below in a rectangular outline is:
Rd No 255280. In addition there is a hand painted mark in gold. The mark looks like a nine with a long tail. This could be the gilders/decorators mark.
MANUFACTURER: John Aynsley & Sons (Ltd) Longton, Staffordshire

NOTE: A white earthenware mug (not tapered) with the same transfer and decoration, but with gilt edge to base in addition to a gilt rim, was also produced for Harrods with identical registration number. This mug has no manufacturers mark. An illustration appears on page 90 of the book *Royal Memorabilia* by Peter Johnson. A description is given in the Commemorative Collectors Society catalogue for the Jubilee Royal exhibition held in May/June 1977.

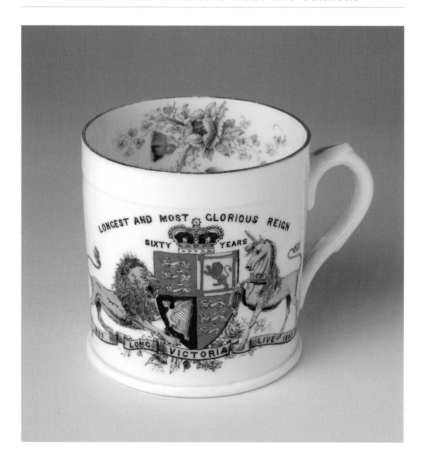

FIG. 3.24

A white china mug with printed black transfer, hand painted in coloured enamels, of
the Royal Coat of Arms, topped by a crown, and supported by a lion rampant on
one side and a unicorn on the other. At the base of the shield there are intertwined
national flowers. Above the crown, in a circular design are the words: LONGEST AND
MOST GLORIOUS REIGN. On the left of the crown is written: SIXTY and on the other
side:- YEARS. Below the shield is a yellow ribbon bearing the words:
1837 LONG VICTORIA LIVE 1897
On the reverse is a sepia printed floral bouquet of roses, thistles and shamrock.
This transfer is very tastefully overpainted in coloured enamels. On the inside of the
back of the mug is another floral bouquet. The rim is gilded and there is a gold
stroke on the handle.
The decoration on this mug is clean, bright and sharp. The design is somewhat
unusual in that no portrait of the Queen is included.
MARK: Printed in black is a crown topping an ornate monogram of W & C. Above
the crown are the words: THE FOLEY CHINA and below the monogram ENGLAND.
Below this is Rd 290929.
MANUFACTURER: Wileman & Company, Longton, Staffordshire. The company, based
at the Foley China Works, started as Henry Wileman and later became James &
Charles Wileman. In 1925 the company changed its name to Shelley Potteries Ltd.

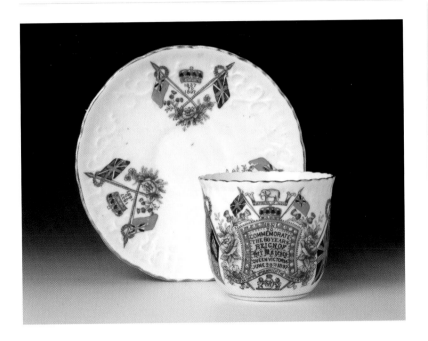

FIG. 3.25

A hand painted sepia printed transfer decorating a bone china cup and saucer.
The cup and saucer are both embossed and have scolloped gilded rims. Indeed the
design contains much gilding. One of a small number of colourful designs produced
to commemorate Queen Victoria's Diamond Jubilee.
The centrepiece is a blue shield with raised gilded studs on its periphery. At the top of
the shield is a crown flanked by a flag on each side and topped by an elephant
beneath which is written EMPRESS OF INDIA. The inscription on the shield reads:

1837

TO

COMMEMORATE

THE 60 YEARS

REIGN OF

HER MAJESTY

QUEEN VICTORIA

JUNE 20TH 1897

On a scroll beneath the shield is written:

QUEEN OF AN EMPIRE UPON WHICH THE SUN NEVER SETS. National flowers frame the shield
with a wreathed Royal Standard on one side and a wreathed Union Flag on the
other.
The saucer design has crossed flags flanking a crown with 1837 to 1897 inscribed
beneath with a wave of national flowers below. This pattern is repeated each 120
degrees.
MARK: CUP Printed in sepia is MADE IN ENGLAND below which is W.L. over a rectangular
outline containing Rd No 290284. An L. appears below. Hand painted in gold is the
number 3720 plus a handpainted blue B.
SAUCER Printed in sepia MADE IN ENGLAND W.L.L.
MANUFACTURER: W.Lowe of Longton, Staffordshire.

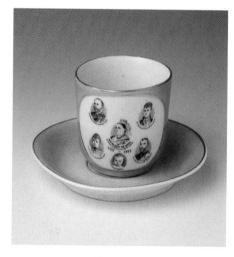

Fig. 3.26

A delightful white china cup and saucer. The top of the saucer and the outside of the cup, apart from the handle and a pumpkin shape opposite the handle, are in a pink lustre finish. Both the cup and saucer rims are gilded as is the circumference of the unpainted pumpkin shape. The handle also has a gilt stroke.

Inside the pumpkin shape are six printed black transfer portraits representing four generations. In the centre is a portrait of Queen Victoria with her tiny crown. Beneath this portrait are the words: HER MAJESTY THE QUEEN. Four of the other portraits are arranged evenly around the side of the Queen's portrait. These portraits are: Prince of Wales (King Edward VII) and Princess Alexandra; Prince George (King George V) and Princess Mary. Below the portrait of the Queen is one of Prince Edward (the Queen's Great Grandson – later King Edward VIII). Beneath each of the portraits, with the exception of Prince Edward's, are the words: BY PERMISSION OF W&D DOWNEY LONDON. In the centre beneath the Queen's portrait are the dates 1837-1897.

MARK: Printed in black in a circle MADE IN GERMANY. Outside the circle is REGISTERED.

MANUFACTURER: Unknown

Figs. 3.27 and 3.28

A white earthenware mug with sepia transfer print partly overpainted with coloured enamels. The rim and base edge are gilded. A portrait of Queen Victoria appears on the front of the mug. The lower half is framed by a laurel wreath flanked by national flags. Above the flags on each side is a bouquet of national flowers. Above the portrait is a blue cartouche which runs around the complete mug just below the rim. Between this cartouche and the portrait are the words:- GOD SAVE THE QUEEN. Below the portrait on a draped ribbon are the dates 1837 and 1897. The dates appear again each side of the national flags.

Opposite the handle below the blue cartouche is the Royal Coat of Arms surrounded by three ribbons. The top one is inscribed QUEEN VICTORIA DIAMOND JUBILEE. The side ribbons bear the words THE LONGEST REIGN OF ANY PREVIOUS MONARCH. Below this is a decoration of national flowers.

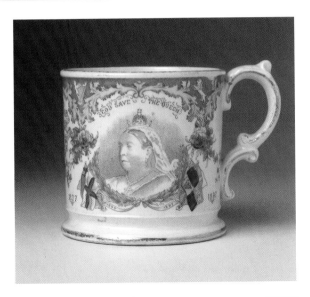

On the reverse of the mug is a picture of St Paul's Cathedral with caption. Above on a ribbon are the words: QUEEN OF ENGLAND EMPRESS OF INDIA. Below St Paul's Cathedral is a picture of a clock next to a sundial with the caption: PROGRESS. This is flanked by a picture of a steam locomotive to the left and a Naval ship to the right. MARK: Printed in sepia inside a double bordered square are two globes. Above and below each globe are the words WILLIAM WHITELY UNIVERSAL PROVIDER. At the top is written TRADE MARK and below WESTBOURNE GROVE LONDON W. Also printed is REGd APPLIED FOR plus a hand painted red F.
MANUFACTURER: Unknown – possibly William Alsagar Adderley (&Co), Daisy Bank Pottery, Longton, Staffordshire.

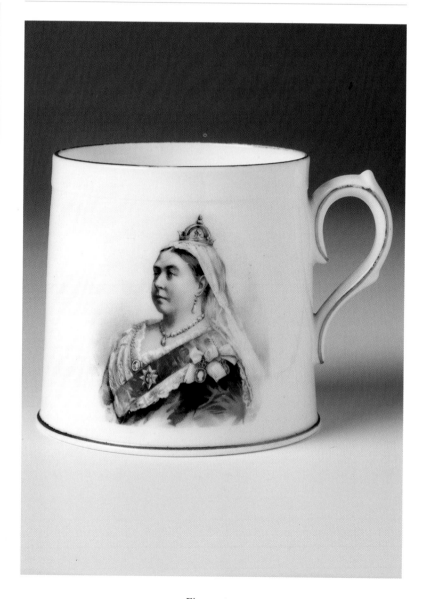

Fig. 3.28A

A fine white china mug, with moulded rim and handle. The rim, foot and handle are gilded. The front is printed with an exquisite polychrome portrait of Queen Victoria wearing the small crown and Garter ribbon. This was the official portrait for the Diamond Jubilee. The reverse is decorated, in gold, with the Royal cypher surmounted by a crown. Above this is a scrolled ribbon inscribed:

DIAMOND JUBILEE 1897.

MARK: The traditional Doulton device surrounded by the words 'Doulton' and 'Burslem' surmounted by a crown with England below.

MANUFACTURER: Doulton & Co (Royal Doulton Ltd.), Burslem, Staffordshire.

Fig. 3.28C

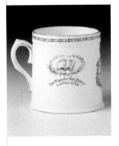

Fig. 3.28D

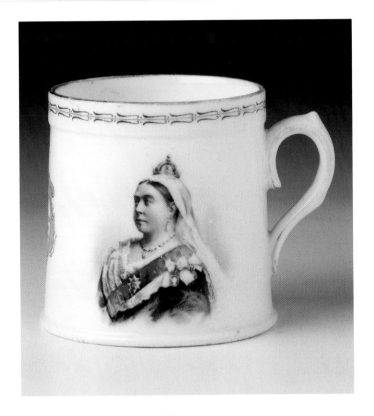

Fig. 3.28B

A fine white china mug with moulded rim and flared foot, similar in shape to that produced by Doulton (Royal Doulton) for Queen Victoria's Diamond Jubilee illustrated in Fig. 3.28A but taller and with a slightly larger diameter. This mug produced to mark the death of Queen Victoria on 22nd January 1901, incorporates the same transfer as that used on the Diamond Jubilee commemorative in Fig. 3.28A. The external rim is decorated with a design in purple. Opposite the handle, (see Fig. 3.28C) is a purple medallion design topped by a crown, with the inscription:

<div align="center">

IN

MEMORIAM

VICTORIA

OUR BELOVED QUEEN

Born May24 1819

Died Jany 22 1901

</div>

On the reverse, again in purple, is a picture of an open book titled: *Sacred Law,* (see Fig. 3.28D). The book is encircled by a wreath, beneath which is the inscription:

<div align="center">'SHE WROUGHT HER PEOPLE LASTING GOOD'.</div>

MARK: Printed in black is the traditional Doulton device surrounded by the words 'Doulton' and 'Burslem' surmounted by a crown with England below.

MANUFACTURER: Doulton & Co (Royal Doulton Ltd), Burslem, Staffordshire.

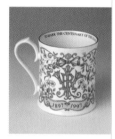

Fig. 3.30

King George V and
Queen Mary visiting
Royal Doulton's Nile
Street pottery during
their visit to the
County Borough of
Stoke-on-Trent on
22nd and 23rd April
1913.
MARK: Printed in sepia
is a crown above a
circular scroll
inscribed AYNSLEY.
Flanking the crown
above the scroll is EST
and 1775. Beneath this
mark is:
FINE BONE CHINA
MADE IN ENGLAND
TO MARK THE
CENTENARY OF THE
DIAMOND JUBILEE OF
H.M. QUEEN VICTORIA
1897-1997
EXCLUSIVE TO
PETER JONES CHINA
OF WAKEFIELD
LIMITED EDITION OF
2500
This backstamp is
framed by a floral
garland.
MANUFACTURER: John
Aynsley & Sons (Ltd),
Longton,
Staffordshire.

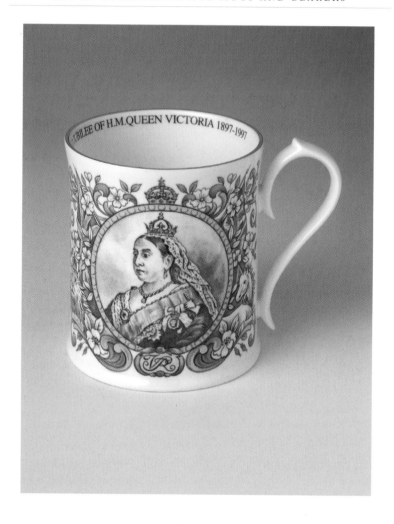

Fig. 3.29

A limited edition, white bone china flared mug with printed sepia transfer, gilded rim
and plain handle. The portrait, on the front of the mug, is of Queen Victoria, circa
1897, with her small crown and Order of the Garter. The portrait is set in a studded
circular frame topped by a crown with a VR monogram at the base. A lion, with
crown, and unicorn flank each side at the base of the portrait with draped flags
flanking each side of the upper half of the portrait. Flower garlands complete the
ornate design on the front. The reverse features an elaborate cypher of VR flanked
by flower garlands topped by a ribbon bow. Beneath the cypher, in a scroll panel, are
the dates 1897-1997.
Within the rim an inscription reads:- TO MARK THE CENTENARY OF THE
DIAMOND JUBILEE OF H.M. QUEEN VICTORIA 1897-1997.

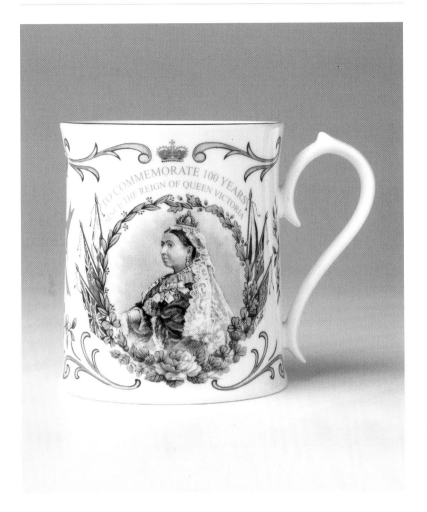

Fig. 3.32

MARK: Printed in black is the Aynsley mark below which is the inscription: TO COMMEMORATE 100 YEARS SINCE THE REIGN OF QUEEN VICTORIA 1901–2001. ISSUED IN A LIMITED EDITION OF 2000. EXCLUSIVELY COMMISSIONED BY PETER JONES CHINA OF WAKEFIELD.

Fig. 3.31

A limited edition, white bone china flared mug printed with a fine polychrome transfer of Queen Victoria surrounded by a floral bouquet of the four National plant emblems. On the reverse are portraits of the young Queen Victoria and Prince Albert circa 1845. Below which is an illustration of Osborne House, Isle of Wight, built for Queen Victoria in 1845 to a design by Prince Albert. Osborne House, where Queen Victoria died in 1901, was one of her favourite residences. The inscription on the front reads:

TO COMMEMORATE 100 YEARS SINCE THE REIGN OF QUEEN VICTORIA.

This delightfully designed mug commemorates the Centenary of the end of Queen Victoria's reign.

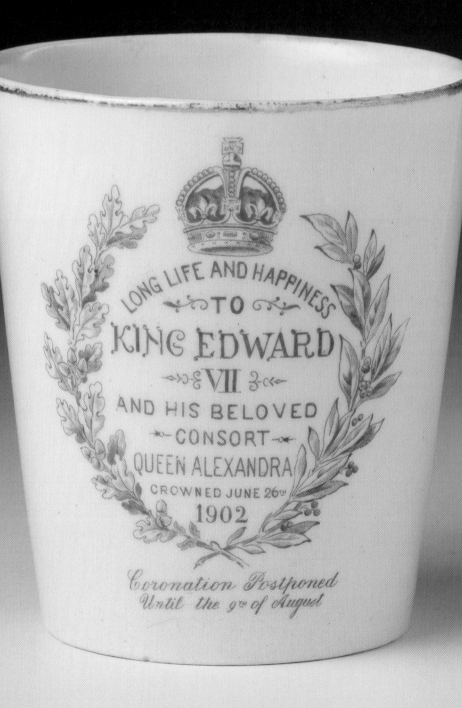

LONG LIFE AND HAPPINESS
TO
KING EDWARD
VII
AND HIS BELOVED
CONSORT
QUEEN ALEXANDRA
CROWNED JUNE 26th
1902

Coronation Postponed
Until the 9th of August

King Edward VII
1901 - 1910

Albert Edward, the second of Queen Victoria's nine children and her eldest son, was born in Buckingham Palace on 9th November 1841 and proclaimed Prince of Wales on the 4th December 1841, before his baptism. He married Princess Alexandra of Denmark in St George's Chapel, Windsor Castle on 10th March 1863. Incidentally it was in this year that the Prince of Wales bestowed the first Royal Warrant of Appointment upon Thomas Goode & Co Limited, the well known china retailers of South Audley Street, London, who regularly commissioned items, some in limited editions, to commemorate Royal occasions. As mentioned earlier (Chapter Two) the Prince and Princess of Wales were much involved in 1887 with the arrangements for Queen Victoria's Golden Jubilee, particularly the Hyde Park children's party. The Golden Jubilee celebrations tended to overshadow other events in the Royal Calendar such as the Prince and Princess of Wales' Silver Wedding anniversary on 10th March 1888. The potteries, however, were alive to the occasion and produced a number of items to celebrate the Silver Wedding.

Albert Prince of Wales decided on his accession to the Crown on 22nd January 1901, when he was sixty years of age, to use the title Edward VII. His coronation was fixed for 22nd June 1902. The potteries and souvenir manufacturers had geared themselves up for this event and they were at the ready. Many had used Queen Victoria's Diamond Jubilee celebrations as a dummy run. Royal Doulton were one of the few potteries to advertise their commemoratives for King Edward VII's Coronation, (see Fig. 4.01).

A plethora of coronation commemoratives were produced. However, King Edward VII became ill with appendicitis requiring an operation. The Coronation was postponed until 9th August 1902. The commemoratives already produced bearing the 22nd June 1902 date were still released. Some of these were overstamped with the new date, (see Fig. 4.12). A few potteries produced a small number of coronation commemoratives with the correct date

OPPOSITE

The inscription on the reverse of a white porcelain beaker commemorating the coronation of King Edward VII. The pottery, Royal Doulton, added the postponement notice at the time of the announcement that the date of the coronation had been deferred until 9th August 1902 because of the King's illness.

65

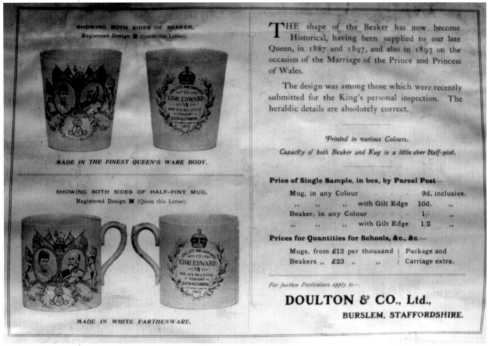

The following is the text within the advertisement image:

SHOWING BOTH SIDES OF BEAKER.
Registered Design B (Quote this Letter).

MADE IN THE FINEST QUEEN'S WARE BODY.

SHOWING BOTH SIDES OF HALF-PINT MUG.
Registered Design M (Quote this Letter).

MADE IN WHITE EARTHENWARE.

THE shape of the Beaker has now become Historical, having been supplied to our late Queen, in 1887 and 1897, and also in 1893 on the occasion of the Marriage of the Prince and Princess of Wales.

The design was among those which were recently submitted for the King's personal inspection. The heraldic details are absolutely correct.

Printed in various Colours.

Capacity of both Beaker and Mug is a little over Half-pint.

Price of Single Sample, in box, by Parcel Post—

Mug, in any Colour	9d.	inclusive.
„ „ „ with Gilt Edge	10d.	„
Beaker, in any Colour	1/-	„
„ „ „ with Gilt Edge	1/2	„

Prices for Quantities for Schools, &c., &c.—

Mugs, from £13 per thousand	Package and	
Beakers „ £23 „ „	Carriage extra.	

For further Particulars apply to—

DOULTON & CO., Ltd.,
BURSLEM, STAFFORDSHIRE.

Fig. 4.01.

An advertisement issued by Royal Doulton in 1902 to promote their commemorative
wares for the coronation of King Edward VII,
(see Figs. 4.03 and 4.04).

incorporated into the original design, (see Fig. 4.02). These are difficult to find. Some books and articles say they are rare whilst others say 'unusual not rare'. Rare or not, King Edward VII's coronation commemoratives with the correct date are highly collectable. King Edward VII died on 6th May 1910. During his many years as the Prince of Wales, and during his short reign, (10 years) he made numerous overseas visits resulting in many strong friendships with Rulers and Heads of State including those that formed the British Empire. Many attended his funeral. A BBC commentator at the State Funeral of King Hussein of Jordan on 8th February 1999 remarked that no previous State Funeral had been so well attended since, perhaps, the funeral of King Edward VII. This says a great deal of two great men who were both very popular and held in high regard by their peoples. The potteries, who had produced commemoratives for most of the events in the life of this popular King, recorded his death too.

Fig. 4.02

An unusual tapered mug in that the correct date of 9th August 1902 is incorporated in the original design. With gilded rim, base and handle this mug has a sepia printed transfer which has been overpainted with coloured enamels.

The design has separate portraits of Queen Alexandra and King Edward VII in gilded frames of raised studs each surmounted by a crown. The studded technique, wreathed flags with a design of national flowers is similar to that employed by the same manufacturer on a cup and saucer produced to commemorate the Diamond Jubilee of Queen Victoria, (see Fig. 3.21). With very little time to develop a new design some manufacturers adapted (or even adopted) a previous design. The round framed portraits are separated by a blue shield inscribed:-

TO

COMMEMORATE

THE

CORONATION

OF

KING

EDWARD

VII

AND QUEEN

ALEXANDRA

AUGUST 9TH 1902

Above the shield is the Royal Coat of Arms. National flowers, of similar design, flank the two portraits with the Royal Standard on one side and the Union flag on the other. Both the Royal Standard and the Union flag carry wreaths. A yellow ribbon scroll running below the portraits and the shield carries the inscription:-

KING OF THE BRITISH DOMINIONS BEYOND THE SEAS

MARK: Printed in sepia, a crown above a rectangular frame containing "Rd. No. 384710". Underneath is: W$_L$L CORONATION

There is also a hand-painted 448.

MANUFACTURER: W.Lowe, Longton, Staffordshire.

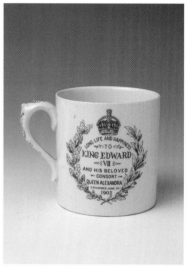

Figs. 4.03 and 4.04

A smartly designed sepia printed transfer decorates this porcelain mug with national flowers printed on the handle. This mug is featured in the advertisement in Fig. 4.01, the design of which was – 'submitted for the King's personal inspection. The heraldic details are absolutely correct' – an extract from the advertisement. On the front of the mug are circular framed portraits of Queen Alexandra and King Edward VII. At the top between the frames is a crown supporting a standing lion wearing a crown. It is most interesting to see that the design of the lion on the crown is identical to that in the Royal Doulton mark printed on the bottom of the mug – only larger. Draped at the back are four flags including the Royal Standard and the Union flag. Flanking the portraits, on each side, is a lion with a crown and an unicorn.

A flowing ribbon runs beneath the lion and unicorn and between the bottom of the portraits at the centre. The ribbon is inscribed: DIEU ET MON DROIT and CORONATION 1902 at the centre. Beneath this is the Royal cypher with sprays of National flowers at each side.

On the reverse is a crown below which is the inscription:

LONG LIFE AND HAPPINESS

TO

KING EDWARD

VII

AND HIS BELOVED

CONSORT

QUEEN ALEXANDRA

CROWNED JUNE 26TH

1902

A single sprig of oak frames one side of the inscription and a laurel sprig the other side.

Note: This mug, as with the sister beaker, was produced in various colours.

The retail price of the mug was 9d (old pennies).

MARK: Printed in sepia is a crowned lion standing on a crown. Beneath this is Royal Doulton, England surrounding the traditional Doulton device.

MANUFACTURER: Royal Doulton & Co.(Ltd), Burslem, Staffordshire.

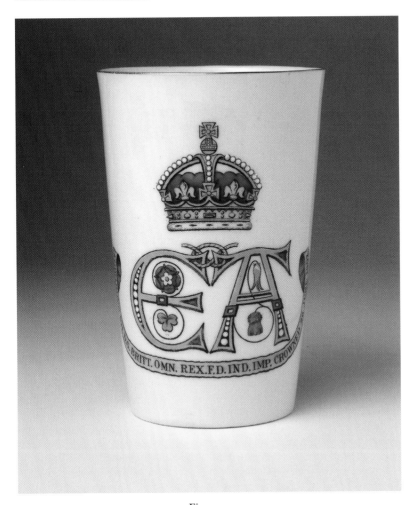

Fig. 4.05

A very fine bone china tapered beaker with gilded rim. A black transfer print, beautifully hand painted in coloured enamels, decorates the front of this beaker. The design of the decoration is both bold and simple. A large crown holds 'centre stage' with a stylistic turquoise E&A, tied together at the top beneath the centre of the crown, by a Staffordshire knot. In each of the four spaces in the letters is depicted one of the four national plant emblems. W.H.Goss produced a similar design to commemorate the Golden Jubilee of Queen Victoria (1887) (see Fig. 3.07). These two designs are unusual in that they both include a national plant emblem for Wales, in each case a leek. These are two of the first commemoratives to include a national plant emblem for Wales, a point fully discussed in Chapter 7. A yellow ribbon with ruby red reverse supports the design. Inscribed, in Latin, on the ribbon is:

EDWARDVS VII. D.G. BRITT. OMN. REX. FD.IND. IMP.

CROWNED 26 JUNE 1902

MARK: Printed in black is a large eagle standing on a striped pole with W.H.GOSS below the pole.

MANUFACTURER: William Henry Goss (Ltd), Stoke, Staffordshire.

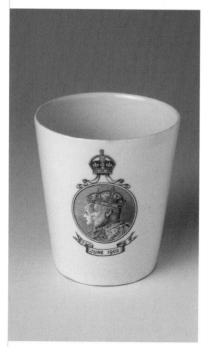
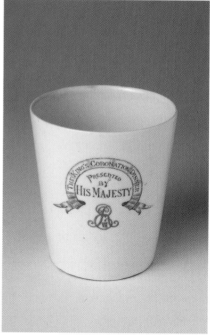

Figs. 4.06 and 4.07

'The King's Dinner Beaker'. A white bone china tapered beaker commissioned by King Edward VII for presentation to children and the underprivileged at free dinners held throughout London on 5th July 1902. This date was arranged so that the dinners were held after the coronation but when the coronation had to be delayed due to the King's illness the decision was made to keep to the original dinner date. The design of this beaker is strikingly simple. The printed transfer is green. On the front is a medallion containing portraits of King Edward VII and Queen Alexandra both wearing their crowns. The medallion is topped by a crown and supported beneath by a ribbon inscribed 'June 1902'. On the reverse is a semi-round ribbon design. On the ribbon is inscribed THE KING'S CORONATION DINNER and inside the semicircle is written:-

PRESENTED

BY

HIS MAJESTY

The King's monogram is printed beneath this inscription.

Note: The beaker detailed here has a green transfer. However these beakers were also manufactured with brown, blue and purple transfers. Larger quantities of beakers with the green transfer were produced than for the other colours.

MARK: A crowned lion standing on a crown. Beneath this is 'Royal Doulton, England' surrounding the traditional Doulton device. Rd. No. 389307 is printed below the mark.

MANUFACTURER: Royal Doulton & Co.(Ltd.), Burslem, Staffordshire.

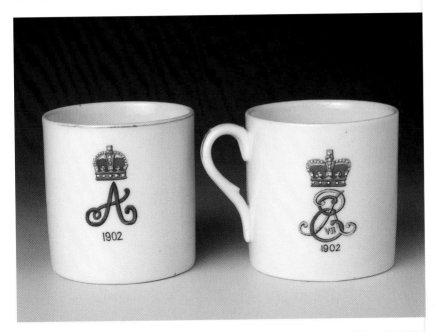

Figs. 4.08/4.09, 4.10 and 4.11

Two white porcelain mugs with gilded rims and gilded stripe on the handles, (see Fig. 4.08 and 4.09). These mugs are printed with black transfers hand decorated in coloured enamels. The Royal cypher of Queen Alexandra, with 1902 below appears on the front of one and King Edward VII's Royal cypher, together with the year of the coronation, is printed and decorated on the other. When these mugs are held up to the light a lithophane portrait of Queen Alexandra and King Edward VII can be seen when looking into the respective mugs, (see Figs. 4.10 and 4.11). The transfer on the Queen Alexandra mug is opposite the handle whilst on the King Edward VII mug the handle is on the left of the decoration. The lithophane process was patented in Paris in 1827 by Baron de Bourgoing. The patent expired fifty years later. The King Edward VII mug has a coat of arms on the reverse and, therefore, was likely to have been presented to schoolchildren at the time of the coronation.

MARK: There are no marks.

MANUFACTURER: Unknown, possibly Minton, Stoke, Staffordshire, but more likely to have been made in Germany.

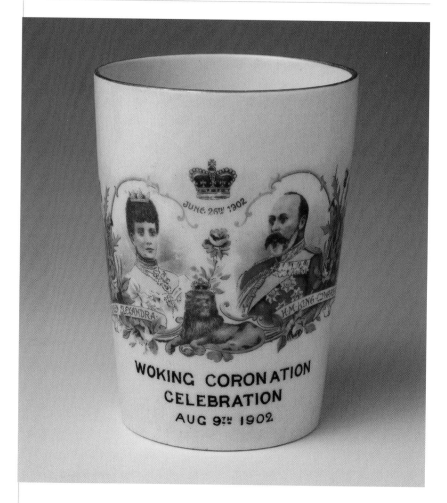

Fig. 4.12 (L)

A most colourful polychrome transfer printed tapered beaker featuring portraits of King Edward VII and Queen Alexandra. The Queen is wearing her crown. The portraits are against a grey to white background set in a yellow scroll frame. In the centre above the frame is a crown with 'June 26th 1902' inscribed below. Between the two portraits is a pink rose with a crowned lion below. Inscribed on yellow scrolled ribbons on each side of the portraits is:- HM QUEEN ALEXANDRA and HM KING EDWARD VII. Each side of the scrolled frame are sprays of the National flowers with the Royal Standard on one side and the Union flag on the other. Printed in black below the transfer is:-

WOKING CORONATION

CELEBRATION

AUG 9TH 1902

This beaker would, most likely, have been presented to all schoolchildren in Woking. Whilst overprinting 'Woking Coronation Celebration' the opportunity was taken to print the revised date for the Coronation.

MARK: There are no marks.

MANUFACTURER: Unknown.

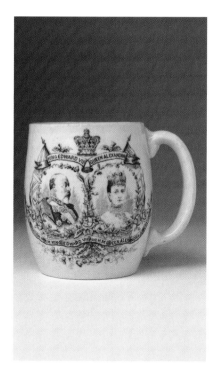

Figs. 4.13 and 4.14

A barrel-shaped mug, with no gilding, of similar dimensions and shape to the four
Maling products described in the previous Chapter. The front of the mug is
decorated with a monochrome blue-green transfer print featuring portraits of their
Majesties, King Edward VII and Queen Alexandra, in a framework of three national
plant emblems (rose, thistle and shamrock) flanked by the Royal Standard and the
Union flag. In the centre at the top is a crown, beneath which is a scrolled ribbon
inscribed KING EDWARD VII QUEEN ALEXANDRA. Below the portraits a scrolled ribbon
carries the inscription THE CORONATION OF H.M KING EDWARD VII AND H.M. QUEEN
ALEXANDRA. JUNE 26TH 1902. On the reverse, in the same colour, is an illustration of
Britannia dressed in her traditional helmet, carrying a cushion upon which is
mounted a crown. To her right is a large benign lion. Behind Britannia is a pillar
supporting a sword and shield. The shield is divided into quarters. Each quarter
carries the name of one of the Dominions – India, Africa, Australia and Canada.
Note: Mugs were also produced with the same design but in
a chocolate brown colour.
MARK: Printed, in the same colour as the transfer, is the C.T.Maling triangle mark
described in detail for the Maling mugs in the previous Chapter, except that this
mark has England added beneath ESTAB 1762. Also included is a printed '8' which is
likely to be the pattern number.
MANUFACTURER: C.T.Maling, Newcastle-upon-Tyne.

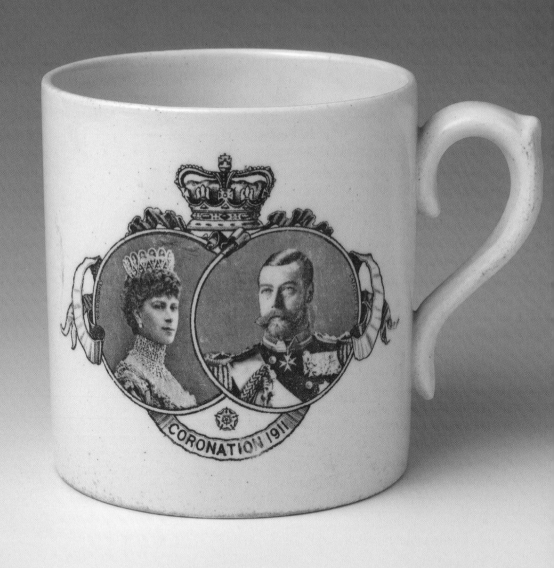

King George V
1910 - 1936

Prince George, the second son of Albert, Prince of Wales (later King Edward VII) was born on 3rd June 1865 at Marlborough House. Christened George Frederick Ernest Albert on 7th July in St George's Chapel, Windsor he married Princess Mary of Teck (her name was changed from May to Mary) on 6th July 1893 in the Chapel Royal, St James's Palace. The Duke of York and Cornwall, as he was at that time, became heir to the throne on the death of his brother Albert Victor, Duke of Clarence in 1892, and by Royal Warrant received the badge of the Heir Apparent to the throne, the triple plume of ostrich feathers. This was some nine years before he became George, Prince of Wales on 9th November 1901 on his father's accession. Many people mistakenly believe this badge has a connection with Wales as it is frequently referred to as the Prince of Wales Feathers. The badge has no connection with Wales. An article written by A.C.Fox-Davies in the South Wales Daily News of 12th November 1927 states '. . . there is no crest for or of Wales'. However, since the heir is usually created Prince of Wales, the mistake is understandable.

On the 6th May 1910 George, Prince of Wales succeeded to the throne. His Coronation on 22nd June 1911 was heralded by many commemoratives. Since the last coronation an increasing number of potteries had switched over to polychrome transfers, resulting in a greater number of colourful designs, (see Fig. 5.01). The technique of over painting the monochrome transfer with coloured enamels was fast receding.

King George V's only visit, as King, to a member country of the British Empire was his visit to India in 1911. (See Chapter Six). On 17th July 1917 the proclamation of the House of Windsor was announced by King George V.

The King continued to uphold Royalty's close relationships with the pottery industry when he and Queen Mary paid a two-day visit to the County Borough of Stoke-on-Trent on the 22nd and

OPPOSITE

A simple but smart monochrome design on a white porcelain mug commemorating the coronation of King George V. (See Figs. 5.06 and 5.07)

23rd April 1913. Their programme included a visit to Royal Doulton's Nile Street pottery in Burslem, (see Fig. 5.02).

The visit of King George V and Queen Mary was the second Royal visit to the Nile street pottery. Princess Louise, the fifth child of Queen Victoria and Prince Albert, visited the pottery with her husband, the Marquis of Lorne (later Duke of Argyll) in 1894. The County Borough of Stoke-on-Trent commissioned an earthenware mug to commemorate the 1913 Royal visit, (see Fig. 5.02A and 5.02B). The mug is printed with a polychrome transfer similar to that decorating the centre beaker in Fig. 5.01 commemorating the 1911 coronation. The only differences are the portraits and that their positions are reversed. The inscription on the blue ribbon at the centre still reads 'crowned' but the date of the coronation has been omitted. Although there is no mark on the base it is likely to have been made by Grimwades Ltd., Winton, Upper Hanley, Stoke-on-Trent.

The Silver Jubilee of the reign of King GeorgeV was celebrated on 6th May 1935. As with the Coronation many potteries, both large and small, produced commemoratives to mark this event. The quality varied considerably, perhaps more so than for any previous Royal event. The British Pottery Manufacturers' Federation introduced designs to Federation members in an attempt to ensure that the quality and the standard of the items produced to cmmemorate Royal events were at the highest levels commensurate with such occasions. The Federation produced designs for King George V's Silver Jubilee and the coronations of King Edward VIII, King George VI and Queen Elizabeth II. Many potteries took advantage of this service and items, almost identical, were manufactured by different potteries, (see Fig. 5.03). Items utilising the Federation designs carried the official mark, (see Fig. 5.04).

An exclusive design for Harrods and copyright designs by Bassano Ltd. and W&D Downey were among the more attractive designs, each of which are detailed in this Chapter. The latter two companies both issued copyright designs for Queen Victoria's Jubilees.

Like the reigns of both his father and grandmother, King George's was one of progress, considerable energy and consolidation of the Empire. There was little time for the 'sun to set'.

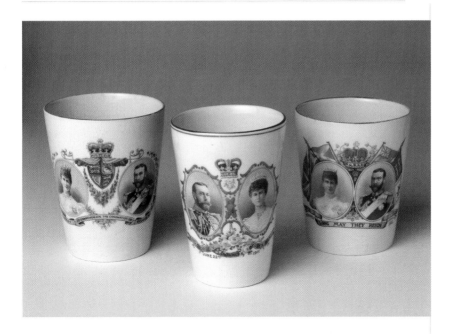

Fig. 5.01

Three King George V coronation beakers each tastefully decorated with a colourful polychrome transfer and gilded rim. The design on the first two includes coloured portraits of the King and Queen, the third has monochrome portraits set in a copyrighted colourful design of flags and national plant emblems (but no emblem for Wales on any of the three beakers). The beaker on the left has no base stamps whilst the central beaker was manufactured by Grimwades Ltd, Winton, Upper Hanley, Stoke-on-Trent. Printed on the reverse is the National Anthem in a laurel border topped by a crown. The right-hand beaker was also produced by Grimwades Ltd. Although both beakers would have been produced at about the same time the details of the base stamps are different. Both contain Grimwades' traditional globe mark with a crown above but on the ribbon across the globe on the centre beaker is inscribed CORONATION. On the right-hand beaker the ribbon carries the name WINTON with the letters 'GB' each side of the globe representing the former name of the company – Grimwade Brothers.

A cup and saucer, (see Fig. 5.27), commemorating the Silver Jubilee is decorated with a design which includes reference to six achievements in the first twenty-five years of King George's reign, (see Fig. 5.05). These are: *Queen Mary* launched 1934; Royal Scot American Tour; Wireless Broadcast; Schneider Trophy; Sydney Bridge and Scott & Black England Australia. These achievements may not be in everyone's personal archive – but each was very significant at the time.

Fig. 5.02

King George V and
Queen Mary visiting
Royal Doulton's Nile
Street pottery during
their visit to the
County Borough of
Stoke-on-Trent on
22nd and 23rd April
1913.

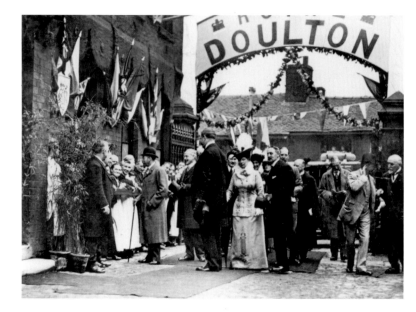

Figs. 5.02A and 5.02B

The front and reverse
of the mug presented
by the County
Borough of Stoke-on-
Trent at the time of
the 1913 Royal visit.

In 1933 a London Midland Scottish Railway (LMSR) Royal Scot engine and a complete eight carriage train set was shipped to North America for exhibition at the Chicago World Fair from 1st June to 11th October. The Royal Scot was one of a class of fifty engines manufactured by the North British Locomotive works, Glasgow for LMSR. The selection of the launch of Cunard's *Queen Mary* in 1934 at John Brown's Clydebank yard and the LMSR *Royal Scot* visit to North America in the six achievements to commemorate the Silver Jubilee of King George V's reign was a good advertisement for Scotland's engineering prowess in the 1930's. On 29th December 1932 King George V broadcast the first Empire Christmas message. In 1912 Jacques Schneider, a French industrialist, promoted a national annual air race for sea planes. The winning nation was presented with the Schneider Trophy. The first nation to win the trophy three times in a five year period would be deemed to have won the trophy outright. Italian teams dominated the early years of the race. However, Britain's Supermarine company produced a series of Rolls-Royce powered seaplanes, culminating in the R engined S.6B, which won the trophy outright in 1931 at an average speed of 340mph – a great achievement for the time and one which, surely, warranted its inclusion in the list of six achievements in the King's reign. Less than two weeks later the same aircraft set a new world record speed of 407.5mph. The winning aircraft was designed by

Fig. 5.03(L)

Two identical King George V Silver Jubilee mugs made by two different potteries using the British Pottery Manufacturers Federation design. The mug on the left was produced by J & G. Meakin, Hanley, Staffordshire. The trademark used is a face in a rising sun under the word 'SOL'. This mark was registered in 1912. This pottery used a Royal Coat of Arms mark in the late nineteenth century as did at least three other potteries with the same surname viz: Alfred Meakin, Tunstall; Charles Meakin, Hanley and Henry Meakin, Cobridge. The mug on the right was manufactured by British Anchor Pottery, Longton. This mug also carries the 'local' inscription:-BISHOP'S STORTFORD PRESENTED BY THE CITIZENS. Each mug, in addition to the manufacturer's trade mark, has the official mark of the British Pottery Manufacturers Federation printed on the base.

Fig. 5.04

The mark of the British Pottery Manufacturers Federation which was printed on all articles manufactured to their designs. This particular mark is from the base of a Queen Elizabeth II coronation mug (2nd June 1953) but is exactly the same as the Federation marks on the King George V Silver Jubilee mugs (6th May 1935) illustrated in Fig. 5.03.

R.J.Mitchell who later designed the legendary Spitfire. The construction company, Dorman Long & Co. Ltd. of Middlesborough, UK, together with consulting engineers Ralph Freeman were awarded the massive Sydney Harbour bridge project in March 1924. This bridge, a single-span, two-hinged steel arch bridge was officially opened by Premier J.T.Lang on 19th March 1932. (Incidentally, Newcastle-upon-Tyne's Tyne bridge was patterned on that for Sydney Harbour). The same contractor and consulting engineer were commissioned to build the Tyne bridge which King George V officially opened on 10th October 1928,

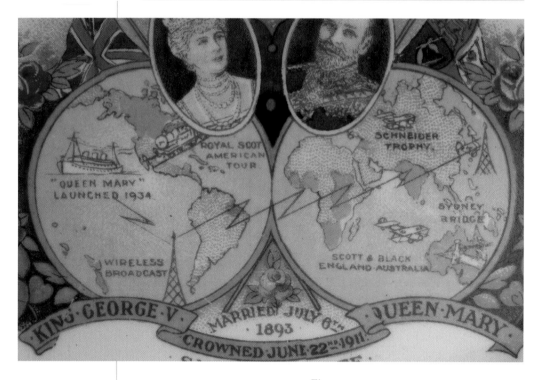

Fig. 5.05

A close-up of the two halves of the globe which form the centre-piece in the design of a King George V Silver Jubilee cup, saucer and plate produced by Thomas Cone Ltd., Longton, Staffordshire. The six achievements accomplished in the twenty-five years of King George V's reign, three on each half of the globe, can be clearly seen.

(some 3 1/2 years before its big brother on the other side of the world.) On 23rd October 1934, C.W.A. Scott and T.Campbell Black won the MacRobertson trophy in the England to Australia (Melbourne) air race. They covered the distance, in a De Haviland DH 88 Comet racer in 2 days 23 hours. Each of these six achievements were clearly very significant at the time and even to-day will hold their own in most people's list of twentieth-century British achievements. It is not until we sit down to write a list of six achievements of the forty-nine years of Queen Elizabeth II's reign that we realise the significance of the six selected by the designers at Thomas Cone Ltd. in Longton, Staffordshire seventy years ago.

The original caption to the photograph in Fig. 5.12 states that the Royal Doulton King Edward VII coronation beakers were fetching 7s 6d in sale rooms in 1911. This is an increase of seven and a half times in nine years. It is interesting to note that the

Fig. 5.06 and 5.07

A white porcelain mug with green printed monochrome transfer of a simple but striking design. Two medallions, one containing a portrait of the King and the other the Queen form the centrepiece of this design. A scrolled ribbon flanks the medallions. Inscribed on the ribbon below the portraits is:
CORONATION 1911. Above this, in the centre, is the traditional design of a single rose. A crown tops the medallions.
On the reverse is the King's cypher with:
CORONATION 1911
inscribed between the crown and the monogram. The monogram design is identical to that employed on the three beakers described next.
NOTE: Inscribed on the medallion with the Queen's portrait is 'W&D.Downey' and on the medallion bearing the King's portrait is 'Lafayette Ltd', the portraits' copyright holders.
MARK: Printed in green is a standing lion on a crown. Beneath this is 'Royal Doulton, England' surrounding the traditional Doulton device. Below this is printed 'Copyright'.
MANUFACTURER: Royal Doulton & Co (Ltd), Burslem, Staffordshire.

appreciating value of Royal Commemoratives was considered to be newsworthy in 1911.

King George V and Queen Mary had six children – two of whom were to become King in the same year as King George V died – 1936. His death on 20th January 1936 was only 8 months and 14 days after the Silver Jubilee, hence the silver bands on the Royal Doulton In Memoriam loving cup (see Figs. 5.33 and 5.34).

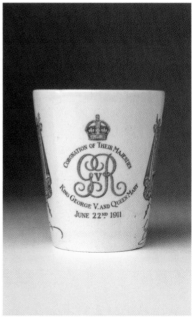

Figs. 5.08 and 5.09

A white porcelain tapered beaker with printed sepia transfer in four separate panels
running around the beaker, (see Figs. 5.08 to 5.11 inclusive). Fig. 5.12 is from a
newspaper or gazette (possibly The Pottery Gazette) and shows these beakers in the
final stages of completion at Royal Doulton's Burslem pottery.
In the first panel is a uniformed portrait of King George V. The portrait is framed by
drapes supported by two crossed staffs. The drapes are topped in the centre by a
crown. Below the portrait a scrolled ribbon is inscribed GEORGE V, and beneath this is
the King's signature. Turning the beaker anti-clockwise is King George's Royal
Cypher. Above the cypher, below a crown is the semi-circular inscription:

CORONATION OF THEIR MAJESTIES

below the cypher is the inscription:

KING GEORGE V AND QUEEN MARY

JUNE 22ND 1911

The portrait of Queen Mary can be seen by turning the beaker a further ninety
degrees. The setting is exactly the same as that for the King. The inscription beneath
the portrait, on a scrolled ribbon is QUEEN MARY and below this is the Queen's
signature. In the last quadrant is Queen Mary's Royal Cypher. Above the cypher and
below a crown is the semi-circular inscription:

PRESENTED BY THEIR MAJESTIES

below is the inscription:

CRYSTAL PALACE

JUNE 30TH 1911

MARK: Printed in sepia is a lion standing on a crown. Beneath this is 'Royal Doulton,
England' surrounding the traditional Doulton device. Below this is
printed COPYRIGHT.
MANUFACTURER: Royal Doulton & Co (Ltd), Burslem, Staffordshire.

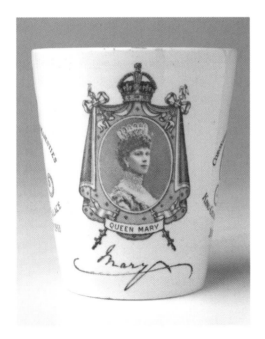

Fig. 5.10

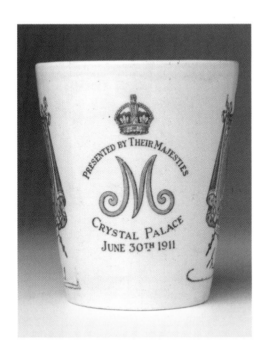

Fig. 5.11

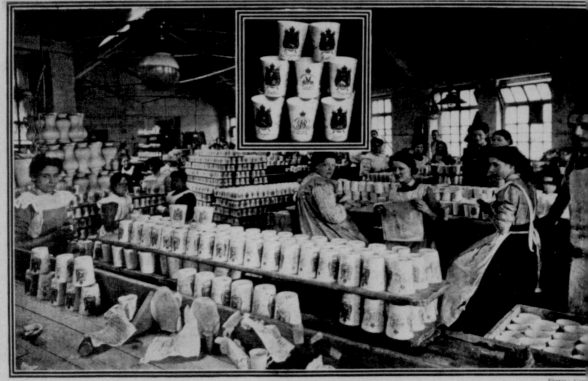

TRANSFERRING THE ROYAL PORTRAITS AND AUTOGRAPHS UPON THE KING'S CORONATION MUGS

At the Royal Doulton potteries, Burslem, the King's order for the 100,000 mugs which are to be given to His Majesty's juvenile guests at the Crystal Palace fête June 30th is rapidly approaching completion. The mugs will be sent to the Crystal Palace a week or ten days before the fête. Our photographs show the beaker process of transformation from a lump of clay weighing half-a-pound to a beautiful piece of pottery, and a pyramid of the finished beakers showing the comp design, including the special portraits and autographs furnished by the King and Queen. The beakers made by the same firm for King Edward at his Corona have already fetched as much as 7s. 6d. each in the sale-room, so that the juvenile recipients will do well to treasure their presents carefully. The beakers are ma fine ivory porcelain decorated in a chocolate colour. The workmanship and materials are British throughout

Fig. 5.12.

A captioned photograph taken from a newspaper or gazette. The caption reads:
'TRANSFERRING THE ROYAL PORTRAITS AND AUTOGRAPHS UPON THE KING'S CORONATION MUGS'.
At the Royal Doulton potteries, Burslem, the King's order for the 100,000 mugs (beakers) which are to be given to His Majesty's juvenile guests at the Crystal Palace fete on June 30th is rapidly approaching completion. The mugs will be sent to the Crystal Palace a week or ten days before the fete. Our photographs show the beakers in process of transformation from a lump of clay weighing half a pound to a beautiful piece of pottery, and a pyramid of the finished beakers showing the complete design including the special portraits and autographs furnished by the King and Queen. The beakers made by the same firm for King Edward at his Coronation have already fetched as much as 7s 6d each in the sale room so that the juvenile recipients will do well to treasure their presents carefully. The beakers are made of fine ivory porcelain decorated in a chocolate colour. The workmanship and materials are British throughout'.

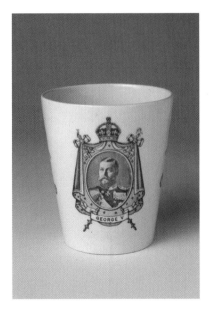

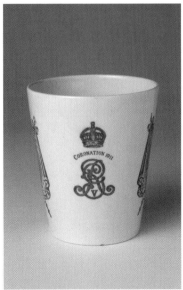

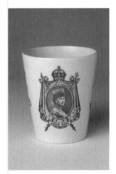

Fig. 5.15

Figs. 5.13 and 5.14

Two white porcelain tapered beakers dimensionally identical to the previous beaker. The design of the printed sepia transfer is less interesting than that on the previous beaker which was designed and produced for presentation at a specific event. The first of these two beakers, (see Figs. 5.13 to 5.16) was most likely produced for general sale. Again there are four distinct panels running around the beaker, the first contains a portrait of the King in exactly the same setting as detailed in the description for the previous beaker with GEORGE V inscribed on the scrolled ribbon beneath the portrait. There is no signature. The portrait is not the same as the King is wearing a different uniform and decorations. In the next panel the Royal Cypher is smaller and of a slightly different design. The V is at the bottom of the cypher and not in the centre. The cypher is topped by the same design of crown as used previously with an inscription below the crown of: CORONATION 1911. The portrait of Queen Mary, in the third panel, is exactly the same as that on the previous beaker. Again there is no signature. In the fourth panel is a smaller Queen's Cypher with a neat little symbolic rose in the top of the M. Between the crown and cypher is the inscription: CORONATION 1911. The crown above Queen Mary's Royal Cypher is different from that used on the previous beaker. Presumably in this design the Queen's own crown has been included.

The second beaker, (see Fig. 5.17), is in the local category in that it was commissioned by Scarborough (Coronation Celebration Committee). The transfer has been adapted to include the Scarborough inscription in the place of the Queen's Cypher. Around the top of the Scarborough Town Crest is inscribed SCARBOROUGH CELEBRATION JUNE 23RD 1911 and below the crest is W.S.ROWNTREE MAYOR.

MARK: Printed in sepia is a lion standing on a crown. Beneath this is 'Royal Doulton, England' surrounding the traditional Doulton device. Below this is printed COPYRIGHT.

MANUFACTURER: Royal Doulton & Co (Ltd), Burslem, Staffordshire.

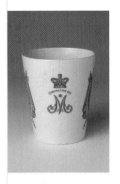

Fig. 5.16

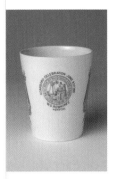

Fig. 5.17 (L)

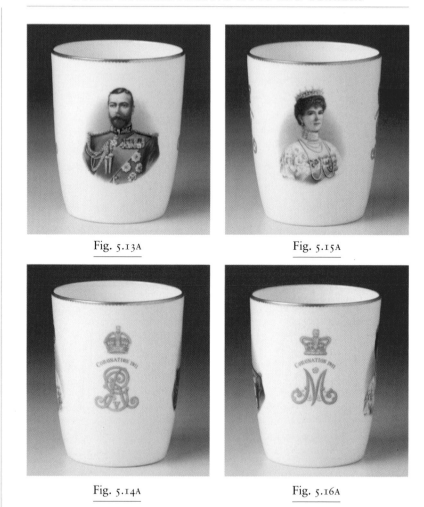

Fig. 5.13A

Fig. 5.15A

Fig. 5.14A

Fig. 5.16A

Figs. 5.13A; 5.14A; 5.15A and 5.16A are of a white bone china Royal Doulton beaker of similar design but with printed polychrome transfer portraits and gilded Royal Cyphers with a gilded rim, an 'up market' variant.

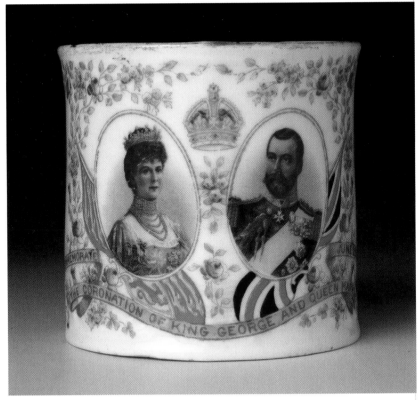

Fig. 5.18

A white bone china mug with flared gilded rim and scrolled handle with gold stroke. Two colourful and detailed portraits dominate the design on the front of this mug. The transfer print in sepia is overpainted in coloured enamels. The portraits are in yellow frames separated by a crown and pink roses. The Queen with crown, pearl choker and four strings of pearls is wearing a green dress. The king is resplendant in one of his military uniforms. The Royal Standard is draped to the side and below the Queen's portrait and the Union flag similarly draped beside the King's portrait. Sprays of pink roses, thistles and shamrock liberally decorate the area around the portraits. Running below the portraits is a blue scrolled ribbon.

The ribbon is inscribed:

TO COMMEMORATE THE CORONATION OF KING GEORGE AND QUEEN MARY JUNE 22ND 1911

National shields of the six countries (three each side) constituting the Empire decorate the sides of this delightful mug. There is a picture of a three funnelled naval ship on each side with four military persons, in uniforms, pictured below. Two on each side are on horseback. It appears that the military people depicted are one from each of the countries whose shields are featured on that side plus one from Britain. On the Queen's side the Briton is a sailor, whilst on the other side is a guardsman on horseback.

MARK: Printed in green is AYNSLEY over a crown below which is ENGLAND.

MANUFACTURER: John Aynsley & Sons (Ltd), Longton, Staffordshire.

Fig. 5.19

Fig. 5.20

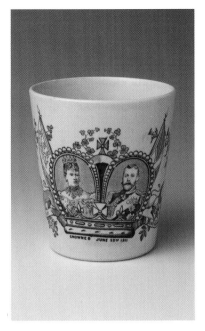 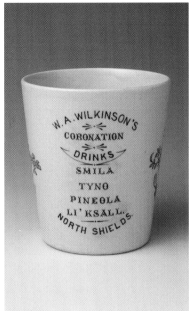

Figs. 5.21 and 5.22 (L)

An interesting tapered white porcelain beaker with green printed transfer. On the front of the beaker are portraits of King George V and Queen Mary incorporated in a crown design. The crown is flanked by the Royal Standard and a lion with a spray of national flowers on one side and the unicorn on the other side together with a spray of national flowers. The cross at the top centre of the crown is 'framed' with sprigs of shamrock. Running from left to right beneath the lion and the unicorn is a scrolled ribbon inscribed:

QUEEN MARY and KING GEORGE. Inscribed below the crown is:

CROWNED JUNE 22ND 1911.

On the reverse is:

W.A. WILKINSON'S

≈

CORONATION

≈

DRINKS

SMILA

TYNO

PINEOLA

LI'KSALL

NORTH SHIELDS

Clearly a local commemorative which oozes the Geordie dialect.

MARK: There is no mark.

MANUFACTURER: Unknown. With C.T.Maling's pottery only some six miles down the road on the same side of the Tyne (surely the source, if only the name, of the Coronation drink TYNO!) it may possibly have been made there.

Fig. 5.23

A white porcelain mug with gilded rim and gilded stroke on the handle, with moulded double ring at base. A polychrome printed transfer decorates the front of the mug featuring very fine portraits of King George and Queen Mary. The depth and range of colours of this transfer are outstanding. The King is dressed in uniform and the Queen, wearing her crown, is pictured with a high pearl choker and four strings of pearls. Both portraits are in ornate yellow oval frames each with labels bearing the names QUEEN MARY and KING GEORGE V. The two frames are surrounded by a laurel wreath. Between the two portraits is the Royal Coat of Arms, behind which the Union flag and Royal Standard are draped. Above this is a crown. Inscribed below the crown is:

22ND JUNE

1911

Neatly set out at the bottom is an arrangement of pink roses. The design is balanced with draped Royal Standards and Union flags at each side.

Printed on one side of the handle is: and on the other side is:

SEND THEM	RULERS
VICTORIOUS	OF AN
HAPPY AND	EMPIRE
GLORIOUS	ON WHICH THE
LONG TO	SUN
REIGN OVER US	NEVER SETS

Inside the rim is:

CORONATION SOUVENIR

22 JUNE 1911

MARK: Printed in sepia is:

HARRODS LTD

EXCLUSIVE DESIGN

GUARANTEED ALL BRITISH

plus some decoration in an overall oval design.

MANUFACTURER: There is no manufacturer's mark. A similar mug (exclusive to Harrods) is reproduced in the book *Royal Souvenirs* by Geoffrey Warren where it is referred to as Blundson ware. However the identical transfer was used by C.T.Maling & Sons (Ltd) on a white tapered beaker commissioned by the City and County of Newcastle-upon-Tyne. Beneath the transfer in tiny yellow print are the words HARRODS Ltd EXCLUSIVE DESIGN. The backstamp of this beaker is printed in a red-sepia colour with the C.T.Maling & Sons CETEM WARE mark. From 1910 Maling started selling considerable quantities of its Cetem Ware to Harrods. Harrods also commissioned exclusive items from Maling. It is most likely that this mug was manufactured by C.T.Maling & Sons (Ltd), at their Ford Potteries, Newcastle-upon-Tyne.

Fig. 5.24

A white porcelain tapered beaker with a pleasantly designed polychrome transfer featuring excellent portraits of King George V and Queen Mary. The portraits are very similar to those painted by Langfier, which appear in a different design celebrating the coronation. The portraits are each framed by laurel wreaths, separated at the top by a crown. Inscribed each side of the crown is: CORONATION JUNE 22ND 1911. At the centre of the design is a yellow medallion bearing the year 1911. The portraits are flanked by draped national flags and the Royal Standard. Beneath each portrait is a scrolled nameplate bearing the inscriptions:

H.M.KING GEORGE V and H.M.QUEEN MARY.

On the reverse there are crossed flags surmounted by a crown surrounted by a golden halo.

NOTE: The design is the copyright of W&D.Downey, according to the inscription on each side of the flags.

MARK: Printed in sepia is 'Bristol Semi Porcelain' above a coat of arms, beneath which is 'P& Co Ltd, England'.

MANUFACTURER: Pountney & Co (Ltd), Bristol, Avon.

 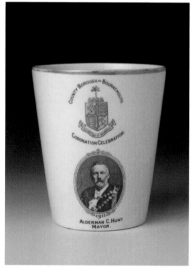

Figs. 5.25 and 5.26 (L)

A very fine white tapered porcelain beaker with gilded rim, ten thousand of which
were commissioned by the Bournemouth Coronation Celebration Committee.
The design on the front is striking in its simplicity with separate polychrome head
and shoulder portraits of King George V, in a red military uniform, and Queen Mary.
Above the portraits, in sepia, is a crown beneath which is: CORONATION 1911.
Below the portraits is the King's cypher. On the reverse are the Arms of the County
Borough of Bournemouth. Beneath is the inscription: CORONATION CELEBRATION.
Below is a head and shoulders portrait of the Mayor of Bournemouth ALDERMAN C.
HUNT, MAYOR.
The *Bournemouth Times & Directory* published a supplement, on the 3rd May 1935
celebrating King George V's Silver Jubilee, which included an article titled 'The 1911
Coronation Great Rejoicing'. It reports the celebrations were '... based on the
experience of those in connection with King Edward's Coronation in 1902'. A major
part of the festivities was a 'children's Pageant of Empire' in which over 8,000
elementary schoolchildren took part. However, these festivities had to be postponed
from 22nd June 1911 to 28th June 1911 due to very heavy rain. 'Each child taking
part was presented with a beaker, similar to those supplied to the King for the
children's party at the Crystal Palace, but bearing, in addition to the portraits of the
King and Queen, the Borough Arms and a portrait of the Mayor.' The Bournemouth
Visitors Directory dated 1st July 1911 reported '... the special beakers provided by
the Corporation funds' were distributed a few days before the
re-programmed Pageant.
NOTE: Royal Doulton produced a twenty-four piece tea service with the front transfer,
plus a mug and an ashtray. The pieces of this tea service were available as separate
items.
Some transfers show the King wearing a red military uniform, as on the beaker
detailed above, while in others the King is wearing a blue naval uniform.
MARK: Printed in sepia is a crowned lion standing on a crown. Beneath this is
'Royal Doulton' surrounding the traditional Doulton device.
MANUFACTURER: Royal Doulton & Co (Ltd), Burslem, Staffordshire.

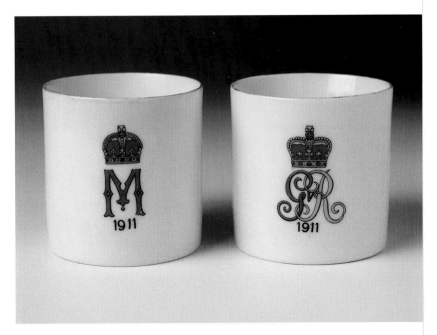

Figs. 5.26A; 5.26B and 5.26C

Two white porcelain mugs with gilded rims and gilded stripe on the handles
commemorating the coronation of King George V and Queen Mary. Each mug is
printed with polychrome transfers opposite the handles and both contain a
lithophane captioned portrait in the base similar to the King Edward VII and Queen
Alexandra mugs illustrated in Figs. 4.08 to 4.11 inclusive.

MARK: There are no marks on either mug.
MANUFACTURER: Unknown.

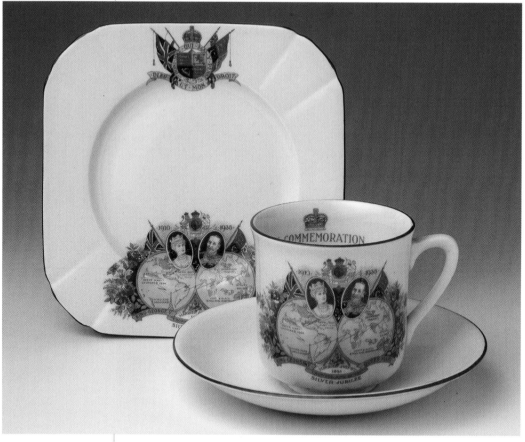

Fig. 5.27

An earthenware cup, saucer and plate commemorating the Silver Jubilee of King George V and Queen Mary, printed with coloured transfers enhanced with enamels with blue rim and blue stripe on the handle. The design features both sides of the globe above which there are small oval portraits of King George V and Queen Mary. Above the portraits are the Royal Arms and the dates 1910 and 1935. The portraits are flanked by the Union flag and the Royal Standard. Flanking each side of the globe are arrangements of red roses, thistles and shamrock. Three achievements accomplished in the first twenty-five years of King George V's reign are highlighted on each side of the globe. These are:

	ROYAL SCOT	
"QUEEN MARY"	AMERICAN	SHNEIDER TROPHY
LAUNCHED 1934	TOUR	
		SYDNEY
		BRIDGE
	SCOTT & BLACK	
	ENGLAND AUSTRALIA	
WIRELESS		
BROADCAST		

Each of these achievements are reported upon in detail on page 76.
Beneath the globe runs a scrolled yellow ribbon and:

KING GEORGE V MARRIED JULY 6TH QUEEN MARY
1898
CROWNED JUNE 22nd 1911
SILVER JUBILEE

King George V, Queen Mary and the coronation date are inscribed on the ribbon.
On the reverse is the Royal Coat of Arms. Inside the cup is inscribed IN
COMMEMORATION with crown above.
The saucer, with blue rim, is similarly decorated.
MARK: On both the cup and saucer, printed in black, is a crown with 'Alma Ware
England' below.
MANUFACTURER: Thomas Cone Ltd., Longton, Staffordshire.

Fig. 5.28

A white bone china tapered mug with silver rim, foot and outline of handle with a
silver stroke on the handle. A high quality commemorative decorated with a printed
brown transfer meticulously hand painted in coloured enamels. In the centre is a
light blue ornately designed 'GR' in a 'U' of pink roses. To the right is a shield of the
Union flag with sprays of shamrock and to the left a shield of the Royal Standard
with sprays of thistles. Top centre is a crown, each side of which is inscribed:- SILVER
JUBILEE. A scrolled ribbon runs through the thistles and shamrock below the two
shields and roses. The ribbon is inscribed:
ACCEDED MAY 6TH 1910 KING GEORGE V 1910-1935 & QUEEN MARY CROWNED
JUNE 22ND 1911.
Below this is:
LONG MAY THEY REIGN
MARK: Printed in brown HAMMERSLEY, LONGTON, ENGLAND
Hand painted in red 2001/1
MANUFACTURER: Hammersley & Co, Longton, Staffordshire.

95

Figs. 5.29 and 5.30

A fine white bone china tapered mug with a moulded ring below the top lip and
above the foot. The rim is gilded and the handle has a gold stroke. The front is
decorated in a bright colourfully designed transfer print, Copyright Bassano Ltd.,
featuring sepia portraits of King George V and Queen Mary. Between the two
portraits is the Royal Coat of Arms topped by a crown behind which is the rising
sun. Above this is a scrolled ribbon inscribed: HONI SOIT QUI MAL Y PENSE. Above this
is:

1910 . SILVER JUBILEE . 1935.

Flanking the portraits are two Union flags, a crowned lion stands in front of the left
hand flag supporting the Queen's portrait whilst a Unicorn is undertaking a similar
responsibility on the right hand side. Below the portraits, in ornate scroll work, are
the shields of the Dominions of the Empire – India, Africa, Canada and Australia.
Above the shields, below the portraits, are the names of the Queen and the King. On
the reverse is a scroll of ribbons topped by a crown. The ribbons are inscribed:

1910 . SILVER JUBILEE COMMEMORATION 1935.

MARK: Printed, on the base, in gold is a crown with Made In England above and the
initials 'T&K with an 'L' incorporated in the '&'. A small handpainted 'W' is also on
the base of this mug, most likely the initial of the decorator.

MANUFACTURER: Taylor & Kent (Ltd), Florence Works, Longton, Staffordshire.

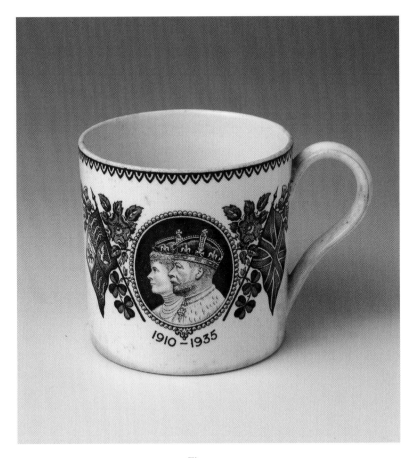

Fig. 5.31

An earthenware mug with a chocolate brown printed transfer decoration. The rim is decorated with a continuous pennant design. The centrepiece is a medallion bearing an excellent, head and shoulders portrait of Queen Mary and King George V. The Queen and the King are both wearing their crowns. Beneath the medallion is:

1910 – 1935

An arrangement of national flowers (minus the national plant emblem for Wales), the Royal Standard and the Union Jack flank the medallion. The reverse is printed with the Royal Coat of Arms.

MARK: Printed in brown, inside a circle, is:

. 1910 .

SILVER

JUBILEE

1935 .

Printed around the circle is: KING GEORGE V. QUEEN MARY.

Impressed is: 'Wedgwood Made in England' and '36'.

MANUFACTURER: Josiah Wedgwood (& Sons Ltd), either at their Burslem, Etruria or Barlaston potteries. The impressed number 36 denotes the year of manufacture as 1936.

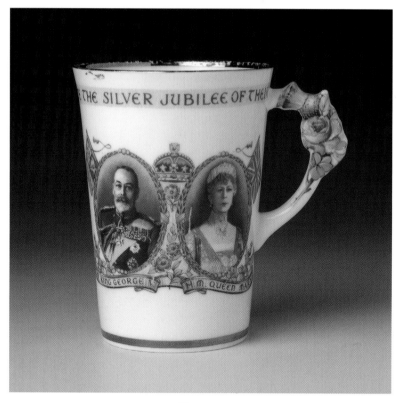

Fig. 5.32

A white bone china tapered tankard with unique handle moulded and painted with a
thistle, rose and shamrock. This graceful tankard, with silver rim and silver band
above the foot, features sepia portraits of King George V and Queen Mary in blue
frames, flanked at the top by the Royal Standard on one side and the Union flag on
the other. Between the frames is a crown and red roses whilst flanking each side at
the bottom are shamrock and thistles. Inscribed on a scrolled ribbon running along
the bottom of the portraits is: H.M.GEORGE V and QUEEN MARY. Below the rim on a pale
yellow band, inscribed in purple is:

TO COMMEMORATE THE SILVER JUBILEE OF THEIR GRACIOUS REIGN.

On the reverse is:

1910 1935.

MARK: Printed in purple is PARAGON above a square containing the Royal Coat of
Arms with BY APPOINTMENT below. Beneath the square is:

FINE CHINA

MADE IN ENGLAND

REGD

SOUVENIR

TO COMMEMORATE

THE SILVER JUBILEE

OF THEIR MAJESTIES

THE KING AND QUEEN

COPYRIGHT

MANUFACTURER: Paragon China (Co) Ltd., Longton, Staffordshire.

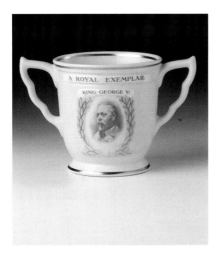 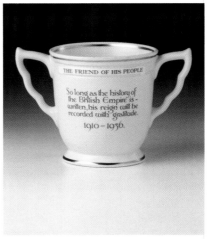

Figs. 5.33 and 5.34

This In Memoriam cream porcelain Loving Cup has inscribed on a white scroll, just below the rim:

A ROYAL EXEMPLAR

Beneath, on a smaller scroll, is:

KING GEORGE V.

A photographic portrait, in sepia, of King George V is in the centre surrounded by a green coloured laurel wreath. The effect is commanding as befits this popular and sucessful King. The dictionary meaning of 'exemplar' is a model type and the achievements in his reign certainly justified this acclamation. On the reverse on a white scroll is the inscription:

THE FRIEND OF HIS PEOPLE

Below this is inscribed:

SO LONG AS THE HISTORY OF

THE BRITISH EMPIRE IS —

WRITTEN, HIS REIGN WILL BE

RECORDED WITH GRATITUDE.

1910 — 1936

Around the rim and foot is a silver band.

NOTE: This Loving Cup is larger than it appears in the images above and its true size can be seen in Fig. 1.07 where it can be seen in a group of "regular" sized mugs and beakers.

MARK: Printed in black is the Royal Doulton mark
MANUFACTURER: Royal Doulton & Co (Ltd), Burslem Staffordshire.

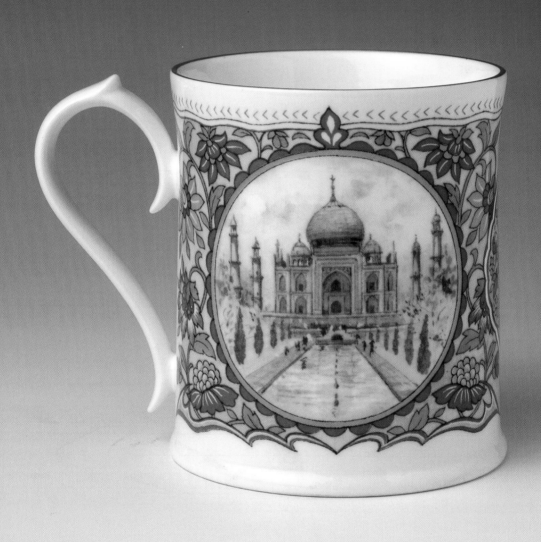

Royal Visits to India

Many Royal Commemoratives, especially those produced for the reigns of Queen Victoria, King Edward VII, King George V and the ones prepared for the coronation of King Edward VIII include in their design reference to the countries which constituted the British Empire, (see Fig. 6.01). References to India particularly, appear on many commemoratives due in part to Queen Victoria being proclaimed Empress of India in January 1877. Beneath the portraits on the King Edward VII teapot illustrated in Fig. 1.01 is inscribed 'King & Emperor' and 'Queen & Empress'. Reference has already been made (Chapter 3) to a design incorporating the Indian elephant. The King Edward VII Coronation mug "sponsored" by Brixham Town Council referred to in Chapter 2 includes, in its design, a reference to India, (see Fig. 6.02). An example in which an Indian elephant is a significant part of the design is the mug commissioned from Dame Laura Knight for the Coronation of King Edward VIII, which on his abdication was adapted to commemorate King George VI's coronation, (see Figs. 8.07 to 8.10 inclusive). A recent mug, (see Fig. 6.12), commemorating Queen Elizabeth II's visit to India in 1997 (her third visit as Queen) includes a picture of the Taj Mahal, arguably the world's greatest monument.

British Royalty have been regular visitors to India since the visit by Albert, Prince of Wales (the 18th Prince of Wales, later King Edward VII) from 8th November 1875 to 13th March 1876, ten months before his mother, Queen Victoria, was proclaimed Empress of India. Landing in Bombay, the Prince of Wales visited Baroda; Madras; Calcutta; Lucknow; Delhi; Kashmir; Moradabah; Allahabad; Jabalpur; the caves of Elephanta and the Taj Mahal.

Thirty years and one day after Albert, Prince of Wales, commenced his visit to India, George, Prince of Wales, (later King George V) arrived in Bombay aboard the Renown on 9th November 1905 and departed on 19th March1906. In this Chapter, (see page 107), an etched glass welcoming the Prince and Princess of Wales on their visit to India is described in detail. This glass was found in

OPPOSITE

A polychromatic transfer-printed painting of the Taj Mahal on the reverse of an Aynsley mug commemorating the visit of Queen Elizabeth II to India to attend the celebrations marking the 50th Anniversary of India's Independence.

a Mumbai antique shop, supporting the Author's experience that local commemoratives do not travel far from their place of origin.

In the year of their Coronation they made a return visit, this time as King Emperor George V and Queen Empress Mary, arriving in Bombay aboard the *Medina* on 2nd December 1911, (see Fig. 6.03). The *Medina*, unlike the *Renown*, was not a Naval vessel but was under contract from P & O. King Emperor George V was the first British Monarch to visit India and the only British Monarch to visit India whilst it was part of the British Empire. The highlight of this visit – which continued until 10th January 1912 – was the Delhi Coronation Durbar held in Delhi on 12th December 1911, described in the *Dictionary of National Biography* 1931-40 (ed.L.G.Wickham Legg, Oxford University Press, 1949) as "a State Durbar of matchless magnificence", (see Fig. 6.04). The Durbar was held in the Diwan-i-Khas, a hall in Shah Jahan's palace, Urdu-i-Mu'alla, more commonly known as Lal Qila or Red Fort. In the time of Akbar Shah II and Bhadur Shah the palace was called the Qila-i-Mu'alla or the Fort of Exalted Dignity. This palace is the most famous of all Indian palaces. Inscribed on the corner arches of the northern and southern walls of the Diwan-i-Khas is the couplet (translated): *If on earth there be a place of bliss, it is this, O it is this!* At the Durbar, King Emperor George V declared "that the seat of government was to be transferred from Calcutta to Delhi..." so Delhi became the capital of India. Their visit to Bombay was commemorated by the construction, in 1924, of the city's most famous landmark – the Gateway of India.

At the time of their visit the Indian agents of M.B.Foster & Sons distributed, throughout India, a King George V Coronation mug promoting the beer they bottled in London and exported to India. This mug is featured on page 107. The design of the inscription on the reverse of this mug is similar to one of Foster's beer-bottle labels, (see Fig. 6.05). M.B.Foster & Sons Ltd., established in 1829, were one of Bass and Co's leading bottlers, both for the home trade and export. The Bass was brewed in Burton upon Trent. Foster's export market included India, America, Burma and Canada. India was a particularly important market. In the 27th August 1879 edition of the *Bombay Gazette* an advertisement, (see Fig. 6.06), by one of Foster's Indian agents, Treacher and

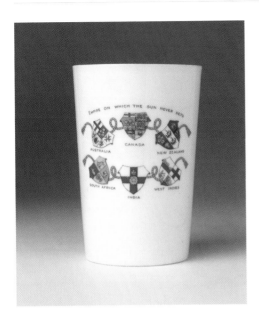

Fig. 6.01.

The design on the reverse of an Aynsley mug commemorating the coronation of King Edward VIII. The shields of the countries constituting the British Empire appear under the title EMPIRE ON WHICH THE SUN NEVER SETS.

Fig. 6.02.

The design of the King Edward VII coronation mug commissioned by Brixham Council included reference to the British Dominions and the King's position as Emperor of India. Many commemoratives include such a reference but few have it encapsulated in a separate panel.

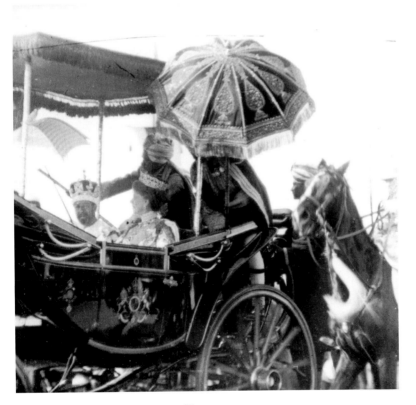

Fig. 6.03.

King Emperor George V and Queen Empress Mary arriving in Bombay (Mumbai) on 2nd December 1911 en route to Delhi for the Durbar. This photograph was taken by Vernon & Co.

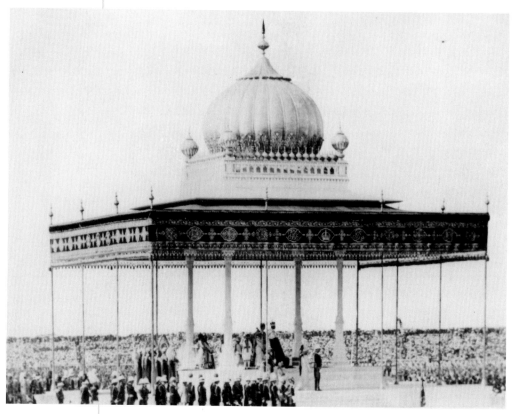

Fig. 6.04

King Emperor George V and Queen Empress Mary on the Durbar Throne in Delhi on 12th December 1911. Little imagination is required to appreciate how splendid this occasion must have been. "Matchless magnificence" indeed. The pillars of the Diwan-i-Khas hall can be clearly seen. The Mughals built their halls in India with only pillars replicating the great tents or shamianas of their central Asian forefathers.

Company Ltd, Bombay, Byculla and Poona stated "Messrs Foster's account is the largest on Bass & Co's books, and since the establishment of their business in 1829, their shipments abroad have extended to every leading market of the globe". The advertisement continued extolling the virtues of Foster's bottled Bass beers and ended with the price of "Pints in cases of 6 doz... per doz. Rs 4.0". [One of the major markets for Foster's were the many British Regiments stationed throughout India. Bass brewed a beer developed to be particularly refreshing in India's harsh climate and to be in peak condition inspite of the distance travelled. This beer was named Indian Pale Ale (IPA), see figure 6.07. Although developed specifically for the Indian market it also became popular in the home market after a shipwreck, just off Liverpool resulted in the rescued beer being sold in the home market.]

Prince Arthur, Duke of Connaught, Queen Victoria's third and youngest son visited Delhi in 1921 to open Sir Edwin Lutyens' Parliament buildings. Seventy-nine years on these splendid buildings continue to house the National Government and captivate tourists.

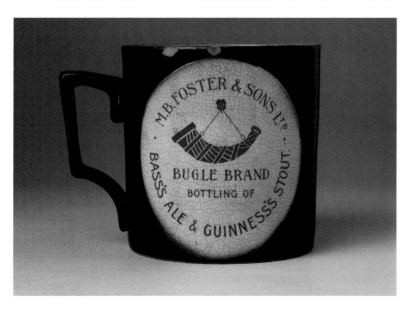

Fig. 6.05.

An M.B.Foster and Sons bottle label, dated 1901, alongside the reverse of the King George V Coronation mug found in Mumbai (Bombay).

WEDNESDAY, AUGUST 27, 1879.

BASS'S FIRST QUALITY
INDIA PALE ALE,
BOTTLED BY M. B FOSTER & SONS,
CHIEF AGENTS TO MESSRS. BASS & Co.

MESSRS. FOSTER'S account is the largest on Bass & Co.'s books, and since the establishment of their Business in 1829, their shipments abroad have extended to every leading market of the globe. Their premises for Home and Export trade far exceed in magnitude and perfection those of any other bottler in the world, and afford employment for upwards of three hundred hands.

As a special mark of Messrs. Bass & Co.'s confidence, it may be noted that Messrs. FOSTER are the only bottlers of the Beer who are authorised to place their own labels on the bottles, a fact which in itself is significant, and will be appreciated by all who value the certainty of obtaining a *genuine*, pure, and *unadulterated* article.

The new season's bottling is now forward in magnificent condition, and fully sustains the prestige that half a century's experience has gained for this favourite Beer.

Pints in cases of 6 doz.............per doz. Rs.	4	0	
Impl. Pints do. 6 doz............. do.	5	4	
Quarts. do. 3 doz.............			

SOLE AGENTS FOR THE BOMBAY PRESIDENCY,
TREACHER & COMPANY, Ld.,
BOMBAY, BYCULLA, AND POONA.

Fig. 6.06

An advertisement from the 27th August 1879 edition of the *Bombay Gazette*, inserted by Treacher and Company Ltd extolling the virtues of M.B.Foster and Sons' bottled Bass beers.

Fig. 6.07.

A reproduction, from the Label Guard Books held by The Bass Museum, of the M.B.Foster and Sons' label for the Bass India Pale Ale that they bottled for the export market. This particular label was in use in January 1891.

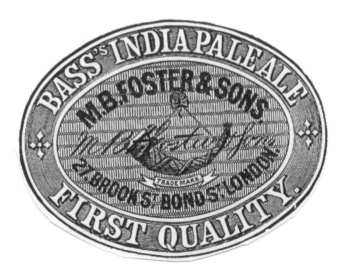

Fig. 6.08

HM Queen Elizabeth II and HRH Prince Philip, Duke of Edinburgh on arrival at Rashtrapati Bhavan, New Delhi, on their State visit to India in October 1997 on the occasion of the Golden Jubilee of India's Independence. This was Queen Elizabeth II's third official visit to India. In the picture with Queen Elizabeth II and the Duke of Edinburgh are (from left to right): Mrs I.K.Gujaral, wife of the then Prime Minister; K.R.Narayanan, President of India and Mrs Narayanan. Rashtrapati Bhavan, opened in 1927 by Arthur, Duke of Connaught (the sixth of Queen Victoria's nine children), is the Government complex housing the Union Government.

Fig. 6.09

An etched glass tumbler featuring the badge of the Heir Apparent to the Throne, the triple plume of ostrich feathers, in the top centre of the design. A scrolled ribbon running beneath the plume of feathers carries the words:

ICH DIEN. Beneath this is: INDIA. A scroll, beneath this is inscribed:

WELCOMES THE ROYAL VISITORS

In simple frames, with a flower vase design separating each frame, are portraits of George, Prince of Wales and Mary, Princess of Wales. Beneath each portrait are the following inscriptions:

H.R.H. THE PRINCE OF WALES H.R.H. THE PRINCESS OF WALES

BORN JUNE 3RD 1865 BORN MAY 26TH 1867

MARRIED JULY 6TH 1893

This tumbler was found in Mumbai (Bombay) where the Royal visitors landed on 9th November 1905.

The I in ICH is etched as a J. Similarly the first I in INDIA is also etched as a J. An explanation for this may be that in certain typeface lettering the upper case I closely resembles the upper case J.

MARK: 'Made in Germany' etched beneath the inscription MARRIED JULY 6TH 1893.

Fig. 6.10 (L)

A large 'heavy duty' cream-coloured earthenware mug unfortunately showing the signs of heavy use. Apart from the circular panels, on the front and the reverse, the mug is painted a rich cobalt blue. The panels are outlined in gilt as is the handle. The front panel features an unusual sepia portrait of King George V and Queen Mary flanked by the Union flag and the Royal Standard. Above the portrait is a crown flanked by JUNE 22ND and 1911. Below the portrait is an arrangement of three National plant emblems with an inscribed scrolled ribbon. The inscription reads:

A SOUVENIR OF THE CORONATION QUEEN

OF KING GEORGE V AND MARY

The panel on the reverse, (see Fig. 6.05), contains a bugle below which is inscribed :

BUGLE BRAND

BOTTLING OF

and around the panel runs the inscription:

M.B.FOSTER & SONS LTD. BASS'S ALE & GUINNESS'S STOUT.

MARK: None

MANUFACTURER : Unknown.

Figs. 6.11 and 6.12

A flared white bone china mug with a colourful printed transfer, gilded rim and plain
handle. The photographic portrait on the front of the mug is of Her Majesty Queen
Elizabeth II in a delightful blue dress with a strikingly designed hat. The Queen is
wearing a very large floral garland of Rajnigandha flowers presented to her during
the tour. The portrait is framed in a blue circular border surrounded by a port wine
coloured scallop design. The reverse, in a similar frame, features a painting of India's
most famous monument – the Taj Mahal. A broad buttercup yellow band runs
around the mug on which are printed classically designed Indian flowers including
the lotus.

MARK: Printed in black is a crown above a circular scroll inscribed AYNSLEY.
Flanking the crown above the scroll is EST and 1775.
Beneath this mark is:
Fine Bone China
MADE IN ENGLAND
To mark the official visit by
H.M.Queen Elizabeth II
to India to attend the celebrations
to mark the 50th Anniversary of
India's independance
1947 – 1997
Exclusively Commisioned by
Peter Jones China Wakefield
Limited Edition 2500
MANUFACTURER: John Aynsley & Sons(Ltd), Longton, Staffordshire.

Edward, Prince of Wales (later King Edward VIII) visited India from 17th November 1921 to 17th March 1922. During this visit a Durbar was also held in the Diwan-i-Khas.

Some thirty-nine years later, on 21st January 1961 Queen Elizabeth II made her first visit to India. The Queen's programme also included visits to Pakistan and Nepal. Whilst in India the Queen and Prince Philip, Duke of Edinburgh, were Guests of Honour at the Republic Day Parade. This visit ended on 2nd March 1961.

The Queen's second visit, in connection with the Commonwealth Heads of Government Meeting in New Delhi, was from 17th November to 11th December 1983.

Charles, Prince of Wales and Princess Diana visited India from 10th to 17th February 1992. This was the fourth visit to India by a Prince of Wales, a span of 117 years from the first visit by Albert, Prince of Wales in 1875.

In 1997 Queen Elizabeth II and Prince Philip again visited India on the occasion of the 50th Anniversary of India's Independence, Fig. 6.08 shows Queen Elizabeth II being greeted by the President of India at the start of their visit. 1997 was also the Golden Wedding Anniversary of Queen Elizabeth II and Prince Philip. Both events were commemorated by mugs and beakers.

Here's to the next Royal visit to India.

EDWARD · VIII

King Edward VIII
1936

Born on the 23rd June 1894, Edward was the eldest of the six children born to King George V and Queen Mary.

His investiture, as Edward, Prince of Wales, was held at Caernarvon Castle on 13th July 1911. This was the first such ceremony to be held since the Middle Ages. Prior to its revival for Prince Edward, the proclamation of the Prince of Wales was an announcement from the Palace.

Edward, Prince of Wales, worked energetically travelling extensively throughout the Empire and North America. Edward VIII ascended the throne on 28th January 1936 following the death of his father, King George V, on 20th January 1936.

That part of the ceramic industry that produced commemoratives in celebration of Royal events finalised their designs for the coronation to be held on 12th May 1937. Production commenced well in advance of the coronation. As the King was not married, only his solitary figure appeared in the designs: in marked contrast to the two previous coronations where Queen Alexandra and Queen Mary were prominently featured on the coronation commemoratives of King Edward's grandfather and father.

An Aynsley beaker, (see Fig. 7.04), has daffodils in its design, in addition to the three traditional national plant emblems – rose, shamrock and thistle. These three national emblems are included in the designs of many of the Royal commemoratives published from 1887. Wales is rarely represented either by a leek or daffodil. Wales is not included in the Sovereign's coat of arms, on which England has two quarters, Scotland one and Ireland one (in Scotland there are two quarters for Scotland and one each for England and Ireland). The State of Wales as a nation in its own right, started to be included more regularly in Royal commemorative designs for the Silver Jubilee of King George V. The design of a Copeland loving cup commemorating the 1935 Silver Jubilee, produced for Thomas Goode & Co Ltd, included a leek. A glass goblet also

Fig. 7.01.

The headline of an article on the national plant emblem for Wales which appeared in the *South Wales Daily News* of 12th November 1927.

commemorating King George V's Silver Jubilee was engraved with a leek in addition to the three traditional national plant emblems. The inclusion of a leek in the W.H.Goss beakers for Queen Victoria's Golden Jubilee and King Edward VII's Coronation was unusual. An article, from the 12 November 1927 *South Wales Daily News*, (see the headline in Fig. 7.01), discusses the controversy of whether the leek or daffodil should be recognised as the national plant emblem for Wales. This debate has been "in session" for many, many years. The leek has been associated with Wales for centuries, Yeomen of the Guard used to present a leek to the Princess Mary (later Queen Mary I) on St David's Day in the late 1530's and early 1540's. The leek still retains precedence and is considered to be the more authentic emblem, hence its inclusion on the current one pound coins, (see Fig. 7.02). The commemorative mugs and beakers for Royal events after the reign of King Edward VIII mostly include either the leek or daffodil where national plant emblems form a part of the design. A Copeland mug for King George VI's coronation prominently features the daffodil, (see Fig. 9.05). The John Wadsworth fine Minton beaker, (see Fig. 10.56), commemorating the Coronation of Queen Elizabeth II, includes in its design national plant emblems but Wales is not represented. However, later commemoratives appear consistently to include either a daffodil or leek. A mug commemorating the birth of Prince William includes both the leek and daffodil, (see Fig. 10.27). The daffodils on the Princess Diana beaker illustrated in (Fig. 10.42) are even more prominent. Leeks are incorporated in a Royal Crown Derby loving cup produced to commemorate the fortieth anniversary of Queen Elizabeth II's accession, (see Fig. 10.36).

The mugs and beakers being produced in large numbers for

the coronation of King Edward VIII, with or without daffodils or leeks, were rendered redundant by events. On the 10th December 1936 King Edward VIII abdicated to marry a twice-divorced American, Mrs Wallis Simpson. Completed commemoratives awaiting despatch in the potteries were broken up resulting in heavy losses. Maling, like most of the pottery companies, had produced many thousands of King Edward VIII Coronation commemoratives well before the event. Fig. 7.03 shows paintresses employed by C.T.Maling at their Ford Pottery, in September 1936, working on King Edward VIII commemoratives. The abdication reportedly caused Maling much financial hardship in 1936. The more entrepreneurial manufacturers, to cut their losses, added a small inscription and released the items as abdication pieces. One such mug is featured in Fig. 7.09. The inscription reads 'The uncrowned King' together with the dates Edward VIII acceded and abdicated. It is ironical that the main transfer reads 'Long May He Reign'.

On his abdication Edward VIII became HRH the Duke of Windsor and on 3rd June 1937 married Mrs Simpson, whose title on marriage became the Duchess of Windsor. The Duke of Windsor died on 28th May 1972 and the Duchess on 24th April 1986.

It is a misconception that King Edward VIII commemoratives are rare and difficult to find. Many commemoratives were released prior to the abdication. Some of these were inscribed with the date of the coronation, others stated 'crowned May 12th 1937'.

One of the first commemoratives on which King Edward VIII appeared was the cup and saucer produced to commemorate the Diamond Jubilee of Queen Victoria in 1897, when the then Prince Edward was three years old (see Fig. 3.26 in Chapter 3).

Fig. 7.02.

A 1985 United Kingdom one pound coin with the leek displayed as the national plant emblem for Wales.

Fig. 7.03.

Paintresses working on commemorative mugs and tankards for King Edward VIII's coronation at C.T.Maling & Sons (Ltd), Ford Pottery, Newcastle - upon - Tyne in September 1936.

Fig. 7.04

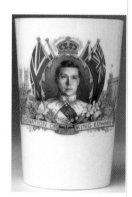

A very fine white bone china tapered beaker, with gilded rim, featuring a sepia portrait of the King set in a colourful design. The portrait of the King, in uniform, is framed by a yellow scroll topped by a crown. National flags flank the portrait with national flowers at the bottom. It is interesting to note that this design is one of the first commemoratives which incorporates daffodils in addition to the thistle, shamrock and pink rose seen in most designs from Queen Victoria's Golden Jubilee onwards. On the left hand side is a picture of Westminster Abbey, captioned: THE ABBEY and on the right Windsor Castle, captioned: WINDSOR. Boardering this design at the bottom is a scrolled yellow ribbon inscribed: MAY 12TH CORONATION OF KING EDWARD VIII 1937. On the reverse are the national shields of each country of the Empire: AUSTRALIA, CANADA, NEW ZEALAND, SOUTH AFRICA, INDIA and WEST INDIES depicted in two lines of three, each line with a yellow rope running behind each shield.

MARK: Printed in green is a crown over a semi-circular scroll inscribed AYNSLEY. Above the scroll and flanking the crown are the words BONE CHINA. Beneath the scroll is ENGLAND.

MANUFACTURER: John Aynsley & Sons (Ltd), Longton, Staffordshire.

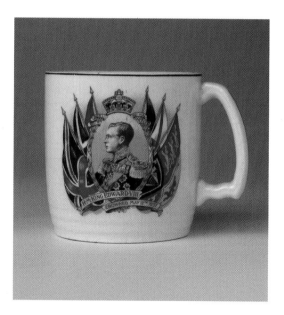

Fig. 7.05

A white porcelain mug triple-waisted at the foot with blue ring at the rim and blue stroke on the handle. The decoration is with a full colour transfer featuring a portrait of the King in uniform with gold frame topped by a crown. Three flags flank each side of the portrait. On one side are two national flags and the Union Jack whilst the other side has two national flags and the Royal Standard. On a scrolled ribbon on each side of the frame, at the top, are the words:

HONI	QUI . MAL
SOIT	Y . PENSE

Across the design at the bottom is a yellow scrolled ribbon inscribed:

H.M.KING EDWARD.VIII

CROWNED MAY 12TH 1937

On the reverse is the cypher of King Edward VIII.

MARK: Printed in black is a round mark with MIDWINTER in the top half-circle and BURSLEM in the bottom half-circle. Across the centre is PORCELON. Below this is ENGLAND.

MANUFACTURER: W.R.Midwinter (Ltd), Burslem, Staffordshire.

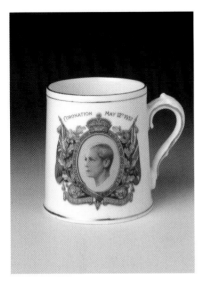

Figs. 7.06 and 7.07

A high quality white bone china mug with gilded rim, gilded rings close to the rim and foot, a scrolled handle with gilded outline and stroke on the handle.

The decoration is certainly elegant, perhaps a little sombre. The monochrome ochre portrait is set against a light blue background framed in a darker blue coloured Garter belt inscribed: HONI . SOIT. QUI. MAL. Y . PENSE. Superimposed at the top centre is a crown. Each side of the frame is an oak sprig with acorns in autumnal shades. Each sprig is terminated in a symbolic English rose in the same ochre colour. Beneath the framed portrait runs an ochre scrolled ribbon inscribed: H.M. KING EDWARD VIII.

A flag is draped at each side adding colour to the decoration. Above the crown, printed in sepia is:- CORONATION MAY 12TH 1937. On the reverse is King Edward VIII's cypher with an ochre laurel spray at each side. Beneath the cypher are the words LONG MAY HE REIGN.

MARK: Printed in green is STANLEY CHINA surounding a mitre shaped crown with MADE IN ENGLAND below.

MANUFACTURER: Charles Amison & Co. Ltd., Longton, Staffordshire. The pottery was the Stanley China Works.

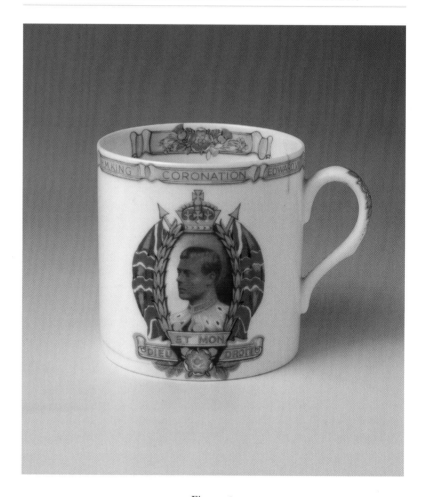

Fig. 7.08

A delightful fine white bone china mug with Tudor rose and leaves in ochre on the
handle. A colour-printed transfer decorates the front featuring a sepia portrait of
King Edward VIII in an oval frame of laurel leaves topped by a crown. Flanking the
frame are two draped Union flags. Inscribed on an ochre ribbon on the front near the
rim is:

HM KING CORONATION EDWARD VIII.

Most interestingly, on the inside is a scrolled ribbon decorated by the four national
plant emblems – yes Wales is again represented, by a daffodil, and this time by a
different pottery. On the reverse is the King's cypher in a laurel-leafed frame topped
by a crown with a single tudor rose below.

On a scrolled ribbon near the rim is 12 MAY 1937.

MARK: Printed in grey in a lozenge-shaped shield is the inscription 'Shelley' with
England below outside the shield. Another more elaborate mark, printed in ochre,
also appears on the base: an oval, with 'Shelley' printed in the centre, surrounded by
laurel leaves with a tudor rose at the top and a scroll below inscribed ENGLAND.

MANUFACTURER: Shelley Potteries Ltd., The Foley, Longton, Staffordshire.

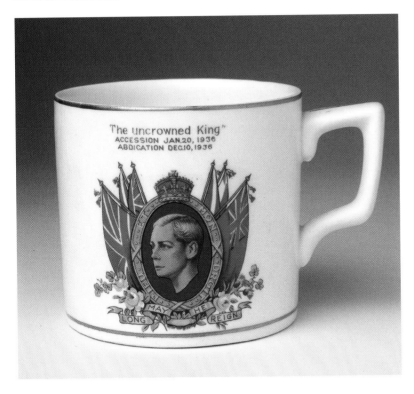

Fig. 7.09

A white porcelain mug with gilded rim and gold band above the foot with gold stroke on the handle, a full colour printed transfer featuring a portrait of the King's head against a blue background set in a gold frame topped with a crown. Inscribed on the frame is:

DIEU ET MON DROIT. Three draped flags flank each side of the portrait. Below this is an arrangement of roses, shamrock and thistles with a scrolled ribbon inscribed LONG MAY HE REIGN. Inscribed in sepia above the main decoration is:

THE UNCROWNED KING

ACCESSION JAN 20, 1936

ABDICATION DEC 10, 1936

On the reverse is King Edward VIII's cypher in a gold frame topped by a crown flanked by two national flags each side with a national flower arrangement below. MARK: Printed in chocolate brown is a crown below which is 'Crownford', in script and underlined. Below this is a circle containing a monogram of 'F&S' flanked one side by 'Burslem' and on the other 'England'.

MANUFACTURER: Ford & Sons (Ltd), Burslem, Staffordshire.

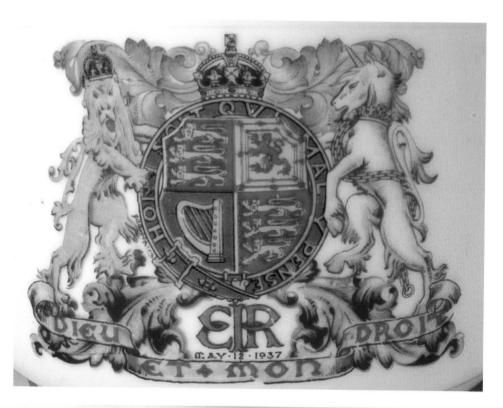

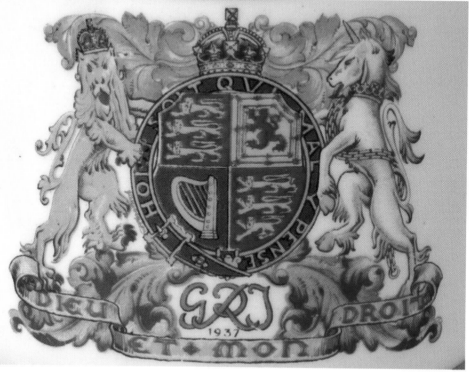

CHAPTER EIGHT

King Edward VIII and King George VI

King Edward VIII abdicated on 10th December 1936; the announcement was made on 11th December. The potteries immediately stopped production of King Edward VIII coronation commemoratives. Many of these were already on the high street. The decision to retain the 12th May 1937 date for the coronation of King George VI gave the potteries very little time to design and tool up for completely new ceramic commemoratives. Three Royal events, two Coronations and one Silver Jubilee, had been commemorated in the thirty-eight years following Queen Victoria's Diamond Jubilee. Each of these events had been predicted, consequently designs and production schedules were prepared well ahead of the event. The postponement of King Edward VII's Coronation (due to his appendicitis operation) created a 'blip' on what had previously been, for the potteries at least, a smooth and well-ordered existence. In the event only a few potteries accepted the challenge, on that occasion, to produce new commemoratives bearing the correct date.

The potteries were now faced with a completely new situation with only 153 days to the coronation. This was certainly so as far as the eighteenth and nineteenth centuries were concerned. However, for the coronation of King Charles II in 1660 (116 years before transfer printing on pottery had been invented – see page 142) one pottery, faced with a real-time constraint, took a piece that had been designed to commemorate Oliver Cromwell and replaced his head, by hand painting, with that of King Charles II. Some 276 years later, for King George VI's coronation, the industry were using similar initiatives to conquer similar time constraints. Some potteries were bold and elected to prepare completely new designs (see Chapter 9) while others worked on programmes designed to keep the additional costs and time required to produce King George VI coronation commemoratives to a minimum. The Royal commemorative industry was very competitive and it was important for potteries to get their wares onto the high street before the competition.

Figs. 8.01; 8.03; 8.02 and 8.04

Earthenware mugs and beakers utilising the designs supplied by the British Pottery Manufacturers' Federation and each one produced by a different pottery. The design originally produced to commemorate the coronation of King Edward VIII was adapted to meet members' needs on news of the abdication. The changes between the design initially supplied for the coronation of King Edward VIII and that used for the King George VI coronation commemoratives are limited to the portrait, the inscription around the rim and the cypher on the reverse.

The design on the front, (Figs. 8.01 and 8.02) features a silhouette portrait of King Edward VIII within a Garter belt surmounted by a crown and flanked by sprigs of oak with leaves and acorns. The inscription around the rim reads:

CORONATION . OF . KING . EDWARD. VIII . MAY 1937.

On the King George VI designs, (Figs. 8.03 and 8.04), the portraits are facing at an angle as there was insufficient space in the existing design for two silhouette portraits. The inscription around the rim reads :-

CORONATION . OF . KING . GEORGE . VI . AND . QUEEN. ELIZABETH. MAY 1937.

MARKS: In addition to the official design mark of the British Pottery Manufacturers' Federation each pottery has stamped their individual marks.

MANUFACTURERS: (8.01) Soho Pottery Ltd, Elder Works, Cobridge, Staffordshire. (8.02) Wood & Son(s) (Ltd), Trent and New Wharf Potteries, Burslem, Staffordshire. (8.03) John Beswick (Ltd), Gold Street, Longton, Staffordshire and (8.04) Myott, Son & Co (Ltd), Cobridge, Staffordshire.

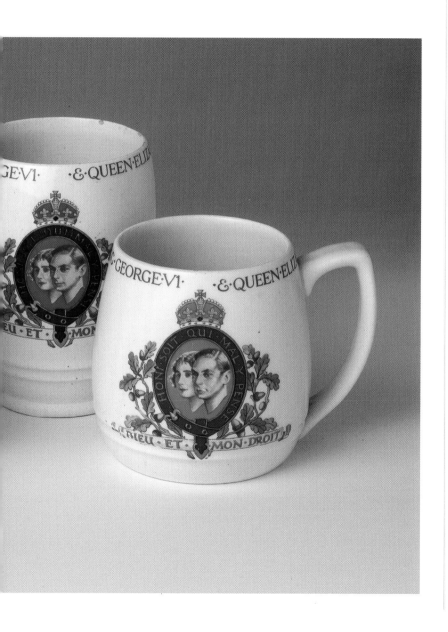

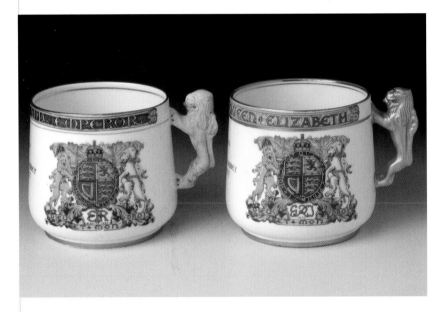

Figs. 8.05 and 8.06

Two very fine bone china mugs decorated with well detailed beautifully coloured polychrome transfers. The gilding is similar on both except that the King George VI mug has a gold band encircling the mug beneath the inscription around the rim, and the lion handle is gilded. As there are no portraits involved, the work required to adapt the King Edward VIII design, (Fig. 8.05), for King George VI was less than that for the design discussed previously. The design on the front of these mugs is of the Royal Coat of Arms with the Royal cypher below the Garter belt. Inscribed immediately below King Edward VIII's cypher is: MAY 12TH 1937, whilst on the King George VI mug only the year is inscribed. The inscription, opposite the handle, is identical on both:

CROWNED IN

WESTMINSTER ABBEY

MAY . 12 . 1937

The design on the reverse of both mugs is identical, Dominion flags around a cartouche framed in laurel leaves with a crown in the centre set against a background of red crosses as found in the Union flag. Beneath this on an ochre scrolled ribbon is:

MAY . 12 . 1937

Around the rim of the King Edward VIII mug the inscription reads: EDWARD VIII KING AND EMPEROR and KNIG GEORGE VI AND QUEEN ELIZABETH is inscribed on the King George VI mug.

MARKS: Apart from the Royal names the backstamps are identical. Beneath the Royal Coat of Arms is:

BY APPOINTMENT

A PERPETUAL SOUVENIR

IN PARAGON CHINA

TO COMMEMORATE THE CORONATION OF

H.M.KING EDWARD VIII

CROWNED WESTMINSTER ABBEY

MAY 12 1937

REGISTERED AND COPYRIGHT

MADE IN ENGLAND

On the King George VI mug in place of H.M.King Edward VIII is:

THEIR MAJESTIES

KING GEORGE VI & QUEEN ELIZABETH

MANUFACTURER: Paragon China (Co) Ltd, Atlas Works, Longton, Staffordshire.

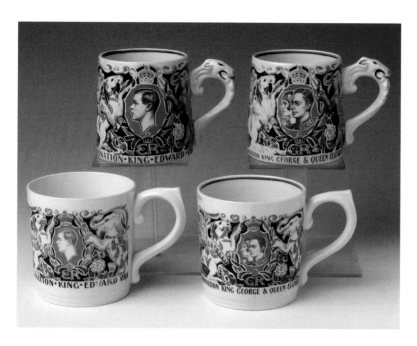

Figs. 8.07 ; 8.08; 8.09 and 8.10

The artist Dame Laura Knight, a member of the Royal Academy, well known for her circus paintings, was commissioned to design and model a range of commemorative mugs for King Edward VIII's coronation. These designs were used by several potteries. Wedgwood used one of the designs for a lidded loving cup. Two of the designs are illustrated above. Figs. 8.07 and 8.08 feature the higher priced mug, each with a hand-painted, lion-head handle. The mug is tapered and the transfer covers the full height of the mug. These two mugs are identical except for the portraits, their cypher and the inscription around the foot of the mug. The inscription on the King Edward VIII mug reads: CORONATION . KING . GEORGE . VIII . whilst on the King George VI mug the inscription, in smaller letters and with no space dots is: CORONATION KING GEORGE & QUEEN ELIZABETH. The designer has used an angled portrait of King George and Queen Elizabeth as there was insufficient room for two silhouette portraits. The design is a refreshing change with orange dominating the colours and an elephant, resplendent in its circus trappings on one side of the design, on the front of the mug, and an armoured St George slaying the dragon on the other side. The Royal Coat of Arms covers the reverse. The date MAY 1937 is inscribed, in orange, at the rim opposite the handle. The pottery that produced both these mugs (Burgess & Leigh (Ltd))hand painted a blue circle around the inside rims.

The other pair of mugs, (Figs. 8.09 and 8.10), are straight-sided, with a simple handle, but with a moulded double-waisted ring at the foot. Although the design is ostensibly identical to the design discussed above, the transfer is smaller and does not fill the whole mug. The inscriptions are the same. However some details of this design are different – particularly the crowns above the portraits and cyphers, and the colouring of the elephant.

Both these designs certainly stand out in any collection of Royal commemoratives and have a unique charm.

MARKS : Printed on the first pair of mugs (8.07 & 8.08), in black, is a black circle containing the appropriate Royal cypher around which, in three lines above the circle is:

R.D. NO. 814375/6

DESIGNED & MODELLED

BY DAME LAURA KNIGHT. D.B.E. R.A.

Below the circle is printed the signature: Laura Knight.

Printed in olive green is the Burleigh Ware beehive mark with B & L Ltd in a band below. Made in England appears below.

The stamp on one of the second pair of mugs, King George VI Fig. 8.10, is identical to that on the lion-head handle mugs. This mug also has a blue band encircling the inside of the rim together with a blue stripe on the handle.

The King Edward VIII commemorative mug, Fig. 8.09, has no manufacturer's mark. There is also no registration number, in its place is:

REGISTRATION APPLIED FOR

MANUFACTURERS: Figs. 8.07, 8.08 and 8.10 Burgess & Leigh (Ltd), Middleport Pottery, Burslem, Staffordshire.

Fig. 8.09 unknown, possibly Johnson Bros. (Hanley) Ltd., Hanley, Staffordshire.

Figs. 8.11 and 8.12

Thomas Goode & Co Ltd, the well-known china retailers of South Audley Street, London, commissioned Royal commemoratives in limited edition from the early years of the 20th century. Founded in 1827 by Mr Thomas Goode the business was first established at 15 Mill Street, Hanover Square, London, W1 and moved to South Audley Street in 1845. One of their selected suppliers was W.T.Copeland (& Sons Ltd), Spode Works, Stoke who produced the two mugs illustrated opposite. These particular mugs were the copyright of Thomas Goode & Co Limited, but were not in limited edition, in fact the base stamp of the King George VI coronation mug confirms that the copyright was held by Herbert Goode, a grandson of Thomas Goode. The two barrel-shaped mugs with moulded lion's-head handles are dimensionally identical, however the decorations are very different. The King Edward VIII mug is printed with a detailed transfer featuring an unusual full-length portrait of the King standing beside a pedestal on which is a lighted Aladin lamp. To the right is a picture of Windsor Castle below which is an industrial scene with smoking chimneys, a smoking pottery kiln and a colliery winding engine. On the left is an illustration of the White Cliffs of Dover with a Naval ship and the recently launched liner – *Queen Mary*. Below these scenes, flanking the King's portrait is a large crowd looking up to the King.

Inscribed around the rim is:

TO COMMEMORATE THE CORONATION OF EDWARD VIII KING EMPEROR MAY 12 1937.

On the reverse in a laurel garland is the Royal cypher.

A line of laurel leaves decorate the handle.

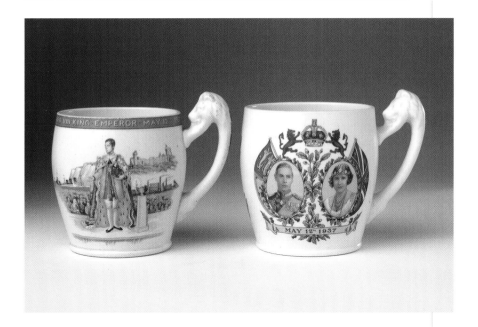

The King George VI mug, as is typical with Royal commemoratives commissioned by
Thomas Goode & Co Ltd, has a most pleasing design featuring sepia portraits of
King George VI and Queen Elizabeth. The portraits are framed by a garland of
acorns, oak leaves and thistles. The Royal Standard and Union Flag are draped at
each side with a design of acorns and oak leaves standing between the two portraits.
At the top is a crown supported by two red lions. A scrolled ribbon beneath the
portraits is inscribed: MAY 12TH 1937. On the reverse is the Royal cypher of Their
Majesties with a scrolled ribbon beneath inscribed:

THE CORONATION.

Opposite the handle is an acorn and oak leaf and a thistle. The handle is decorated,
alternately, by an acorn and thistle.

MARK: Both mugs carry a similar base stamp of a crown at the top with the
inscription:

THOMAS GOODE & CO LTD

LONDON

MADE IN ENGLAND

COPYRIGHT

The King Edward VIII base stamp is printed in black whilst the King George VI
stamp is printed in sepia. Beneath 'copyright' is HERBERT GOODE. At the edge of the
base, on both mugs, is: COPELAND.

MANUFACTURER: W.T.Copeland (& Sons Ltd), Spode Works, Stoke, Staffordshire.

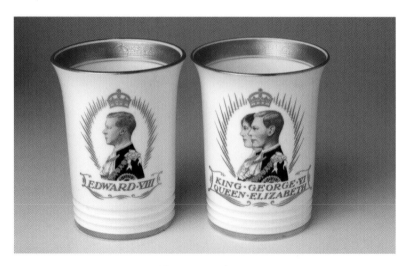

Figs. 8.13 and 8.14

Two very attractive bone china flared beakers, reeded above the foot, which is gilded
as is the rim. The rim interiors are gilded with a broad band etched with a repeating
design of crowns and the year 1937. Both beakers are decorated with printed and
painted quarter-length profile portraits. The gilded frame containing the portraits is
broader on the King George VI beaker to accommodate two profile portraits. It
appears that for the King George VI beaker the same printed body used on the King
Edward VIII beakers has been retained with the addition of the quarter-length
Queen's portrait. The portraits are topped with a gold crown. Beneath the portraits
are the inscriptions on the left hand beaker:

EDWARD . VIII

and on the right-hand beaker:

KING . GEORGE . VI

QUEEN . ELIZABETH

The overall design on the reverse is similar on both beakers with a large gilded
crown surmounting a gilded lobe containing an inscription. However the inscriptions
are succinctly different. On the King Edward VIII beaker the inscription reads: May
12th 1937 whilst on the King George VI beaker is inscribed: Crowned May . 12th
1937. The date inscription on the first beaker is in chocolate brown, not gilded as on
the King George VI beaker. This prompts the thought that the King Edward VIII
beaker may have been completed for distribution to the staff at Minton after the
announcement of the abdication. This theory is supported by the high number of the
beaker, 1201, in a limited edition of 2000. The insertion of the word 'crowned' in
the inscription on the King George VI beaker gives rise to the thought that it is likely
to have been completed after the coronation. The issue number of the King George
VI beaker is 853.

MARK: The base stamp, printed in gold, is the same on both beakers and has at the
top the new version of the traditional globe mark with MINTONS printed on the band
across the centre of the globe, in a wreath, with ENGLAND beneath EST. 1793. Below
this is printed, in script
'This Beaker is limited to an issue of 2000 of which this is No. '.
MANUFACTURER: Minton, Stoke on Trent, Staffordshire.

The potteries who chose the 'minimal changes' route utilised the same pots already produced for King Edward VIII's coronation and adapted the existing transfers. As two heads had to be accommodated in the same space originally designed for one the result was smaller portraits. Many manufacturers turned to The British Pottery Manufacturers' Federation designs for King George VI's coronation as an alternative to undertaking the design work themselves. At the time of the announcement of the King's abdication, Minton of Stoke-on-Trent were engaged in the production of a limited edition of 2,000 very fine flared beakers, (see Fig. 8.13). Production was immediately halted and all unsold completed pieces were given to the staff. They were far too good to be broken up. Minton's problems were further compounded as they had also contracted to produce a limited edition of 2,000 for the New York City retailer William H.Plummer & Co Ltd, the Thomas Goode of New York. Minton elected to take the 'minimal changes' route. See Fig. 8.14 for their King George VI limited edition beaker. William H.Plummer received their order for the limited edition of 2,000 King George VI beakers. The potteries were now becoming much sharper commercially and were quick to take advantage of a situation. For the visit of King George VI to the United States in 1939 Minton produced a limited edition of 3,000 beakers for William H.Plummer using the same flared beaker as those produced for the Coronation. The front of the beaker carried the identical hand-painted printed transfer. The American Eagle replaced the crown and inscription on the reverse. Scattered gilt stars were also added to the decoration. As can be seen in the Chapters that follow, a number of potteries continue to use existing patterns/moulds to reduce design and production costs.

The mugs and beakers illustrated in this Chapter are from potteries who adopted the 'minimal changes' route. Some used a similar conceptual design but different pot and transfer. The mugs manufactured by the Co-operative Wholesale Society Ltd. at their Windsor Pottery, Longton come into this category, (see Figs. 8.15 and 8.16).

Figs. 8.13A and 8.14A

A handsome pair of fine white bone china mugs with cream coloured handles and cream reeded waisted foot. Each has a barley motif running around the base of the mug above which are the names of the countries forming the British Empire. The flared rim is gilded with a heavy band of gold, beneath which is a separate finer band. In these respects both mugs are identical. However the printed polychrome transfers, on both the front and the reverse, are to a different design, as is the striking detail of the handles. The King Edward VIII mug has a gilded script E incorporated into the design of the handle whilst a gilded script G is in the handle of the King George VI mug. Royal Doulton who produced both these mugs, used exactly the same pot, complete with handle, to commemorate the coronation of Queen Elizabeth II. The decoration was the same as that used on the Queen's coronation beaker illustrated in Fig. 10.57.

MARK: Printed in sepia is a lion standing on a crown above 'Royal Doulton' with the Doulton device below. On each side is a green laurel branch. Below this is the inscription:

CORONATION

12TH MAY 1937

REG. NO. 612549

NOTE: The registered number on both the mugs is the same, indicating that the overall design was registered, not the decoration.

MANUFACTURER: Royal Doulton & Co (Ltd), Nile Street, Burslem, Staffordshire.

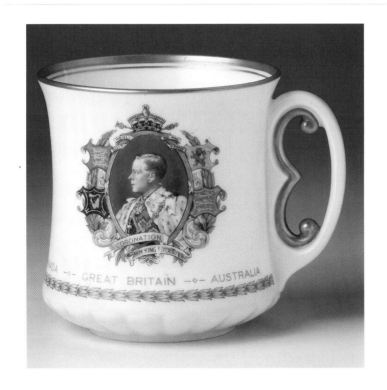

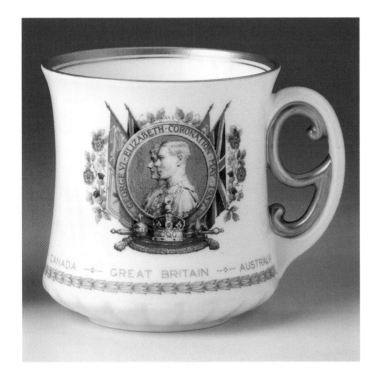

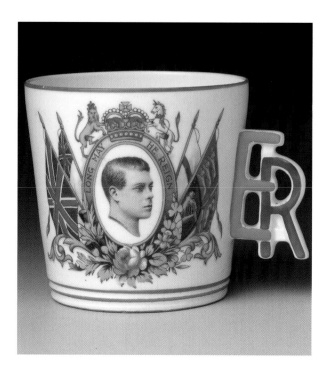

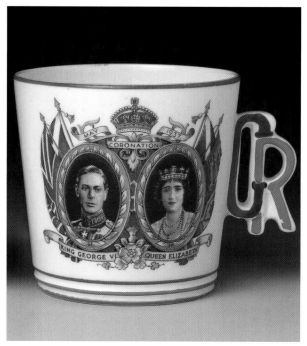

Figs. 8.15 and 8.16

The eight King George VI coronation mugs and beakers featured so far in this Chapter were produced by potteries who adapted their original designs for the coronation of King Edward VIII, to meet the new requirement, in order to save both time and money and have their wares in the marketplace before the competition. The two mugs illustrated here do not follow the 'minimal changes' route so precisely. Although the conceptual design is similar, the physical dimensions of the two mugs shown here are different and the transfer design is very different although the amount of manually applied decoration, the rim, foot and handles is the same. However, the pottery also produced the King Edward VIII mug using the smaller pot as employed for the King George VI mug illustrated here and vice versa. The King Edward VIII mug is of the highest quality, the portrait by Van Dyk of London (his signature is on the right in the scroll beneath the Royal Standard) is tastefully set in a most colourful design with the four national plant emblems arranged below the portrait. On the reverse is a design with an inscription:

<div align="center">

CORONATION OF

12TH MAY KING EDWARD VIII 1937

</div>

In contrast the transfer print on the King George VI mug is of a lower standard, reflecting, perhaps, the very short time that was available to complete a relatively complicated product. The transfer printed on the front of this mug was not exclusive to the Co-operative Wholesale Society Ltd., Windsor Pottery, Longton, Staffordshire, the pottery that produced both these mugs, as it was also used by Barker Bros. Ltd., Meir Works, Barker St., Longton, Staffordshire. However on the Barker Bros. mug beneath the transfer, in tiny print, is inscribed : Copyright Van Dyk. On the CWS mug there is no such acknowledgement. This transfer design includes three national plant emblems, the leek/daffodil is missing. On the reverse is the cypher for King George VI.

MARK: Printed in black is a wheatsheaf within which is inscribed:

<div align="center">

C.W.S.

WINDSOR

CHINA

REGD

NO

811377

</div>

The mark and number on each mug is identical.

MANUFACTURER: Co-operative Wholesale Society Ltd., Windsor Pottery, Longton, Staffordshire.

King George VI
1936 – 1952

Born at Sandringham, on 14th December 1895, Prince Albert, Duke of York, the second son of King George V and Queen Mary, married Lady Elizabeth Angela Marguerite Bowes-Lyon, the youngest daughter of Lord and Lady Glamis, later the 14th Earl and Countess of Strathmore and Kinghorne, in Westminster Abbey on 26th April 1923. This was the Abbey's first Royal wedding since that of Richard II in 1382. The Duke and Duchess of York's first child, Princess Elizabeth Alexandra Mary was born at No 17 Bruton Street, Mayfair, the London home of the Earl and Countess of Strathmore and Kinghorne on 21st April 1926. Their second child, Princess Margaret Rose was born in Scotland at Glamis Castle, the Duchess of York's family seat, on 21st August 1930.

The Duke of York became heir to the throne on the accession of his elder brother, Edward, Prince of Wales on 28th January 1936. King Edward VIII's abdication on 10th December 1936 resulted in Prince Albert, Duke of York acceding to the throne. The Prince, christened Albert Frederick Arthur George, elected to use his fourth christian name for his Coronation to confirm continuity of the monarchy following the upset caused by the abdication of King Edward VIII. The date of the coronation was retained as 12th May 1937. The previous Chapter discusses the dilemma that faced the potteries and the decision some of them made to adapt King Edward VIII designs for the Coronation of King George VI. This Chapter concentrates on mugs and beakers produced to a new design. However, some potteries used the same moulds but with a change of handle. The Copeland barrel shaped mug, (see Fig. 9.05), utilises the same pot as the two Copeland mugs described on page 125 but a plain handle replaces the lion's-head handle. Some designs featured the King and Queen with their daughters in the same portrait. The Marcus Adams portrait proved particularly popular whilst others included a separate picture of the two Princesses, either on the reverse or occasionally on the front. Examples of all these designs appear in the following pages.

OPPOSITE

The reverse of the flamboyantly decorated Shelley loving cup commemorating the coronation of King George VI and Queen Elizabeth, the front of which is illustrated on the title page. The public of the day responded strongly to designs which included portraits of Princess Elizabeth and Princess Margaret. This photographic portrait is by Marcus Adams. The design of this loving cup is most striking and still stands out today just as it did when published in 1937.

Fig. 9.01

On the reverse of a
King George VI
Coronation one pint
mug is this portrait of
the Heir Apparent,
Princess Elizabeth.

Some designs included a separate picture of the 10 year old Princess Elizabeth as the heir apparent, (see Fig. 9.01). In Fig. 9.02 Princess Elizabeth is looking at a display of Royal commemoratives produced by the Royal Doulton pottery. This display includes a 1937 beaker commemorating her title as Princess Elizabeth of York. Six years before this beaker was produced in 1931, the Duchess of York visited Royal Doulton's Nile Street pottery in Burslem.

The potteries who opted for new designs ran the risk of getting their wares to market after most people had made their purchases from the mugs and beakers produced by adapting the King Edward VIII designs and even after coronation day. Unfortunately this was often the case and many potteries were left with unsold items. These were sold at reduced prices despite the fact that some of the designs were attractive and more interesting than those that reached the marketplace earlier. This was indeed a difficult time for the many potteries who banked on Royal commemoratives to boost their bottom lines.

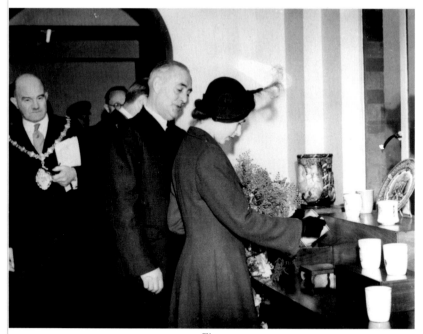

Fig. 9.02

For Princess Elizabeth's visit to the Burslem pottery of Royal Doulton in 1949 a number of Royal commemoratives, manufactured by the pottery, were displayed. In this picture Princess Elizabeth is seen admiring one of the items.

Although the potteries were still recovering from the effects of the Second World War, a number of ceramic commemoratives were produced to celebrate the wedding of Princess Elizabeth and Lieutenant Philip Mountbatten (born 10th June 1921) in Westminster Abbey on 20th November 1947, both of whom were great-great-grandchildren of Queen Victoria. At the time of the marriage the title HRH Prince Philip, Duke of Edinburgh was conferred. On 26th April 1948 King George VI and Queen Mary celebrated their Silver Wedding. Their first grandchild, Charles Philip Arthur George was born on 14th November 1948. The Prince of Wales, with George as one of his four christian names, has an option open to him to take a similar decision, on his accession, to that of his grandfather. Perhaps George VII? His sister, Anne Elizabeth Alice Louise, was born on 15th August 1950.

King George VI died on 6th February 1952 at Sandringham aged 57. His widow chose to be known, henceforth, as Queen Elizabeth The Queen Mother.

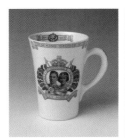

Figs. 9.03 and 9.04

A flared tapered white porcelain tankard printed in sepia featuring a portrait of King George VI and Queen Elizabeth, copyright Vandyk, framed in a Garter belt and flanked by red, white and blue banners. A crown surmounts the portraits.On the front, at the rim, in an ochre scrolled ribbon is inscribed: H.M.KING GEORGE VI. On the reverse is a portrait of Princess Elizabeth and Princess Margaret set in a laurel frame topped by a crown. Beneath the portrait in very tiny letters is: COPYRT. MARCUS ADAMS and below this in an ochre scrolled ribbon, is inscribed:

THE ROYAL

PRINCESSES

At the rim, in an ochre coloured scrolled ribbon is the inscription: H.M.QUEEN ELIZABETH. On the inside of the reverse rim is a scroll bearing the King's cypher with MAY on one side and 1937 on the other.

The handle is decorated with a tudor rose.

MARK: Printed in grey, inside a lozenge is 'Shelley' with ENGLAND below.

MANUFACTURER: Shelley Potteries Ltd., Longton, Staffordshire.

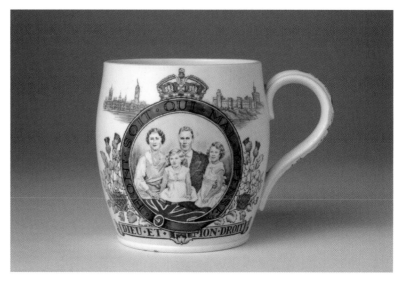

Fig. 9.05

The much acclaimed Marcus Adams sepia portrait of King George VI, Queen
Elizabeth, Princess Elizabeth and Princess Margaret dominates this delightful barrel-
shaped earthenware mug with handle decorated with the four national plants.
Superimposed on the portrait at the bottom is a hand-painted section of the Union
flag. Framed in a Garter belt and topped with a crown this most pleasing uncluttered
design includes a picture of Windsor Castle and the Houses of Parliament at each
side of the crown, with the four national plants arranged each side of the portrait.
On the reverse is a crown above a shield with plant emblems at the base of the
shield. The shield is inscribed:

TO COMMEMORATE

the

CORONATION

of

KING GEORGE VI

and

QUEEN ELIZABETH

MAY 12TH

1937

MARK: Printed in sepia is a crown, below which is Their Majesties' cypher. Below
this is: COPELAND above the Spode mark with ENGLAND below. Beneath this is:
PORTRAITS BY MARCUS ADAMS. An intricate design of scrolled ribbons inscribed with:
CHEDDLETON AND WETLEY ROCKS Presented by BRITTAINS LIMITED appears at the bottom.
MANUFACTURER: W.T.Copeland (& Sons Ltd), Spode Works, Stoke, Staffordshire.

NOTE: Brittains Limited were Established in 1854 and Incorporated in 1890.
However, a mill to produce hand-made paper, 'for transfer printing in the local
potteries' started operations on the Cheddleton site in 1797 some forty-one years
after Robert Hancock invented the process of printing onto porcelain. The original
product of these mills 'developed in connection with the local pottery industry' was
'a thin tissue paper used for the transfer of the decorated design from engraved
copper plates to china and earthenware'. In1895 a 'duplex lithographic transfer
paper' was introduced for polychrome designs replacing hand painting with coloured

enamels on the monochrome printed porcelain. In 1932 the Cheddleton Paper Mills employed over four hundred people from the Cheddleton and Wetley Rocks area and it is likely that Brittains Limited presented these coronation mugs to their employees and the schoolchildren of Cheddleton and Wetley Rocks. The above quotations are taken from a paper issued by Brittains Limited in February 1932.

Fig. 9.05A is a copy of the first page of this paper.

Fig. 9.05A

A copy of the front page of the paper issued by Brittains Limited found in the archives of Newcastle-under- Lyme library.

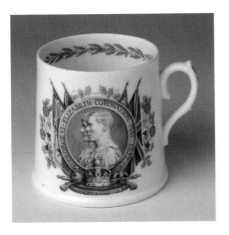
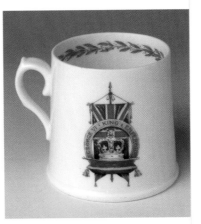

Figs. 9.06 and 9.07

A fine white bone china tapered mug with laurel leaf decoration inside the rim and on the handle. An exquisite quarter-length profile signed portrait, on a blue grey background, by J.Maratina is the centrepiece of this mug's design. (Incidentally Royal Doulton also used this portrait on their pink-ground beaker commemorating King George's coronation.) The portrait is set in a Garter belt around which is inscribed:

GEORGE VI - ELIZABETH . CORONATION . MAY . 1937. Beneath the portrait is the Imperial crown, orb and sceptres, at each side are the Royal Standard and Union flag around which is an arrangement of three National plant emblems – Wales is not represented. On the reverse is a crown and sceptre set against a draped Union flag. Around the crown, in a Garter belt is the inscription: GEORGE VI . KING & EMPEROR.

MARK: A standing brown lion on a yellow crown. Beneath this, printed in sepia is 'Made in England' above 'Royal Doulton, England' surrounding the traditional Doulton device. The mark is flanked by sprigs of green laurel, beneath which is printed:

CORONATION

12TH MAY 1937

MANUFACTURER: Royal Doulton & Co (Ltd). Burslem, Staffordshire.

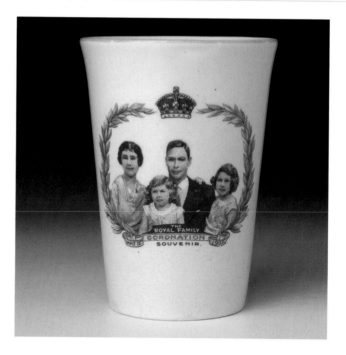

Fig. 9.08

A tapered flared beaker with yellow painted rim featuring a Marcus Adams family portrait. The portrait is framed in a garland of yellow laurel with a crown at the top. A golden scrolled ribbon runs along the bottom of the portrait bearing the inscription:

MAY 12 CORONATION 1937

Above this is the inscription:

THE

ROYAL FAMILY

and below:

SOUVENIR

On the reverse, beneath a crown flanked by a lion and unicorn, is the inscription:

THE

ROYAL FAMILY

THEIR MAJESTIES

KING QUEEN

GEORGE VI ELIZABETH

THE

PRINCESS ELIZABETH

AND

PRINCESS MARGARET

ROSE

Beneath this, in a scrolled ribbon, is the inscription:

MAY 12TH CORONATION SOUVENIR 1937

MARK: Printed in black is 'Woods Ivory Ware' above a crown, below which is 'England'.

MANUFACTURER: Wood & Son(s) (Ltd), Trent and New Wharf Potteries, Burslem, Staffordshire.

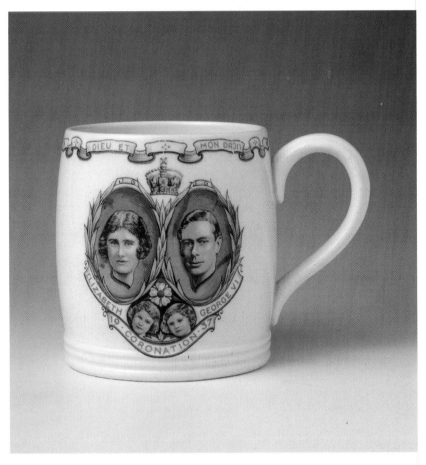

Fig. 9.09

A white barrel-shaped mug with three rings at the foot. 'Cut out' portraits of Queen
Elizabeth, King George VI, Princess Elizabeth and Princess Margaret Rose are
featured on this mug. The background around each of the portraits and the scrolled
ribbons at the rim on the front and reverse have been hand painted with a blue
enamel. The portraits of the King and the Queen are framed in pink garlands with a
crown at the top centre. A Tudor rose crowns the separate portraits of the Princesses.
Beneath the portraits are the inscriptions:

ELIZABETH GEORGE VI

19 . CORONATION . 37

On the reverse, topped by a crown, is the cypher of Their Majesties.

MARK: Printed in black is a large triangle, the top two-thirds of which contains a
unicorn against a blue background. In the remaining third are the words:

WEDGWOOD & CO LTD

ENGLAND

There is also a hand-painted mark in blue of an 'N' of the paintress who decorated
this mug.

MANUFACTURER: Wedgwood & Co. (Ltd), Unicorn and Pinnox Works, Tunstall,
Staffordshire.

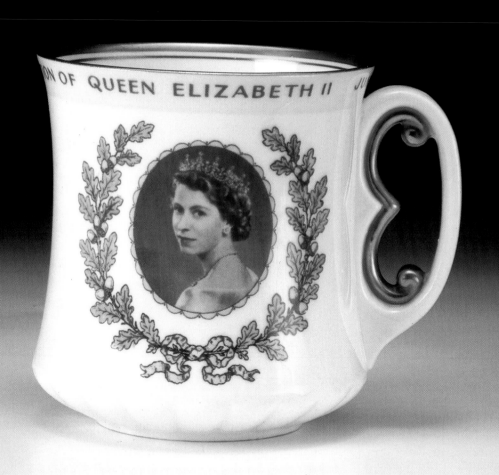

Queen Elizabeth II
1952 –

On the death of King George VI, Princess Elizabeth succeeded to the throne on 6th February 1952. The pottery industry was still recovering from the effects of the Second World War when the date for the coronation was announced as 2nd June 1953. Although a number of potteries geared up for Queen Elizabeth II's Coronation it was not until the Queen's Silver Jubilee that the past enthusiasm to produce Royal commemorative mugs and beakers really returned. Detailed descriptions of some of the mugs and beakers produced to commemorate these two events can be found on pages 178 to 191. Since the Silver Jubilee in 1977 there have been many Royal occasions all of which have been commemorated by mugs and beakers. Many of these have been limited editions, particularly Royal birthdays which have been well commemorated. Examples of many of the commemoratives celebrating these events are featured in this Chapter.

Princess Margaret Rose, the Queen's sister, married Antony Armstrong-Jones, thereafter 1st Earl of Snowdon, on 6th May 1960. They had two children, Lady Sarah Armstrong-Jones and David, Viscount Linley. Also in 1960, on 19th February a third child, a son, was born to Queen Elizabeth II and Prince Philip, Duke of Edinburgh. He was christened Andrew. On 19th March 1964 Edward, the fourth child of Queen Elizabeth II and Prince Philip, was born.

Prince Charles was created the Duke of Cornwall at the time of the Queen's accession and she conferred upon him the title of Prince of Wales and Earl of Chester on 26th July 1958 although the investiture, at Caernarvon Castle, was not held until the 1st July 1969 when he was in his twenty-first year. Coincidentally he is the twenty-first Prince of Wales. Figs. 10.01 and 10.02 illustrate two examples of the numerous mugs and beakers produced to commemorate the investiture. The designs are very different – the Aynsley mug (Fig. 10.01) has a traditional design whilst that designed by Marianne Zara and Kenneth Wright (Fig. 10.02) for Lord Nelson

OPPOSITE

The Royal Doulton mug commemorating Queen Elizabeth II's coronation. The pot is exactly the same as that used for King Edward VIII's coronation (see Fig. 8.13A)

Fig. 10.01

Illustrated here is an Aynsley fine bone china tapered investiture mug, with waisted foot and gilding at the rim and foot, with the Prince of Wales' Coat of Arms filling the front. The colouring and spacing give a delicacy which is missing in the similar design used on the Aynsley mug commemorating the marriage of the Prince of Wales and Lady Diana Spencer, (see Fig. 10.17). On the reverse is a listing, with dates, of all the twenty-one Princes of Wales. The scroll work around the names includes daffodils, with the badge of the Heir Apparent (triple plume of ostrich feathers) at the top. Inside the rim on a dark blue ribbon is inscribed:

TO
COMMEMORATE
THE INVESTITURE
OF HRH THE
PRINCE OF WALES
1969.

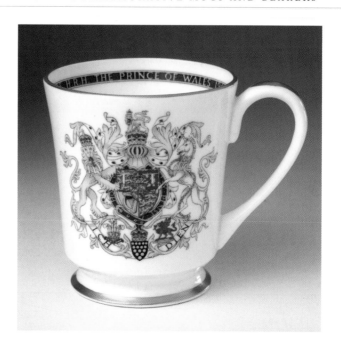

Pottery (Elijah Cotton (Ltd)) is modern with a striking red dragon wrapping itself around the mug. The Royal Worcester pottery were commissioned by Howell's of Cardiff to produce a porcelain mug in a limited edition of 500. An additional 150 mugs were made and presented to the employees of Royal Worcester Industrial Ceramics Ltd at Tonyrefail. The previous Royal commemorative mugs produced in Worcester were made in the period 1758 to 1762. Three mugs were produced, decorated with portraits of King George II, King George III and Queen Charlotte – the latter two coronation mugs are illustrated in Fig. 1.08. The decoration, in either black or mauve, was applied by the process of printing onto porcelain invented by Robert Hancock in 1756 whilst he worked for Worcester's main pottery which was owned by Dr John Wall and fourteen other partners. Worcester Royal Porcelain Company received its first Royal Warrant in 1789 from King George III and was similarly honoured in 1809 by the then Prince of Wales. Since then it has held the Royal Warrant in every reign.

The twenty-fifth wedding anniversary of Queen Elizabeth II and Prince Philip on 20th November 1972 was commemorated by Aynsley with a fine bone china mug bearing a splendid picture of Westminster Abbey, see Fig. 10.03. Wedgwood commemorated the twenty-fifth wedding anniversary with Professor Richard Guyatt's

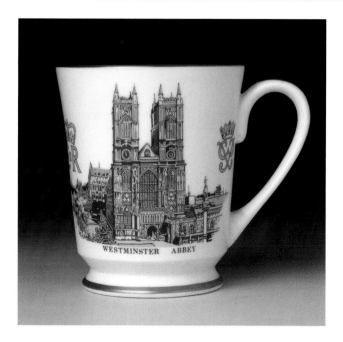

Fig. 10.03

A fine picture of Westminster Abbey, London, dominates this Aynsley mug commemorating the twenty-fifth wedding anniversary of Queen Elizabeth II and Prince Philip on 20th November 1972.

Fig. 10.02

A white earthenware investiture mug with a strikingly resplendent dragon wrapped around the mug. Inscribed on the mug is: CAERNARVON 1969. This mug would have appealed to the commemorative collectors wanting to see a break from the traditional designs which had predominated since the Jubilees of Queen Victoria.

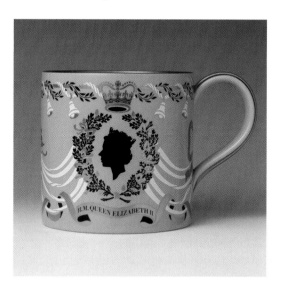

Fig. 10.04

The Wedgwood large fine earthenware mug, designed by Professor Richard Guyatt commemorating the twenty-fifth wedding anniversary of Queen Elizabeth II and Prince Philip on 20th November 1972. The inside of the rim is decorated with a platinum band.

Fig. 10.05

Professor Richard Guyatt's Wedgwood mugs commemorating the weddings of: Princess Anne and Captain Mark Phillips at Westminster Abbey on 14th November 1973; Charles, Prince of Wales and Lady Diana Spencer at St Paul's Cathedral on 29th July 1981 and Prince Andrew and Miss Sarah Ferguson at Westminster Abbey on 23rd July 1986. The mugs celebrating the weddings of Charles, Prince of Wales and Lady Diana Spencer and Prince Andrew and Miss Sarah Ferguson were produced in limited editions – 1500 and 750 respectively. The mugs illustrated here are numbers 1235 and 10.

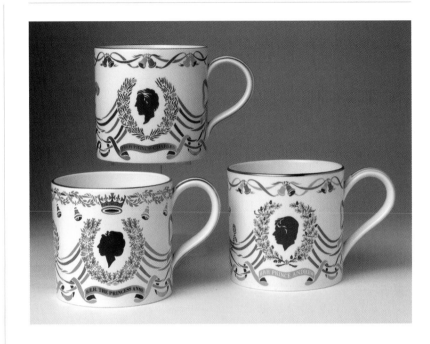

design on Wedgwood's large fine earthenware mug, (see Fig. 10.04). Wedgwood first produced this large mug for the Eric Ravilious design commemorating the coronation of King Edward VIII. An adaptation was produced to commemorate the coronation of Queen Elizabeth II. Wedgwood also published a Professor Richard Guyatt design (his first for Wedgwood) on this large mug to celebrate Queen Elizabeth II's coronation, (see Fig. 10.55).

The wedding of Princess Anne and Captain Mark Phillips on 14th November 1973 at Westminster Abbey was commemorated by Wedgwood with a Professor Richard Guyatt design on the same theme as that used for the twenty-fifth wedding anniversary of Queen Elizabeth and Prince Phillip. Fig. 10.05 shows this mug, together with mugs of a similar design, commemorating the weddings of Charles, Prince of Wales and Lady Diana Spencer in 1981 and Prince Andrew and Miss Sarah Ferguson in 1986.

On the 6th February 1977 Queen Elizabeth II completed the twenty-fifth year of her reign, the Queen's Silver Jubilee, therefore, was actually celebrated in the twenty-sixth year of the Queen's reign. On 24th April 1977 Charles, Prince of Wales, launched The Queen's Silver Jubilee Appeal. A special emblem, (see Fig. 10.06), was designed for application to all items manufactured by companies financially supporting The Queen's Silver Jubilee Appeal.

Although the economy was depressed the potteries went into overdrive. All the traditional potteries, plus a number of potteries who previously had not produced Royal commemoratives, published commemoratives both for Queen Elizabeth's Silver Jubilee and for the twenty-fifth anniversary of the Coronation on 2nd June 1978. Figs. 10.07 to 10.13 illustrate commemoratives published to celebrate the twenty-fifth anniversary of the Queen's coronation. Without exception all seven designs are refreshingly different from the more traditional designs produced for both the Coronation and the Silver Jubilee. One of the potteries new to the Royal commemorative scene was Portmeirion Potteries Ltd., Stoke on Trent, world famous for 'The Botanic Garden' oven-to-table ware designed by Susan Williams-Ellis. They produced Silver Jubilee tankards in a number of different designs. Royal Worcester, too, produced an unlimited edition porcelain mug for the Queen's Silver Jubilee and have produced mugs to commemorate four further Royal events: the wedding of Charles, Prince of Wales and Lady Diana Spencer, (see Fig. 10.18); the birth of Prince William, (see Fig. 10.29); the wedding of Prince Andrew and Miss Sarah

Fig. 10.06

The Queen's Silver Jubilee Appeal emblem which indicated that the company utilising the emblem on their products was financially supporting the Appeal. This emblem is on the reverse of a white ironstone one pint tankard (see Fig. 10.67) produced by Wood & Sons Ltd, Burslem, Staffordshire. The emblem was also incorporated in the base stamp on this particular item.

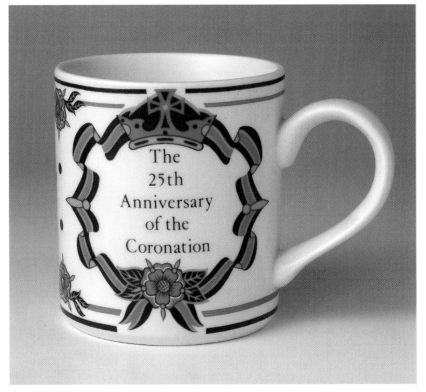

Fig. 10.07

A simply designed William Adams 'Real English Ironstone' mug. The panel on the reverse is inscribed: 'of Her Majesty Queen Elizabeth II'. The orange and blue colour theme is unusual.

145

Fig. 10.08

The Paragon loving cup with gilded lion handles commemorating the twenty-fifth
anniversary of the coronation of Queen Elizabeth II. This design includes all four
national plant emblems. The decoration on the reverse includes a picture of the
coronation coach. Inside the rim is the inscription:

MY . LIFE . DEVOTED . TO YOUR. SERVICE..

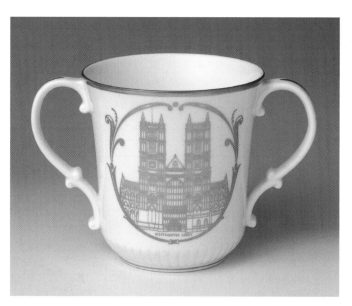

Fig. 10.09

A very fine Royal Doulton white bone china loving cup with fluted waisted foot.
The design, inscriptions and backstamp are all in gold with Westminster Abbey
featured in the front panel. On the reverse is inscribed: THE 25TH ANNIVERSARY OF THE
CORONATION OF HER MAJESTY QUEEN ELIZABETH II
2ND JUNE 1978

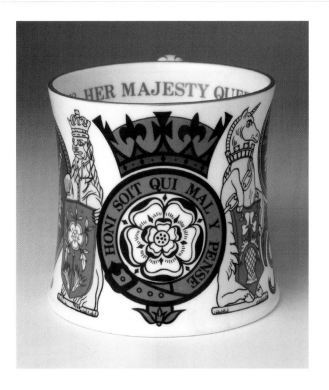

Fig. 10.10

An unusual design and colour make this beautifully crafted waisted mug by Coalport stand out from many others. Illustrated here is the panel opposite the handle. The gilded inscription, inside the rim, reads:
HER MAJESTY QUEEN ELIZABETH II CORONATION 1953 . 1978

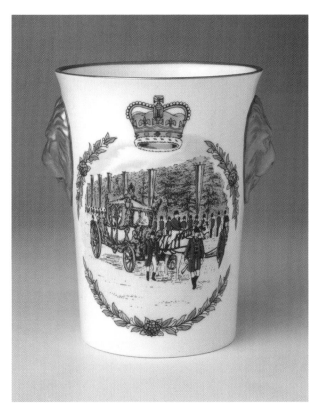

Fig. 10.11

A limited edition lion head beaker by Caverswall. This is number 1170. The picture on the front is the Coronation coach going down the Mall. On the reverse is the inscription:
TO CELEBRATE THE 25TH ANNIVERSARY OF HER MAJESTY QUEEN ELIZABETH II'S CORONATION 1953 – 1978.

147

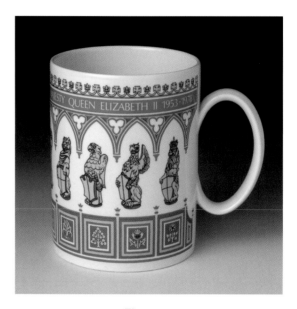

Fig. 10.12

A Wedgwood Queens Ware tankard featuring the Queen's beasts.
Below, in a repeating design are the four national plant emblems – Wales is
represented by a leek. The inscription around the top reads:
SILVER JUBILEE OF THE CORONATION OF HER MAJESTY QUEEN ELIZABETH II 1953 – 1978

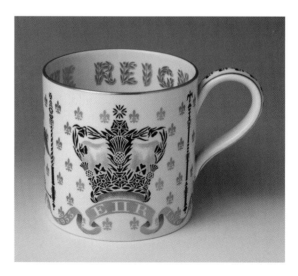

Fig. 10.13

The large Wedgwood fine earthenware mug, in cream, with gold and blue decoration
by Professor Richard Guyatt. Around the inside of the rim, in large letters, is the
inscription: LONG MAY SHE REIGN. Issued in an edition of 5000. Incorporated in the
base stamp is: TO COMMEMORATE THE 25TH ANNIVERSARY OF THE CORONATION OF HER
MAJESTY QUEEN ELIZABETH II . 1953 – 1978.

Fig. 10.14

A humorous mug published by Carlton Ware Ltd, Carlton Works, Stoke on Trent to commemorate the engagement of Charles, Prince of Wales to Lady Diana Spencer on 24th February 1981. Inscribed on the reverse is: 'Whatever beverage brims in this cup Thank God for PRINCE CHARLES when you pick it up, And as you quaff it, bless that same grand Planner Who gave him for a bride the fair DIANA.'

Ferguson and the 50th Wedding Anniversary of Queen Elizabeth II and the Duke of Edinburgh. Commissions were also undertaken, (see Fig. 10.39 -1). The year 1977 marked another milestone in the long and distinguished life of Queen Elizabeth The Queen Mother, this was the birth of her first great-grandchild, Peter, to Princess Anne.

The announcement of the engagement, (see Fig. 10.14), of Charles, Prince of Wales to Lady Diana Frances Spencer on the 24th February 1981 and subsequently the arrangements for their wedding, to be held in St Paul's Cathedral on 29th July 1981, gave the potteries a real boost at a time when the country was in recession, with many potteries working a reduced number of hours. Almost overnight the china industry was booming with myriads of mugs and beakers being produced to suit all pockets and tastes. There were limited editions and high-class pieces available from the traditional manufacturers down to 75 pence (new pence) mugs at the local supermarkets. Some of the Royal commemoratives produced to meet the burgeoning interest of the mass market were made 'dishwasher safe' – clearly these would journey no further

Fig. 10.15

Four mugs, all 'Made In England', produced to commemorate the wedding of Charles, Prince of Wales and Lady Diana Spencer. The right-hand one carries a manufacturer's back stamp in addition to an impressed MADE IN ENGLAND. The registered trade mark is KILN CRAFT tableware. Around this is the inscription: 'Staffordshire Potteries Limited Dishwasher Safe English Ironstone'.

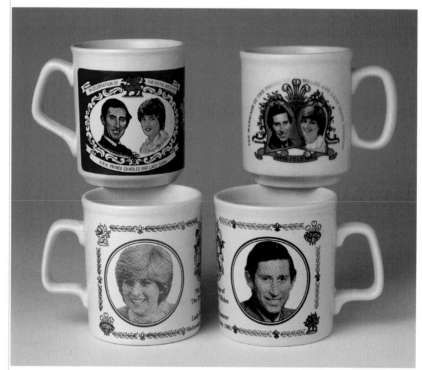

than the kitchen and never reach pride of place next to the clock on the mantelpiece! (See Fig. 10.15). The variety too was greater than for any previous Royal occasion. An article titled '66 mugs to raise' in the *Sunday Times* magazine issued on 21st June 1981 featured sixty six mugs and beakers published to commemorate the Royal wedding. The same magazine published a photograph of 1017 souvenirs produced to commemorate this wedding. The public interest was considerable. FIGS 10.16 to 10.22 illustrate examples of mugs and beakers produced by potteries, of long standing, for this happy occasion.

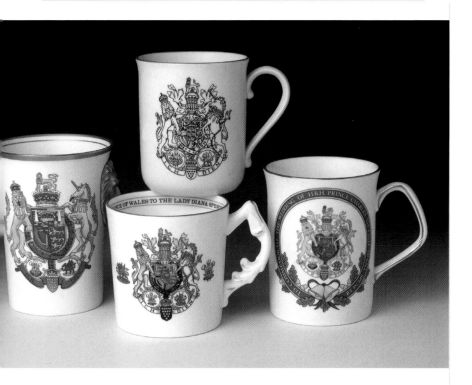

Figs. 10.16 to 10.19

Two mugs, one tankard and one beaker all commemorating the wedding of Charles,
Prince of Wales and Lady Diana Spencer at St Paul's Cathedral on 29th July 1981.
On the front of each of these commemoratives is the Coat of Arms of the Prince of
Wales. 10.16:- This fine hand finished Caverswall Lion Head beaker is number 64 in
a limited edition of 250. On the reverse is a picture of Caernarvon Castle below,
which, in a garland of red roses, are two bells hanging from a blue ribbon bow above
two white doves. Item 10.17 was produced by Aynsley. On the reverse are the family
trees of the 21st Prince of Wales and Lady Diana Frances Spencer. 10.18 is a Royal
Worcester fine white porcelain mug with a monochrome printed transfer in mauve.
On the reverse is a picture of St Paul's Cathedral across which is a scrolled ribbon
bearing the inscription: 'H.R.H Prince Charles 29th July 1981 Lady Diana Spencer'.
10.19: Ringtons Limited, the tea suppliers based in Newcastle-upon-Tyne
commissioned this fine tankard from Taylor & Kent (Ltd), Florence Works, Longton.
The base stamp specifies this pottery's trade name, Elizabethan, which has been in
use since 1961. Inscribed around the Coat of Arms is:

TO COMMEMORATE THE WEDDING

OF H.R.H. PRINCE CHARLES

TO LADY DIANA SPENCER.

Fig. 10.20

A Royal Doulton bone china beaker with sepia printed transfer. Inscribed on a ribbon above the portraits is: A PRINCESS FOR WALES. The base stamp carries the inscription:

TO CELEBRATE THE MARRIAGE OF THE PRINCE OF WALES AND LADY DIANA SPENCER.

Fig. 10.21

A delightful mug featuring a photograph taken at the announcement of the engagement of Charles, Prince of Wales to Lady Diana Spencer. On the reverse of this W.T.Copeland (and Sons Ltd) mug is the inscription: TO CELEBRATE THE WEDDING OF HIS ROYAL HIGHNESS CHARLES, PRINCE OF WALES TO THE LADY DIANA SPENCER. ST PAUL'S CATHEDRAL 29TH OF JULY 1981.

The printed mark on the base is: SPODE ENGLAND.

Fig. 10.22

(front and reverse) A Wedgwood Queens Ware tankard designed by Carl Toms with Lord Snowdon, in an edition limited to 5000. An unusual green-blue colour scheme has an attraction of its own. The Badge of the Heir Apparent (the triple plume of ostrich feathers) is on the front in a frame of acorns, oak leaves and thistles. On the reverse is a beautifully designed intertwined C and D framed by tudor roses and leak leaves. Opposite the handle is inscribed: 'July 1981'. The backstamp includes the inscription: IN CELEBRATION OF THE WEDDING OF H.R.H. THE PRINCE OF WALES AND THE LADY DIANA SPENCER.

On 21st June 1982 their first child, Prince William Arthur Philip Louis of Wales, was born to Charles, Prince of Wales and Princess Diana, (see Figs. 10.23, 10.24 and 10.25). On 15th September 1984, Prince Henry Charles Albert David, their second child, was born, (see Figs. 10.26 and 10.27). These five commemoratives, each bearing the Princes' names, are only a few of those that were produced to celebrate these two very happy occasions. Some potteries, to hit the market first, did not wait until the names had been announced and referred simply to 'The first born' and 'The second born', see Figs. 10.28. Some potteries incorporated the name in the base stamp. Royal Worcester's commemorative for the birth of Prince William, (see Figs. 10.29 and 10.30) was one such commemorative. Prince William's 18th birthday on 21st June 2000 was commemorated by a Lion Head beaker, in a limited edition of 950, (see Fig. 10.31). A number of other commemoratives were also produced to mark this important birthday in the life of a future King, including a limited edition commissioned by the Commemorative Collectors Society. Govier's of Sidmouth commissioned a Loving Cup from Royal Crown Derby in commemoration of Prince William's 18th birthday. The design by June Branscombe was not released for manufacture until the day of his birthday, 21st June 2000, in order that any title bestowed upon him by the Queen could be included in the inscription on the reverse. In the event no such title was bestowed. The design of this loving cup, (see Fig. 10.31A), features Prince William's Coronet interwoven with a 'W'. The Coronet is that for a grandson of the Sovereign and issue of a son in direct line. The design is similar to that selected for the Royal Crown Derby loving cups published to commemorate the investiture of the Prince of Wales in 1969 and the 25th anniversary of the investiture, hence the dragons on the broad gold base. On the occasion of Prince William's 18th birthday, 21st June 2000, Queen Elizabeth II hosted a family party to mark the 100th birthday of Queen Elizabeth, the Queen Mother; the 70th birthday of Princess Margaret; the 50th birthday of Princess Anne the Princess Royal (all born in August) and the 40th birthday of the Duke of York. Prince William's new Coat of Arms, on his coming of age, was announced on 9th July 2000. No doubt this will be included on a number of Royal commemorative mugs and beakers to be issued in the future. The Arms include a small red scallop shell in the

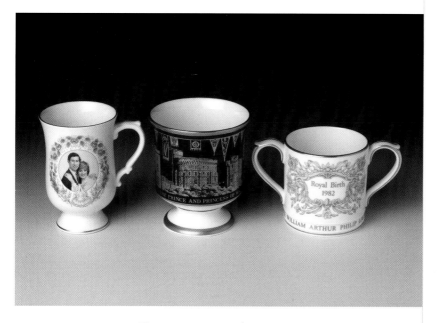

Figs. 10.23, 10.24 and 10.25

Commemorating the birth of 'THE FIRST CHILD TO THE PRINCE AND PRINCESS OF WALES' the designs of the tankard, goblet and loving cup, illustrated here, are impressive. Each carries the name of the Prince, in the case of the goblet it is incorporated in the backstamp.

(10.23) A frame of the four national plant emblems encircles the portrait of the Prince and Princess of Wales with Prince William below in his cot. On the reverse of this Crown Staffordshire Porcelain Co. fine bone china tankard is the inscription: TO COMMEMORATE THE BIRTH OF H.R.H. PRINCE WILLIAM OF WALES ON THE 21 JUNE 1982.

(10.24) This Coalport white bone china goblet, with a slightly flared cylindrical bowl, is decorated in gold on a cobalt blue ground and is of a similar design to the Coalport bone china goblets published to commemorate the Investiture of Prince Charles; the Silver Jubilee of Queen Elizabeth II; the Royal Commonwealth goblet (1977) and the wedding of Charles, Prince of Wales and Lady Diana Spencer. Around the bowl are the Royal residences with banners bearing heraldic devices around the top of the goblet below the heavily burnished rim. TO COMMEMORATE THE BIRTH OF THE FIRST CHILD TO THE PRINCE AND PRINCESS OF WALES is inscribed, in gold, around the bottom of the bowl. The base stamp includes the inscription: TO COMMEMORATE THE BIRTH OF H.R.H. PRINCE WILLIAM OF WALES THE FIRST CHILD BORN TO THEIR ROYAL HIGHNESSES THE PRINCE AND PRINCESS OF WALES 21 JUNE 1982. The goblet illustrated is number 1,274 in a limited edition of 2,000. (10.25) This white Wedgwood bone china loving cup is lavishly gilded and decorated delicately in pastel colours with the same design on both the front and the reverse. In the centre panel, inscribed in gold, is ROYAL BIRTH 1982. Around the base, above the gilded foot, is the inscription: H.R.H. PRINCE WILLIAM ARTHUR LOUIS OF WALES.
The backstamp includes the inscription: TO CELEBRATE THE JOYFUL OCCASION OF THE BIRTH OF THE FIRST CHILD TO THEIR ROYAL HIGHNESSES THE PRINCE AND PRINCESS OF WALES 1982. This is number 818 in a limited edition of 1000.

Figs. 10.26 and
10.27

Two mugs
commemorating the
birth of Prince Henry
Charles Albert David
the second child of
The Prince and
Princess of Wales on
15th September
1984.
(10.26)
A Wedgwood white
bone china mug
designed by Professor
Richard Guyatt in
gold. Wedgwood
produced similar
mugs designed by
Professor Richard
Guyatt to
commemorate the
birth of Prince
William in 1982 and
the birth of Princess
Beatrice in 1988. The
latter mug was in a
limited edition of
2000.
(10.27)
This Caverswall
China Co Ltd. mug
(Edinburgh beaker) is
number 376 in a
limited edition of
1000. The front of
the mug features a
picture of
Caernarvon Castle
within a laurel frame
interwoven with a
blue ribbon and
Tudor roses
surmounted by a
crown. Five national
plant emblems
decorate

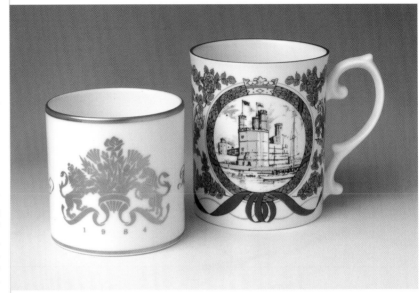

centre of the shield and on the necks of the two supporters, this derives from his mother's family Coat of Arms – the Spencer Coat of Arms. The design of the beaker, issued in 1996 commemorating Diana Princess of Wales, also includes insignia from the Spencer Coat of Arms, see Fig. 10.42).

In 1984 Princess Diana visited the Royal Doulton Burslem pottery, (see Fig. 10.32). This occasion was marked by the production of two pieces from Royal Doulton's 'Bunnykins' nursery ware range. A 'Bunnykins' Royal commemorative was also produced to commemorate the birth of Prince William in 1982, (see Fig. 10.33).

Prince Andrew married Miss Sarah Ferguson on 23rd July 1986 at which time the dukedom of York was conferred on Prince Andrew, (see Fig. 10.34). They had two children, Princess Beatrice born on 8th August 1988 and Princess Eugenie Victoria Helena of York born on 23rd March 1990. The Duke and Duchess of York divorced in 1996.

Mugs and beakers were produced to commemorate the 30th birthday of Diana, Princess of Wales on 1st July 1991. An example is illustrated in Fig. 10.35. This is a commissioned piece in a limited edition of 5000. An increasing number of the Royal family's birthdays are being commemorated, many in limited edition, an indicator of the continuing interest collectors have for Royal ceramic commemoratives. The speed at which these editions are sold out is

CONTINUED

the area around the laurel frame on the front and the reverse. The designer elected to represent Wales by both daffodils and leeks.

Fig. 10.28

A white bone china fluted tapered tankard with flared rim produced by Thomas C.Wild & Sons (Ltd), St Mary's Works, Longton, under their Mark – Royal Albert. A delicate arrangement of the four national plant emblems decorates the front of this attractive commemorative. Within the arrangement is inscribed, in brown, 'CD' (interwoven). Beneath this is 'Firstborn 1982'. On the reverse is the inscription: 'To Celebrate the Birth of the First Child of T.R.H. the Prince and Princess of Wales 1982'.

Figs. 10.29 and 10.30

The front and backstamp of a Royal Worcester fine porcelain mug commemorating the birth of Prince William. The reverse is inscribed: To Celebrate the Birth of the First Child to The Prince and Princess of Wales 1982. The backstamp bears the inscription : H.R.H. PRINCE WILLIAM OF WALES BORN THE TWENTY FIRST OF JUNE 1982

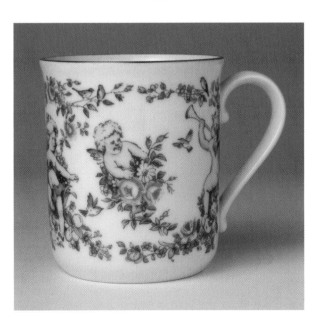

Fig. 10.31

One of the first Royal commemoratives exclusively featuring Prince William. This lion head beaker was commissioned by Peter Jones China in celebration of Prince William's 18th birthday on 21st June 2000. The colour scheme is refreshing and befits the occasion. A recent photographic portrait of Prince William is featured.

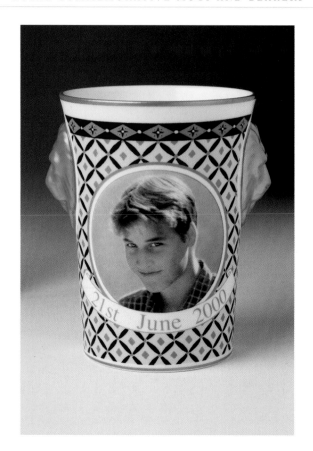

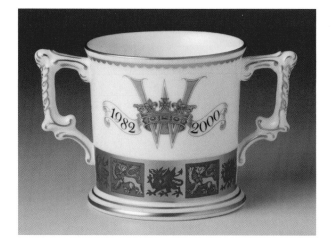

Fig. 10.31A

The Royal Crown Derby loving cup, in a limited edition of 750, commissioned by Govier's of Sidmouth commemorating the 18th birthday of Prince William featuring Prince William's coronet.

Fig. 10.32

H.R.H.Princess Diana receiving the traditional potteries welcome on a visit to Royal Doulton's Nile Street pottery in 1984.

Fig. 10.33

The inscription on the inside of the rim on this loving cup is:

TO CELEBRATE THE BIRTH OF THE FIRST CHILD OF T.R.H. THE PRINCE AND PRINCESS OF WALES . 1982 . This bone china cup is from Royal Doulton's 'Bunnykins' nursery ware range.

Fig. 10.34

The first piece illustrated here is a Coalport fine white bone china waisted mug, in a limited edition of 2500, commemorating the wedding of Prince Andrew and Miss Sarah Ferguson on 23rd July 1986. On the reverse is a family tree depicting the lineage of the bride and bridegroom. The second piece is a white bone china Wedgwood mug decorated in gold featuring silhouette portraits of the Duke and Duchess of York, which is the inscription beneath the portraits. On the reverse is the Duke of York's Coat of Arms. Opposite the handle is the inscription: 'To Celebrate The Conferment of the Dukedom of York on H.R.H. PRINCE ANDREW on the occasion of his wedding to Miss Sarah Ferguson'.

Fig. 10.35

An Aynsley white fine bone china flared mug, with foot, decorated with a photographic portrait of Her Royal Highness The Princess of Wales commemorating her thirtieth birthday. The portrait is surmounted by the badge of the Heir Apparent to the throne. Flowers complete the design on the front. On the reverse, framed in flowers and topped with the badge of the Heir Apparent, is inscribed : 'To Celebrate The 30th Birthday of HRH The Princess of Wales'. This mug was commissioned by Peter Jones China, Wakefield in a limited edition of 5000.

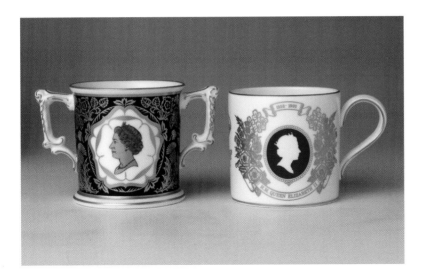

Fig. 10.36

A Royal Crown Derby
loving cup and a
Wedgwood mug
commemorating the
Fortieth Anniversary of
Queen Elizabeth II's
Accession. The loving
cup, in a limited edition
of 1250 (this is number
1003) is similar in
overall design to those
produced to
commemorate previous
Royal occasions, with
the unmistakable Royal
Crown Derby cobalt
blue ground. The
design includes the four
national plant emblems
each boldly displayed.
Inscribed on the reverse
is:
'H.M. QUEEN ELIZABETH II
40 GRACIOUS YEARS
1952 – 1992.' Like the
loving cup the design of
this mug is the same on
the reverse as on the
front except for an
inscription in the
cartouche replacing the
portrait. This design
also incorporates the
four national plant
emblems. The
inscription on the
reverse is:
'40 Years.' Wales is
represented by a leek
on both these pieces.

a further indication that this niche market is buoyant.

In 1992 a number of potteries published mugs and beakers to commemorate the fortieth anniversary of Queen Elizabeth II's accession to the throne, (see Fig. 10.36, 10.37 and 10.38). Previously anniversaries between the Silver Jubilee and the Golden Jubilee had not been commemorated – perhaps this is an example of the potteries entrepreneurship. However, the pieces illustrated are of a very high standard and would certainly do credit to the mantelpiece. The fortieth anniversary of the Coronation was also similarly commemorated.

In 1996 a double event was celebrated – the 70th birthday of Queen Elizabeth II on 21st April and the 75th birthday of Prince Philip, Duke of Edinburgh on the 10th June. A number of mugs and beakers were commissioned to commemorate each of these birthdays, (see Fig. 10.39). The design of both of these commemoratives includes a Royal Coat of Arms as the Lord Chamberlain's office had issued an order approving their use on such items for this particular Royal event, putting it therefore on a par with Coronations, Jubilees and Royal weddings. The 60th birthday of Queen Elizabeth II was also commemorated as was the 70th birthday of Prince Philip, Duke of Edinburgh, (see Fig. 10.40 and 10.41).

Charles, Prince of Wales and H.R.H. Diana, Princess of Wales were divorced in August 1996. As a consequence Princess Diana was no longer entitled to be called 'Her Royal Highness'. A limited

Fig. 10.37

A fine white bone china flared mug, hand decorated by Royal Crown Duchy, Stoke on Trent, with a particularly fine coloured enamel transfer print featuring a formal photographic portrait of Queen Elizabeth II. Beneath the portrait is a scroll, in gold, of Tudor roses. On the inside of the rim at the reverse is a gold portcullis surmounted by a crown. The backstamp includes the inscription : 'Commissioned by The Royal Anniversary Trust to commemorate Her Majesty The Queen's 40th Anniversary 1952 – 1992.' The same portrait was used by Royal Crown Duchy on their commemorative published for the 70th birthday of Queen Elizabeth II.

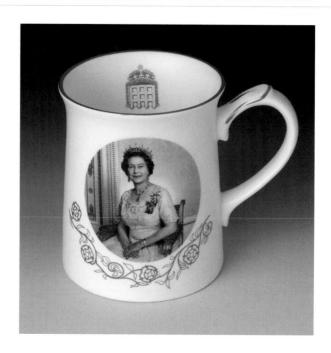

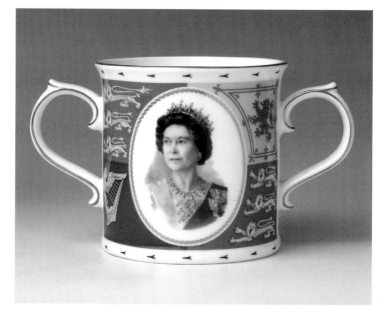

Fig. 10.38

A splendid white fine bone china loving cup produced, in a limited edition of 2500, by Royal Doulton to commemorate the 40th anniversary of Queen Elizabeth II's accession. This is number 1078. Designed by Neil Faulkner, and bearing his signature, each piece has been hand-made and hand-decorated. The design on the reverse is the same as on the front except that in place of the portrait is a garland of oak leaves and acorns around the Queen's cypher topped by a crown.

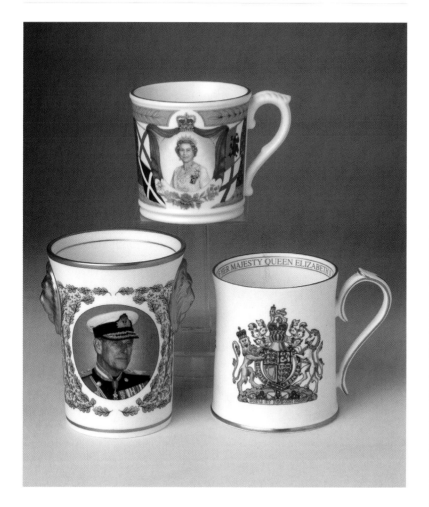

Fig. 10.39

Commemorating the double event of 1996. (1) A Worcester Royal Porcelain white
bone china mug, in a limited edition of 1000, commemorating the 70th birthday of
Queen Elizabeth II. The front features a portrait of Queen Elizabeth II, flanked by
drapes surmounted by a crown with an arrangement of the four national plant
emblems below. (Wales is represented by a daffodil). Draped at the side are the four
national flags. On the reverse the Queen's Coat of Arms replaces the portrait. (2) A
lion head beaker, produced in a limited edition of 500, by Daniel Sutherland & Sons,
Park Hall Street, Longton commemorating the 75th birthday of Prince Philip, Duke
of Edinburgh. The front features a photographic portrait of Prince Philip in Naval
uniform, whilst on the reverse is the Coat of Arms of a Knight of the Garter. This
piece is number 257. Both the mug and the beaker were exclusive commissions by
Peter Jones China, Wakefield. (3) An unlimited edition mug by Aynsley China Ltd of
Stoke-on-Trent, in fine white bone china, features the Royal Coat of Arms on the
front and two verses of the National Anthem, in a floral frame of the four national
flowers on the reverse. On the inside rim, in a gold ribbon, is the inscription:

TO COMMEMORATE THE 70TH BIRTHDAY OF HER MAJESTY QUEEN ELIZABETH II.

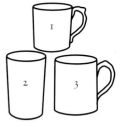

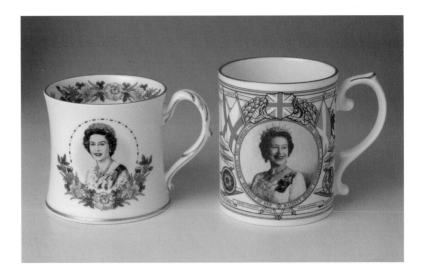

Fig. 10.40

Two mugs commemorating the 60th birthday of Queen Elizabeth II. The Coalport
fine bone china waisted mug on the left features a portrait of the Queen with an
arrangement of the four national flowers below. On the reverse is the inscription:
'To celebrate the 60th birthday of Her Majesty Queen Elizabeth II. April 21st 1986'.

The inside of the rim is very nicely decorated with an arrangement of the four
national flowers, similar to that on the front, running around the rim separated by
two gold crowns. This Caverswall fine bone china mug, designed by Holmes Gray, is
number 489 in a limited edition of 2500. The frame around the photographic
portrait of the Queen on the front is inscribed: TO CELEBRATE THE SIXTIETH BIRTHDAY
OF HER MAJESTY QUEEN ELIZABETH II: 21ST APRIL 1986.

The design includes the four National flags and flowers. On the reverse is a lozenge-
shaped world around which is entwined a ribbon inscribed: The COMMONWEALTH OF
NATIONS. A further long ribbon scrolls around both the front and reverse containing
the names of all the countries forming the Commonwealth.

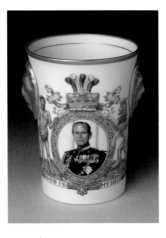

Fig. 10.41

An exclusive commissioned lion head handle
beaker, in a limited edition of 500, celebrating
the seventieth birthday of Prince Philip, Duke
of Edinburgh. On the reverse is a painting of
Windsor Castle surmounted by four ostrich
feathers encircled by a crown. Commissioned
by Peter Jones China of Wakefield the beaker
illustrated is number 362. The manufacturer
was Daniel Sutherland & Sons, Park Hall
Street, Longton.

edition mug was commissioned to commemorate her new title, Diana, Princess of Wales, (see Fig. 10.42). In the early hours of 31st August 1997 the car in which the Princess of Wales was travelling in Paris met with a dreadful accident. Shortly afterwards, in a Paris hospital Diana, Princess of Wales, died. The nation was grief stricken. She had a very special place in people's hearts, not only in the United Kingdom, but the world over. Many commemoratives, some in limited editions, were produced as a reminder of the love and esteem in which she was held. (See Fig. 10.43).

Queen Elizabeth II and Prince Philip, Duke of Edinburgh, celebrated their Golden Wedding on 20th November 1997, the first such occasion in the history of the British Royal family. Only a few potteries planned to produce commemoratives for this event. However, the public interest was so intense that some potteries, who had previously decided not to produce commemoratives for this occasion, did so and were rewarded by a strong market. A number of limited editions were also produced including one commissioned by the Commemorative Collectors Society. (See Figs. 10.44 and 10.45). No dispensation was granted by the Lord Chamberlain's office for the use of the Royal Arms and Royal Cyphers on commemoratives for this event. This is the reason, therefore, why a devised Arms was used on the Holmes Gray mug in Fig. 10.44.

On 19th June 1999 Prince Edward married Miss Sophie Rhys-Jones at St. George's Chapel, Windsor. A number of limited edition mugs and beakers, commemorating both the engagement and the wedding, were produced. Royal Crown Derby, who have produced commissioned pieces for many Royal occasions, produced a striking loving cup designed by June Branscombe, (see Fig. 10.46). This was commissioned by Govier's of Sidmouth and completed before the actual wedding and therefore does not carry the titles bestowed on Prince Edward and Miss Sophie Rhys-Jones on their wedding day of Earl and Countess of Wessex and Viscount and Countess Severn. The design for at least one commission was frozen until the day of the wedding when the titles were announced and therefore carries the titles. A previous Earl of Wessex (1018) was Godwine, a former chief adviser to King Canute. His name continues to-day in that a once fertile island that belonged to him was named Goodwin Sands.

Fig. 10.42

A fine white bone china mug, in a limited edition of 2500, featuring a photographic portrait of Diana, Princess of Wales framed by a garland of flowers with a bow of pink ribbon below. Inscribed, in blue, beneath the bow is: DIANA PRINCESS OF WALES 1996. On the reverse is a large 'copper plate' D through which two daffodils intertwine topped by a coronet. The design also includes two items from the Spencer Coat of Arms: a blue band with scallop shells at the top and a trellis design at the foot of the daffodils. The backstamp includes the inscription :- 'Diana, Princess of Wales, Duchess of Cornwall, Countess of Chester, 1966'. This mug was exclusively commissioned by Peter Jones China of Wakefield on the formal announcement of the divorce and the Princess's new title.

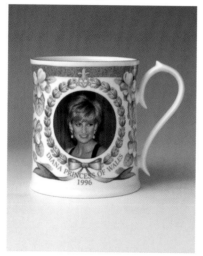

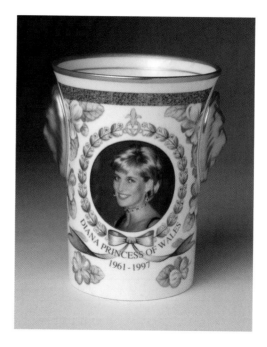

Fig. 10.43

A lion head beaker of a similar design to the mug illustrated in Fig. 10.42 but featuring a different portrait. The dates in the inscription are those of the life of Diana, Princess of Wales. This beaker was one of many commemoratives published at the time of her tragic death. The backstamp includes the inscription: 'A Tribute to Diana Princess of Wales The People's Princess Queen of Hearts 1961–1997'. Commissioned by Peter Jones China in a limited edition of 1997. This is number 675. Manufactured by Daniel Sutherland & Sons, Park Hall Street, Longton.

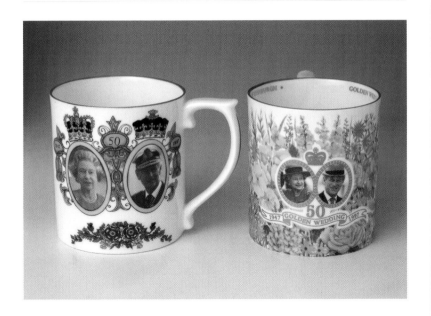

Fig. 10.44

Two bone china mugs by Chown commemorating the 50th wedding anniversary of
H.M. Queen Elizabeth II. The decoration of the right-hand mug is centred opposite
the handle. The mugs themselves are identical. The mug on the left, number 15 in a
limited edition of 1000, was commissioned by the Commemorative Collectors
Society and designed by Holmes Gray. Coloured photographic portraits of Queen
Elizabeth II and The Duke of Edinburgh in oval frames are featured on the front
with a St Edward's Crown surmounting the Queen's framed portrait and a Royal
Duke's Coronet above the framed portrait of the Duke of Edinburgh. Inscribed in
three discs is: 1947 50 1997. Beneath the portraits is an arrangement of the four
National plant emblems. On the reverse are two Garter Belts containing devised
Arms for both the Queen and the Duke above an arrangement of the four national
plant emblems. The golden design of the right-hand mug is very much in keeping
with the occasion being commemorated. Two gold beaded frames contain coloured
photographic portraits of the Queen and the Duke of Edinburgh with a gold crown
above. Below the portraits is a gold '50' and below this is a
gold ribbon with a gold inscription:
1947 GOLDEN WEDDING 1997. Inscribed, in gold inside the rim, is:
GOLDEN WEDDING ANNIVERSARY OF QUEEN ELIZABETH II
AND THE DUKE OF EDINBURGH.

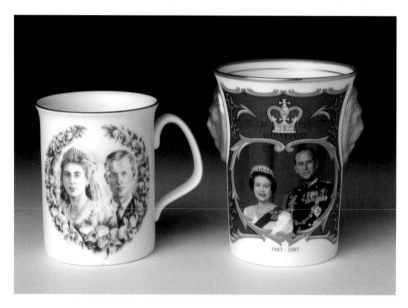

10.45

The white bone china flared mug features a sepia wedding day photographic portrait of Queen Elizabeth II and Prince Philip, Duke of Edinburgh, in a frame of orchids. On the reverse, in a similar frame of orchids, is the inscription: 'The Golden Wedding Anniversary of H.M.The Queen and H.R.H.The Duke of Edinburgh 1947-1997'. The backstamp, of this Royal Doulton mug carries the same inscription as that on the reverse. The lion head handle beaker illustrated is number 440 of a limited edition of 950. The design on both sides of this beaker is identical except for the coloured photographic portrait which on one side is a contemporary portrait and, on the other, one taken at the wedding in 1947. The heart-shaped scroll frame is topped by a crown. Below each of the portraits are the dates: 1947-1997. The backstamp includes the inscription:

TO CELEBRATE THE 50TH WEDDING ANNIVERSARY OF HM QUEEN ELIZABETH II AND HRH PRINCE PHILIP, THE DUKE OF EDINBURGH 1947-1997.

This beaker was commissioned by Peter Jones China of Wakefield and manufactured by Daniel Sutherland & Sons, Park Hall Street, Longton.

Whether one is a collector of Royal Commemoratives or not, Her Majesty Queen Elizabeth The Queen Mother is highly respected, loved and greatly admired. Since her marriage to Prince Albert, Duke of York she has unstintingly undertaken an enormous programme of public duties, including visits to the potteries, (Fig. 10.47 was taken on such a visit). Many commemoratives have been produced over the years in celebration of events in her public programme, her birthdays and as a tribute to her years of service to the nation. The designs often include Queen Elizabeth, The Queen Mother's Coat of Arms, the Supporters of which were granted by Warrant of King George VI dated 2nd February 1937. In heraldic terms – 'They are blazoned on the dexter side (observer's left) A lion guardant Or Imperially crowned proper, and on the sinister side (observer's right) A lion per fesse Or and Gules'. The supporters are clearly illustrated in Fig. 10.51 with crowned gold lion guardant on the left and a lion whose top half is gold and bottom half red on the right. The supporter on the left is from King George VI's Coat of Arms and the lion per fesse Or and Gules (on the right) is from the Coat of Arms of the Queen Mother's father, the Earl of Strathmore and Kinghorne. The Earldom of Kinghorne was created in 1606 and the earldom of Strathmore in 1667. An illustration of the arms of the Earl of Kinghorne, in a manuscript entitled 'Kings and Nobility Arms' compiled by James Esplin circa 1639, shows the sinister supporter with a gold head and a gold mane with red paws (all four), body and tail. The description accompanying the illustration describes the sinister supporter as a 'Lyon rubie'. However, in the Lyon Register circa 1677 the sinister supporter is clearly described as 'a Lyon rampant parted per fess Or and gules' and that is exactly as it is depicted on Queen Elizabeth, The Queen Mother's Coat of Arms. Although concieved over 350 years ago the sinister supporter continues to be highly distinctive today – just as the seventeenth-century Lyon herald had intended.

A number of the mugs and beakers commemorating some of her later birthdays are featured in (Figs. 10.48 and 10.49). However not many Royal Commemoratives will have been as eagerly awaited as those which were issued to commemorate The Queen Mother's 100th birthday on 4th August 2000, the first ever centenary by a member of the British Royal Family. Fig. 10.50 shows a limited

Fig. 10.46

A striking June Branscombe Royal Crown Derby Loving Cup, commissioned in a
limited edition of 750 by Govier's of Sidmouth, commemorating the wedding of
Prince Edward and Miss Sophie Rhys-Jones at St George's Chapel, Windsor Castle.
The 'lattice' design, incorporating Royal Crown Derby's famous cobalt blue ground,
was inspired by the design on the roof of St George's Chapel. The coronet from
Prince Edward's Coat of Arms is featured on the front, above the intertwined initials
E and S. On the reverse is inscribed:
H.R.H. Prince Edward to Sophie Rhys-Jones ST. GEORGE'S CHAPEL WINDSOR
19TH JUNE 1999. This Loving Cup is number 442.

Fig. 10.47

Queen Elizabeth, the Queen Mother on her visit to Royal Crown Derby Porcelain Company on 8th June 1971 when the shape named 'Queen's Gadroon' was launched. 10.47A is a copy of the entry in the Company's Visitors Book on the day of this Royal visit.

Fig. 10.47A

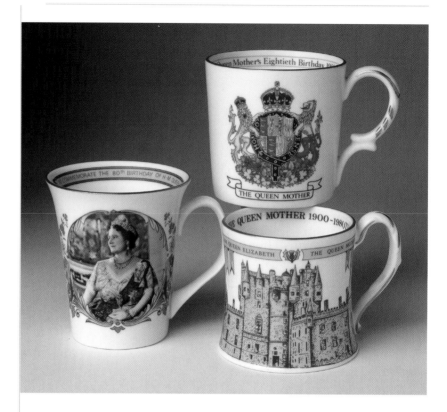

Fig. 10.48

Three fine bone china mugs commemorating the 80th birthday of H. M. Queen Elizabeth, the Queen Mother on 4th August 1980, each mug carries an inscription to this effect inside the rim. (1) The Crown Staffordshire mug features a coloured half-length photographic portrait of Queen Elizabeth, the Queen Mother. The portrait is flanked, each side, by the four national plant emblems. On the reverse is the Queen Mother's crown flanked on each side by the four national plant emblems. (2) The main illustration on this waisted Coalport mug, issued in a limited edition of 2500 pieces, is of Glamis Castle, Angus, in Scotland, the Queen Mother's family seat. On the reverse is the Queen Mother's Coat of Arms. (3) The Aynsley mug carries the Queen Mother's Coat of Arms on the front, above an arrangement of three national plant emblems. On the reverse is her family tree. The Queen Mother's Coat of Arms consists of the Strathmore Coat of Arms supported by the two Royal supporters. The lion supporter, on the right, is half gold and half crimson.

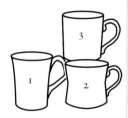

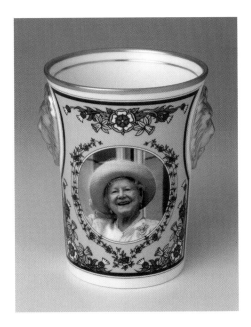

Fig. 10.49

Daniel Sutherland of
Longton, Staffordshire
produced this fine
bone china lion head
beaker
commemorating the
'95TH YEAR OF HER
MAJESTY QUEEN
ELIZABETH THE QUEEN
MOTHER' to the
commission of Peter
Jones China of
Wakefield in a limited
edition of 750, of
which the beaker
illustrated here is
number 453. The front
features a coloured
photographic portrait
of the Queen Mother
wearing one of her
famous hats. The
portrait is surrounded
by the four national
plant emblems. On the
reverse, in the same
arrangement of the
plant emblems, is the
Queen Mother's Coat
of Arms.

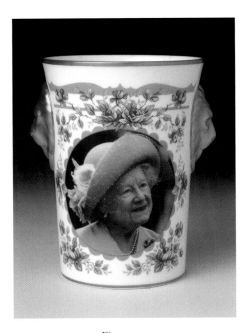

Fig. 10.50

Lion head beaker, number 31 of a limited edition of 950 by Caverswall
commemorating 'the Centenary of H.M. Queen Elizabeth, the Queen Mother 1900-
2000'. A large coloured photographic portrait of the Queen Mother is featured on
the front surrounded by pink roses. On the reverse is the Queen Mother's Coat of
Arms. (The lower half of the Royal supporter on the right is not coloured crimson as
is the authentic design). This beaker was an exclusive commission by Peter Jones
China, Wakefield.

edition (950) Lion Head beaker commissioned by Peter Jones China and produced by Caverswall, Stoke on Trent (now Thomas Goode Manufacturing Division). The portrait of the Queen Mother, in turquoise, is surrounded by roses – her favourite flower. (The Queen Mother is President of the Royal National Rose Society.) Paragon China, in a limited edition of only 200, produced their famous large loving cup with gold lion handles to commemorate the Queen Mother's Centenary, (see Fig. 10.51). The last time this cup was issued to mark a Royal event was for the Queen Mother's 80th birthday. Govier's of Sidmouth commissioned Royal Crown Derby to produce, in limited edition, a loving cup, (see Fig. 10.52), Plate and trinket box, designed by June Branscombe. The year 2000 is also a special year for Royal Crown Derby, the oldest surviving manufacturer of English porcelain, as it is their 250th anniversary. In June 2000 Royal Crown Derby was acquired from the Royal Doulton Group plc by private buyers thus restoring its independence, an enterprising move in this age of consolidation in the ceramics industry. Here's to another 250 years. A delightful design, by Neil Faulkner, was issued by Thomas C. Wild & Sons of Longton (a member of the Royal Doulton Group) under their Royal Albert mark, featuring both young and old portraits, (see Fig. 10.53). Thomas Goode Manufacturing Division produced their own limited edition range to commemorate this very special birthday comprising a plate, mug, beaker and loving cup. A number of other potteries, including Aynsley and Spode, also produced Centenary commemoratives, many in limited editions. The Commemorative Collectors Society commissioned a plate and beaker, each in a world-wide limited edition of 500. The centre-piece of the design, in which pink predominates, is a collection of photographic portraits of Queen Elizabeth, the Queen Mother at three significant times in her life: as Lady Elizabeth Bowes-Lyon at the time of her marriage to the Duke of York in 1923; as Queen Consort to the late King George VI at their Coronation in 1937 and on the occasion of her 99th birthday on 4th August 1999. The design includes 100 roses. This design was also used to decorate a three-handled loving cup, in a limited edition of only 25 pieces, (see Fig. 10.54).

Before the Centenary celebrations were over the potteries had already started gearing themselves up for two further very special occasions – the Golden Jubilee of Queen Elizabeth II in 2002 and

Fig. 10.51

This beautiful Paragon loving cup commemorated Queen Elizabeth, The Queen Mother's Centenary.

Paragon's large size loving cup has not been produced on every Royal occasion but when issued the edition is often over-subscribed. The large size loving cup illustrated here is the one produced to commemorate Queen Elizabeth, The Queen Mother's Centenary. Issued in a limited edition of only 200, the one illustrated is number 150.

In fine white bone china, this hand-made and hand-decorated Cup features the supporters from the Queen Mother's Coat of Arms pointing to the 100 inside the Garter Belt replacing the Strathmore Coat of Arms. Pink roses abound. Beneath the richly gilded lion handles is 1900 and 2000. On the reverse is 'the Queen Mother's Cypher'. Inside the rim is the inscription: 'Celebrating H M Queen Elizabeth the Queen Mother's 100th year 1900-2000'. Paragon China is manufactured under the Royal Albert mark of Thomas C. Wild & Sons (Ltd) at St Mary's Works, Longton, part of the Royal Doulton Group. Previous Royal occasions for which Paragon large size Loving Cups were produced included the Queen Mother's 80th birthday and the marriage of Princess Anne and Captain Mark Phillips in 1973.

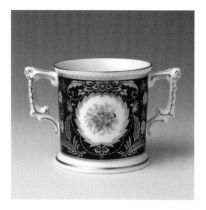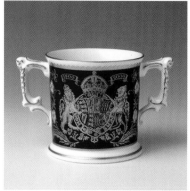

Fig. 10.52

Royal Crown Derby's loving cup, designed by June Branscombe, commemorating Queen Elizabeth, the Queen Mother's, 100th birthday. The front features a beautiful arrangement of three national plant emblems in a lavishly gilded frame of unusual design flanked by further gilding inspired by the Queen Mother's jewellery. On the reverse is the Queen Mother's Coat of Arms in gold on the traditional Royal Crown Derby cobalt blue ground. This Govier's of Sidmouth commission in a limited edition of 1500 is unusual in that for the first time Royal Crown Derby Porcelain Company have incorporated the Royal Warrant in their backstamp, which also includes the inscription: 'H.M. Queen Elizabeth, the Queen Mother 1900-2000'. The Loving Cup illustrated is number 762.

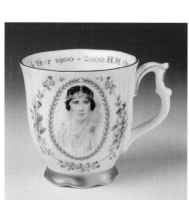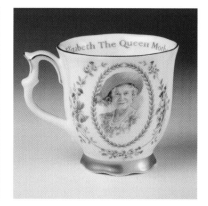

Fig. 10.53

Produced under the mark of Royal Albert, this attractive white bone china mug, commemorating the 100th birthday of Queen Elizabeth, the Queen Mother, designed by Neil Faulkner, features a portrait of The Queen Mother on both the front and the reverse. The portrait on the front was painted when the Duchess of York became Queen Consort on the Duke of York's accession to the throne in 1936. The portrait on the reverse is a recent painting with the Queen Mother wearing one of her famous 'swept up at the front' hats. Each portrait is framed by ochre leaves. This in turn is framed by an arrangement of national flowers with the yellow daffodil looking particularly striking. The handle, rim and scalloped foot are gilded. Inside the rim is the inscription:
'H.M.Queen Elizabeth the Queen Mother's 100th Year 1900-2000'.

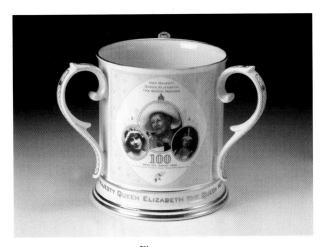

Fig. 10.54

The John Chown '100 Roses loving cup' commissioned by the Commemorative Collectors Society. The inscription encircling the foot reads:

COMMEMORATING THE 100TH BIRTHDAY OF HER MAJESTY

QUEEN ELIZABETH THE QUEEN MOTHER

The front panel features three photographic portraits of Queen Elizabeth, the Queen Mother. The central portrait, in colour, is of the Queen Mother on her 99th birthday. The two smaller sepia portraits are of the Queen Mother in 1923 at the time of her marriage and as Queen Consort at the 1937 Coronation. Incorporated in the design around the three portraits are the four national plant emblems.

The inscriptions read:

HER MAJESTY QUEEN ELIZABETH THE QUEEN MOTHER. 100 BORN 4TH AUGUST 1900.

THE HONOURABLE ELIZABETH MARGUERITE BOWES-LYON

The second panel, set against the same ground as the front, contains the Queen Mother's Royal Cypher, beneath which is the inscription:

COMMEMORATING THE 100TH BIRTHDAY OF A HIGHLY RESPECTED AND MUCH LOVED LADY.

In the third panel is the Queen Mother's Coat of Arms. Each handle is decorated with a gold lattice design with two gold crowns. This loving cup was produced, in a limited edition of only 25, by Chown.

Fig. 10.55A

Fig. 10.56A

On the 21st April 2001 Queen Elizabeth II celebrated her 75th birthday and on the 10th June 2001 Prince Philip, Duke of Edinburgh celebrated his 80th birthday. The Aynsley mugs celebrating these two happy occasions are illustrated above – 10.55A and 10.56A respectively. Both mugs were commissioned in a limited edition of 3000 by Peter Jones China.

the 50th anniversary of the Coronation in 2003. Very special occasions they are – this will be only the third 50th Jubilee of Reign since that of King George III in 1809-10 and Queen Victoria in 1887.

Long may the potteries continue to produce Royal Commemoratives recording Royal events, just as they have done for over three hundred and forty years, (a mug was produced in 1660 to commemorate the coronation of Charles II). Although fewer Royal Commemoratives are presented to schoolchildren today than at the turn of the last century let us hope that everybody continues to have one!

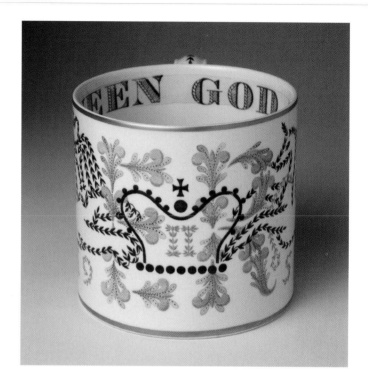

QUEEN ELIZABETH II CORONATION 1953

Fig. 10.55

This much lauded contemporary design by Richard Guyatt, his first for Wedgwood, still stands out to-day just as it did forty-seven years ago. Printed on a fine white earthenware mug in sepia and pink, the specks of gold incorporated in each of the numbers are particularly eye-catching. Inside the rim, on a broad pink band is inscribed:

GOD SAVE THE QUEEN.

The rim, foot and handle are lined in gold with a decoration running down the handle.

MARK: Below a crown is a circular backstamp with the inscription :-

TO COMMEMROTE THE

Coronation

OF HER MAJESTY

QUEEN ELIZABETH II

1953

WEDGWOOD

MADE IN ENGLAND

DESIGNED BY RICHARD GUYATT

Other marks include a printed W in green and hand-painted in orange is CL 6487 with a Y below.

MANUFACTURER: Josiah Wedgwood (& Sons Ltd), Barlaston, Staffordshire.

QUEEN ELIZABETH II CORONATION 1953

Fig. 10.56

A white bone china flared tapered beaker, waisted at the foot. The foot and rim are
gilded as is the decoration and backstamp. The designer's signature, John
Wadsworth, is incorporated into the backstamp. The Royal Coat of Arms is acid
etched on the front with Queen Elizabeth II's cypher, in a shield with crown above,
etched on the reverse. Above the foot is a band of three national plant emblems –
rose, thistle and shamrock. The interior rim is etched, in gold, with the raised
inscription:

TO . COMMEMORATE . THE . CROWNING . OF . QUEEN . ELIZABETH .

THE . SECOND . JUNE . 2ND . 1953 .

MARK: Printed in gold is the mark of Minton below which is :

BONE CHINA

MADE IN ENGLAND

DESIGNED BY

John Wadsworth (signature)

MANUFACTURER: Minton, Stoke on Trent, Staffordshire.

QUEEN ELIZABETH II CORONATION 1953

Fig. 10.57

A sepia photographic portrait of Queen Elizabeth II is featured on this flared cream porcelain beaker with waisted foot and light yellow band at the rim. The portrait is flanked by sprigs of oak bearing acorns tied with a scrolled bow of yellow ribbon beneath the portrait. On the reverse is the Royal cypher. Above the foot, running around the beaker, is the inscription:

COMMEMORATING THE CORONATION OF QUEEN ELIZABETH II JUNE 2ND 1953

MARK: Painted in sepia is a lion standing on a crown above ROYAL DOULTON with the Doulton device below and ENGLAND below this. MADE IN ENGLAND encircles this standard printed mark – number 1334.

MANUFACTURER: Royal Doulton & Co (Ltd), Nile Street, Burslem, Staffordshire.

QUEEN ELIZABETH II CORONATION 1953

Fig. 10.58

This white fine bone china mug commemorating the Coronation of Queen Elizabeth II is unusual in that on the front, printed in blue, is a complete list of England's Kings and Queens from Edward the Confessor in 1042 to Elizabeth II in 1952. On the reverse is the inscription:
H.M. Queen Elizabeth II
Crowned
Westminster Abbey
June 2nd. 1953

MARK: Printed in green is a crown above a scrolled ribbon bearing the name AYNSLEY.
MANUFACTURER: John Aynsley & Sons (Ltd), Portland Works, Longton, Staffordshire.

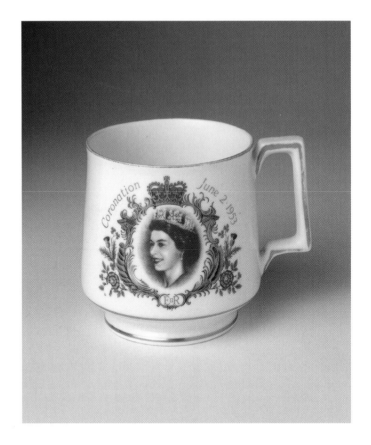

QUEEN ELIZABETH II CORONATION 1953

Fig. 10.59

A white bone china tapered mug with flared rim and waisted foot with gilded rim, foot, above the foot and handle. A sepia photographic portrait of Queen Elizabeth II is featured on the front in an ornate gold frame with a crown at the top and the Queen's cypher below. Each side of the bottom half of the frame is a rose, thistle and shamrock. Inscribed around the top half of the frame is:
'Coronation June 2 . 1953'
On the reverse, all in gold, is the Queen's cypher.

MARK: A H and M separated by a lion standing on a striped pole. Below this is:
SUTHERLAND BONE CHINA
MADE IN ENGLAND
MANUFACTURER: Hudson & Middleton Ltd., Sutherland Pottery, Longton, Staffordshire.

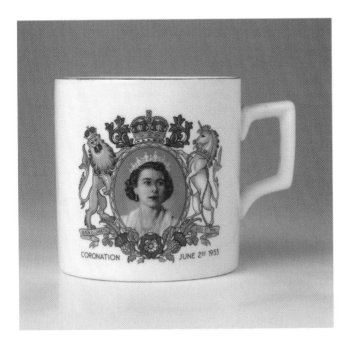

QUEEN ELIZABETH II CORONATION 1953

Fig. 10.60

A cream porcelain mug with gold rim and a gold stroke on the handle featuring a sepia photographic portrait of Queen Elizabeth II in a frame flanked by the Royal supporters. Above is a crown with blue scrolls each side and below is an arrangement of three national plant emblems – rose, thistle and shamrock, beneath which runs the inscription:

CORONATION JUNE 2ND 1953. On the reverse is the Royal cypher.

MARK: Printed in gold, between two parallel lines is:

STAFFORDSHIRE

C ROWN MADE
LARENCE IN
ENGLAND

There is also an impressed B. (See note in description for Fig. 10.62)

MANUFACTURER: Co-operative Wholesale Society Ltd., Crown Clarence Pottery, Longton, Staffordshire.

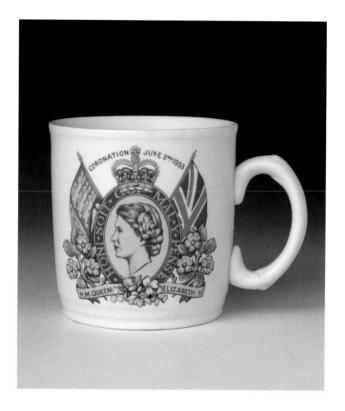

QUEEN ELIZABETH II CORONATION 1953

Fig. 10.61

A cream earthenware mug with raised lip and reeded foot commemorating the
Coronation of Queen Elizabeth II. This mug was produced to the official design of
the British Pottery Manufacturers Federation. The design on the front features a
portrait of Queen Elizabeth II against a pale blue background framed in a Garter Belt
above which is a crown. The framed portrait is flanked by the Royal Standard and
the Union flag and ochre roses. Below, in the centre, is an arrangement in ochre of
thistle, shamrock and daffodil. Runing through this arrangement is a light blue
scrolled ribbon with the inscription:

H.M. QUEEN ELIZABETH II

Above the crown is the inscription:

CORONATION JUNE 2ND 1953

On the reverse is Queen Elizabeth II's cypher.

MARK: There is no manufacturer's mark, only the mark of the British Pottery
Manufacturers Federation as shown in Fig. 5.04.
MANUFACTURER: Unknown.

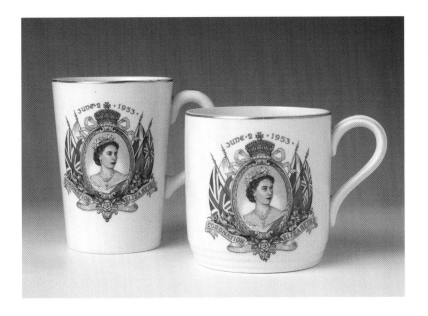

QUEEN ELIZABETH II CORONATION 1953

Fig. 10.62

A white porcelain tankard and mug with gilded rims and gold sroke on the handles.
The same attractive polychrome transfer featuring a sepia photographic portrait of
Queen Elizabeth II decorates both pieces. Above the portrait's frame is a crown with
a blue ribbon bow. JUNE . 2 . 1953 . is inscribed above. Each side of the portrait are
draped flags with an arrangement below, in gold, of three national plant emblems,
beneath which is a scrolled blue ribbon bearing the inscription :
CORONATION ELIZABETH II. On the reverse is the Royal cypher.

MARK: On the tankard is an impressed MIDWINTER above which is an impressed B.
A printed 16 also appears plus the gilder's mark. On the mug, printed in black, is a
crown with MIDWINTER ENGLAND STAFFORDSHIRE.

NOTE: The B incorporated in the impressed mark on the tankard is a Group letter
which was introduced in 1942 by the then Board of Trade to control the
manufacture of domestic china and earthenwares. They were classified into three
categories – A, B and C. At the end of the war (1947) the controls were cancelled,
however the Midwinter impressed mark was still in use with the Group letter
at the time this tankard was produced to commemorate Queen Elizabeth's
Coronation, similarly with the mug produced by the Co-operative Wholesale
Society described earlier.

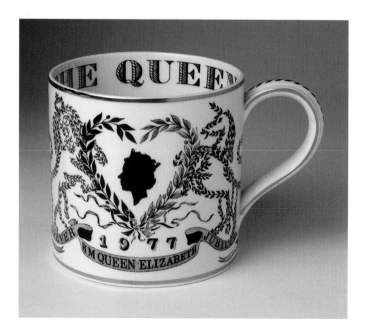

QUEEN ELIZABETH II SILVER JUBILEE 1977

Fig. 10.63

A Richard Guyatt cream earthenware mug decorated with a black/grey transfer print with design on the handle. The rim, foot and handle are lined in platinum. The design features a profile silhouette portrait of H.M. Queen Elizabeth II and H.R.H. Prince Philip in a heart-shaped frame of laurel leaves supported by the Lion and Unicorn. Beneath each portrait is the date 1977. Opposite the handle is a crown below which is E II R framed in the entwined tails of the Lion and Unicorn. Inside the rim in large letters is:

GOD SAVE THE QUEEN

MARK: Printed in black is a crown below which is inscribed:

TO COMMEMORATE THE

Silver Jubilee

OF HER MAJESTY

QUEEN ELIZABETH II

1952-1977

WEDGWOOD

MADE IN ENGLAND

DESIGNED BY RICHARD GUYATT

MANUFACTURER: Josiah Wedgwood & Sons Ltd, Barlaston, Staffordshire.

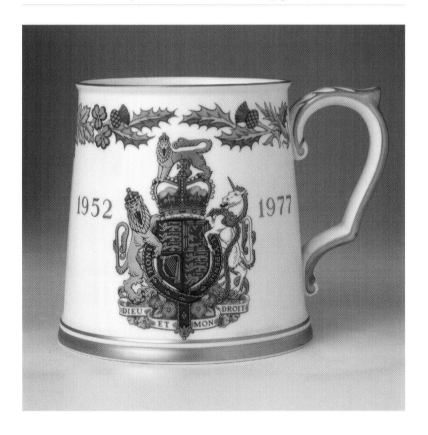

QUEEN ELIZABETH II SILVER JUBILEE 1977

Fig. 10.64

A most handsome fine white bone china tapered tankard with lip. The rim and foot are gilded as is the handle, the front face of which is heavily gilded with a hand-painted design, in gold, on the top of the handle. On the front is the Royal Coat of Arms in full colour and gold, with the date 1952 inscribed, in gold, on one side and 1977 on the other. Beneath the rim is a broad band of the four national plant emblems – Wales is represented by a leek. On the reverse, in a laurel wreath, is the Royal cypher with SILVER JUBILEE inscribed, in gold, beneath.

MARK: Printed in red is 'Spode' with 'Fine Bone China ENGLAND' printed, in black, below.

MANUFACTURER: W.T.Copeland (& Sons Ltd), Spode Works, Stoke, Staffordshire.

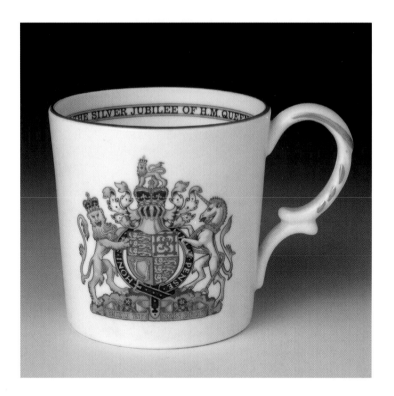

QUEEN ELIZABETH II SILVER JUBILEE 1977

Fig. 10.65

A similar mug, in fine white bone china, to that illustrated in Fig. 10.58. On the front of this mug, designed by Mr R.Heath, is the Royal Coat of Arms whilst on the reverse is the complete list of England's Kings and Queens – just as it appears on the front of the Aynsley mug commemorating the Coronation of Queen Elizabeth II. Inside the rim is inscribed:

TO COMMEMORATE THE SILVER JUBILEE OF H.M. QUEEN ELIZABETH II 1977.

MARK: Printed in green is a crown above a scrolled ribbon bearing the name AYNSLEY.
MANUFACTURER: John Aynsley & Sons (Ltd), Portland Works, Longton, Staffordshire.

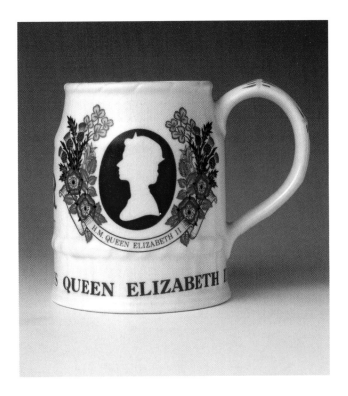

QUEEN ELIZABETH II SILVER JUBILEE 1977

Fig. 10.66

A large cream coloured ironstone tankard featuring a profile silhouette of
H.M.Queen Elizabeth II on the front and H.R.H. Prince Philip on the reverse. Each
portrait is flanked by an identical arrangement of the four national plant emblems.
Opposite the handle is the Royal cypher with the dates 1952-1977 inscribed below.
Above the foot is inscribed:

GOD BLESS OUR GRACIOUS QUEEN ELIZABETH II.

MARK: Printed in deep red is MASON's above a crown.

Below the crown, in a scroll, is:

PATENT IRONSTONE

MADE IN ENGLAND

Below this is the inscription:

COMMEMORATING

THE ROYAL SILVER JUBILEE

1952-1977

MANUFACTURER: Mason's Ironstone China Ltd., Broad St., Hanley, Staffordshire.

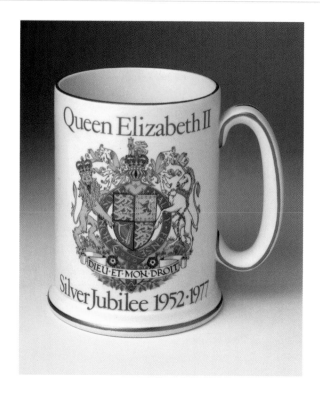

QUEEN ELIZABETH II SILVER JUBILEE 1977

Fig. 10.67

A white ironstone tankard, with metallic silver rim, foot and handle outline,
featuring the Royal Coat of Arms on the front in eight colours. The inscription, in
Garter blue, reads: 'Queen Elizabeth II Silver Jubilee 1952-1977'. On the reverse,
in Garter blue, is the official emblem of The Queen's Silver Jubilee Appeal Fund,
(see Fig. 10.06).

MARK: Impressed is: WOOD & SONS ENGLAND.
Printed in Garter blue, beneath the Silver Jubilee Appeal Fund's emblem is:
Pride of Britain
Silver Jubilee Souvenir
PRODUCED BY
WOOD & SONS
ENGLAND
Potters for 200 years

MANUFACTURER: Wood & Son(s) Ltd., Trent and New Wharf Potteries,
Burslem, Staffordshire.

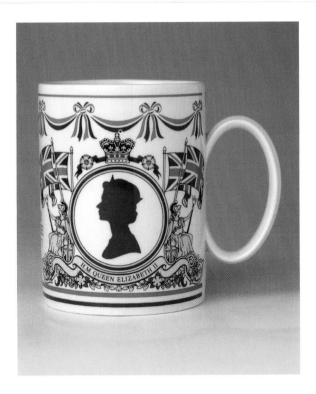

QUEEN ELIZABETH II SILVER JUBILEE 1977

Fig. 10.68

A cream earthenware 'Queens Ware' one pint mug with a Keith Williams coloured enamel transfer decoration. On the front is a profile silhouette portrait of H.M. Queen Elizabeth II and on the reverse H.R.H. Duke of Edinburgh. Each portrait, in a frame surmounted by a crown, is supported by Britannia holding Union flags. Opposite the handle is the inscription: SILVER JUBILEE 1952-1977. Below the top rim is a continuous design of ribbons and bows in red, white and blue. Above the foot are red, white and blue bands.

MARK: WEDGWOOD MADE IN ENGLAND around which is ROYAL SILVER JUBILEE 1952-1977. Below this is the inscription:

TO COMMEMORATE THE SILVER JUBILEE OF HER MAJESTY QUEEN ELIZABETH II 1952-1977.

MANUFACTURER: Josiah Wedgwood & Sons Ltd., Barlaston, Staffordshire.

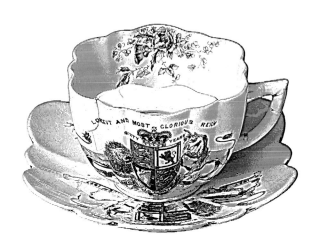

Bibliography

W&FC Bonham & Sons Ltd. *Long To Reign Over Us. Sale Catalogue For The Herbert Ward Collection Of Royal Commemorative China.* W&FC Bonham & Sons Ltd. London, 1990.

Commemorative Collectors Society. *Jubilee Royal. The Catalogue Of An Exhibition To Mark The Silver Jubilee Of Her Majesty Queen Elizabeth II.* Commemorative Collectors Society, 1977.

Commemorative Collectors Society. *A Princess For Wales. The Catalogue To Commemorate The Wedding Of The Prince Of Wales.* Commemorative Collectors Society, 1981.

Commemorative Collectors Society. *Spring 1998 Journal.* Commemorative Collectors Society, 1998.

Flynn, Douglas H. and Bolton, Alan H. *British Royalty Commemoratives.* Schiffer Publishing Ltd., Atglen. PA19310, USA.

Godden, Geoffrey. *Illustrated Encylopaedia of English Pottery and Porcelain.* Barrie & Jenkins,1970.

Hallinan, Lincoln. *Royal Commemoratives.* Shire Publications Ltd. 1997.

Johnson, Peter. *Phillips Collectors Guides. Royal Memorabilia.* Boxtree Ltd., London, 1988.

Jones, Peter. Various Promotional Releases. Peter Jones China, Wakefield.

Lang, Gordon. *Millers Pottery & Porcelain Marks.* Reed International Books Ltd., London, 1995.

May, John & Jennifer. *Commemorative Pottery 1780-1900.* Heinemann, London, 1972.

Moore, Steven and Ross, Catherine. *Maling – The Trade Mark of Excellence.* Tyne & Wear Museums, Newcastle-Upon-Tyne, 1997.

Morgenroth, Alan. Various Promotional Releases. Govier's of Sidmouth.

Potter, Beatrix. *The Tale of The Pie and the Patty-Pan.* Copyright © Frederick Warne & Co., 1905, 1987.

Prior, Rosemary. *Collecting Royal Commemoratives.* Antique Collector, April 1980.

Rogers, David. *Coronation Souvenirs and Commemoratives.* Latimer New Dimensions, London 1975.

Taylor, Judy. Beatrix Potter. *Artist, Storyteller and Countrywoman.* Copyright © Frederick Warne & Co., 1986.

Warren, Geoffrey. *Royal Souvenirs.* Orbis Publishing Limited, London, 1977.

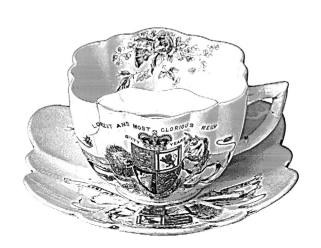

Index